D0619986

RECEIVED

JAN 10 2022

BROADVIEW LIBRARY

Android® Smartphone Photography

NO LONGER PROPERTY OF
SEATTLE PUBLIC LIBRARY

for dummies®

A Wiley Brand

NOT LONGER PROPERTY OF
SEATTLE PUBLIC LIBRARY

Android® Smartphone Photography

by Mark Hemmings

A Wiley Brand

Android® Smartphone Photography For Dummies®

Published by: **John Wiley & Sons, Inc.,** 111 River Street, Hoboken, NJ 07030-5774, www.wiley.com

Copyright © 2022 by John Wiley & Sons, Inc., Hoboken, New Jersey

Published simultaneously in Canada

No part of this publication may be reproduced, stored in a retrieval system or transmitted in any form or by any means, electronic, mechanical, photocopying, recording, scanning or otherwise, except as permitted under Sections 107 or 108 of the 1976 United States Copyright Act, without the prior written permission of the Publisher. Requests to the Publisher for permission should be addressed to the Permissions Department, John Wiley & Sons, Inc., 111 River Street, Hoboken, NJ 07030, (201) 748-6011, fax (201) 748-6008, or online at http://www.wiley.com/go/permissions.

Trademarks: Wiley, For Dummies, the Dummies Man logo, Dummies.com, Making Everything Easier, and related trade dress are trademarks or registered trademarks of John Wiley & Sons, Inc. and may not be used without written permission. All other trademarks are the property of their respective owners. John Wiley & Sons, Inc. is not associated with any product or vendor mentioned in this book.

LIMIT OF LIABILITY/DISCLAIMER OF WARRANTY: WHILE THE PUBLISHER AND AUTHOR HAVE USED THEIR BEST EFFORTS IN PREPARING THIS WORK, THEY MAKE NO REPRESENTATIONS OR WARRANTIES WITH RESPECT TO THE ACCURACY OR COMPLETENESS OF THE CONTENTS OF THIS WORK AND SPECIFICALLY DISCLAIM ALL WARRANTIES, INCLUDING WITHOUT LIMITATION ANY IMPLIED WARRANTIES OF MERCHANTABILITY OR FITNESS FOR A PARTICULAR PURPOSE. NO WARRANTY MAY BE CREATED OR EXTENDED BY SALES REPRESENTATIVES, WRITTEN SALES MATERIALS OR PROMOTIONAL STATEMENTS FOR THIS WORK. THE FACT THAT AN ORGANIZATION, WEBSITE, OR PRODUCT IS REFERRED TO IN THIS WORK AS A CITATION AND/OR POTENTIAL SOURCE OF FURTHER INFORMATION DOES NOT MEAN THAT THE PUBLISHER AND AUTHOR ENDORSE THE INFORMATION OR SERVICES THE ORGANIZATION, WEBSITE, OR PRODUCT MAY PROVIDE OR RECOMMENDATIONS IT MAY MAKE. THIS WORK IS SOLD WITH THE UNDERSTANDING THAT THE PUBLISHER IS NOT ENGAGED IN RENDERING PROFESSIONAL SERVICES. THE ADVICE AND STRATEGIES CONTAINED HEREIN MAY NOT BE SUITABLE FOR YOUR SITUATION. YOU SHOULD CONSULT WITH A SPECIALIST WHERE APPROPRIATE. FURTHER, READERS SHOULD BE AWARE THAT WEBSITES LISTED IN THIS WORK MAY HAVE CHANGED OR DISAPPEARED BETWEEN WHEN THIS WORK WAS WRITTEN AND WHEN IT IS READ. NEITHER THE PUBLISHER NOR AUTHOR SHALL BE LIABLE FOR ANY LOSS OF PROFIT OR ANY OTHER COMMERCIAL DAMAGES, INCLUDING BUT NOT LIMITED TO SPECIAL, INCIDENTAL, CONSEQUENTIAL, OR OTHER DAMAGES.

For general information on our other products and services, please contact our Customer Care Department within the U.S. at 877-762-2974, outside the U.S. at 317-572-3993, or fax 317-572-4002. For technical support, please visit https://hub.wiley.com/community/support/dummies.

Wiley publishes in a variety of print and electronic formats and by print-on-demand. Some material included with standard print versions of this book may not be included in e-books or in print-on-demand. If this book refers to media such as a CD or DVD that is not included in the version you purchased, you may download this material at http://booksupport.wiley.com. For more information about Wiley products, visit www.wiley.com.

Library of Congress Control Number: 2021947170

ISBN: 978-1-119-82490-9 (pbk); ISBN: 978-1-119-82491-6 (ePDF); ISBN: 978-1-119-82492-3 (ePub)

SKY10030245_100721

Contents at a Glance

Table of Contents

Introduction

Adroid smartphone photography continues to amaze me. Last night as I was looking up at the brilliant night sky, I was able to photograph the full moon with such magnification that I could see details in the moon's impact craters! Of course the ability to photograph the moon close up is easily done with a larger DSLR or mirrorless camera, but for a smartphone to have advanced to such an extent that you can create decent astro-photographs is amazing.

The good news is that not only are the physical cameras on Android devices getting better each year, but the software that processes your photos within your smartphone also gets better with each software update. I encourage everyone to update their Android smartphones to take advantage of a better photography experience. No matter what kind of Android phone you have, you can create amazing images that you will be very proud of.

Maybe you're someone who has always found the technical side of things easy, but you struggle with capturing emotion, mood, metaphors, and heart in your photographs. Or maybe you're the opposite, where you feel and understand the soul of a particular place, but have a challenging time with the technical side of photography. Regardless of what your challenge is, this book is well-suited to help you both master the artistic and the technical side of Android smartphone photography.

About This Book

Android Smartphone Photography For Dummies is a book written to help you navigate your phone's incredible camera system and discover the heart and soul of smartphone photography. No matter what level of photography experience you have, the goal of this book is to get you excited about the possibility of seeing photo opportunities each day. As your Android smartphone is almost always with you, either in your backpack, purse, schoolbag, or back pocket, you almost always have access to a surprisingly good quality camera. This book offers you the creative and technical tools that will fuel your desire to photograph pretty much daily.

In this book, I show you how to

» Control light in its many forms to create the best-looking photos.

» Accentuate your images by applying the Rule of Thirds and other composi-
tional tools.

» Initiate Burst mode for sports and street photography to ensure that you get
the shot.

» Access and use the extra camera features, such as panoramas and selfies.

» Navigate your way around all of the Google Photos app settings and options.

» Take and edit your photos in the quickest and most accurate way possible.

» Create the best landscape, sports, family, travel, products, and street
photographs.

» Edit, organize, and share your photos.

» Create smooth-looking videos.

I wanted this book to work perfectly for users of all Android makes and models. As
of this writing, there are 1,300 brands that produce over 24,000 distinct Android
devices. And each brand is able to custom design the look and feel of their Cam-
era app and settings. As it's impossible to create a book that addresses the exact
options of all 24,000 Android devices, I've been able to craft this book using the
universal Google Photos app. The look of the Google Photos app is mostly consis-
tent throughout all 1,300 Android brands. When the look of the Camera app differs
slightly from manufacturer to manufacturer I make sure to explain that your own
device may differ slightly in appearance to my examples. But not to worry! The
differences are often as minor as the shape or color of an icon, and no more.

To reach the highest number of Android users possible, I created this book using
three Android smartphones and both Android 10 and 11 operating systems. These
three devices span three segments of the market:

» The single lens Motorola Moto G7 Play using the Android 10 operating system.
This budget phone won't be upgraded to Android 11.

» The single lens Google Pixel 4a using the Android 11 operating system. This
mid-range phone will eventually be upgraded to Android 12 when the new
operating system is released.

» The Samsung Galaxy S21 Ultra 5G using the Android 11 operating system.
This professional-level smartphone features a very high quality multi-lens
camera system.

It's possible that you have a phone from a different manufacturer, such as HTC, Xiaomi, or Sony. As the pre-loaded Google Photos app is universal in its appearance and functionality, you will be more than fine following along with each tip and technique.

It's also important to mention that I took all the photography examples in this book with my previously mentioned three Android smartphone models.

Foolish Assumptions

This book assumes that you may know nothing about smartphone photography, yet is also highly accessible and valuable to those who may consider themselves as advanced amateurs. *Android Smartphone Photography For Dummies* guides you through the best practices of mobile photography, helping you gain a new creative outlet to express yourself!

So to start you out on a path to photographic success, I assume that you

>> Have an Android smartphone and its operating system is up to date.

>> You have access to Wi-Fi or use a data plan with your mobile phone provider.

Other than these two presumptions, I explain everything else in the book in great detail so that you never feel overwhelmed or bogged down.

Icons Used in This Book

This book, like all *For Dummies* books, uses icons to highlight certain paragraphs and to alert you to particularly useful information. Here's a rundown of what those icons mean:

TIP

A Tip icon means I'm giving you an extra snippet of information that may help you on your way or provide some additional insight into the concepts being discussed.

REMEMBER

The Remember icon points out information that is worth committing to memory.

TECHNICAL
STUFF
The Technical Stuff icon indicates geeky stuff that you can skip if you really want to, although you may want to read it if you're the kind of person who likes to have the background info.

WARNING
The Warning icon helps you stay out of trouble. It's intended to grab your attention to help you avoid a pitfall that may harm your smartphone or photos.

Beyond the Book

In addition to what you're reading right now, this product also comes with a free access-anywhere Cheat Sheet. To get this Cheat Sheet, simply go to www.dummies.com and search for "Android Smartphone Photography For Dummies Cheat Sheet" in the Search box.

Where to Go from Here

Throughout this process of discovering the ins and outs of Android smartphone photography, take inspiration from other photographers who have mastered their preferred photographic genre. Instagram is a good resource for this. However, it's critical that you don't allow yourself to feel bad if your photos are not up to that level. Practice creating photographs every day, if possible, and you will most certainly see your abilities improve radically over a short period of time.

Creativity is in everyone to some degree, and it's often the case that we simply need a guide to kick-start that engine. It's my hope that this book will serve that function and help you to master the technical parts, which will free you to absorb the artistic aspects of smartphone photography. I know that you can do it!

1

Using Your Camera Straight out of the Box

IN THIS CHAPTER

» **Discovering the differences between single and multi-lens Android cameras**

» **Understanding the differences between the many Android OS manufacturers**

» **Taking photos using your phone's built-in camera**

» **Viewing, editing, and sharing your photos**

Chapter **1**

Introducing Android Smartphone Photography

Whether you're brand new to photography using a smartphone, or new to the Android operating system, the aim of this chapter is to familiarize you with the basics so you can get out and start photographing as soon as possible. It's such an incredible feeling to have a powerful camera always with you, in your pocket, bag, or purse. After reading through this introduction to Android cameras, you should feel confident creating images with a smartphone. The photo opportunities await, so get excited about your Android smartphone and its surprisingly high-quality cameras!

Becoming Familiar with Your Android Camera

In the fantastic world of Android-powered mobile devices, you find a wide assortment of lens combinations. Each manufacturer of Android-based smartphones offer a single camera (often with a slightly wide-angle view), and the majority offer what is called a multi-lens combo. It's common these days to see Android smartphones with three cameras plus a front-facing selfie camera.

REMEMBER

If you own a single lens Android smartphone, don't feel that you're stuck with creating mediocre photos. The Google Pixel 4a, for example, only has one front-facing camera lens but it beats many of its competitors that have multiple lenses! What is more important than how many lenses your smartphone has is your ability to craft an image. What this means is how you compose your photo, how you use light to your advantage, and the emotion or narrative that you add to your images are skills that usually have more weight than just pure technical knowledge. This book helps you develop those skills, regardless of how many lenses your smartphone has.

The following list explains a rough description of the most common Android smartphone lens combinations. Some smartphones have one lens, some two, some three, and a few have four or more lenses. Multi-lens smartphone camera lenses are usually described as

- » **Ultra-wide:** Made for sweeping landscapes or interior architecture.
- » **Wide-angle:** This is usually the default general-use lens for all smartphones.
- » **Telephoto:** More of a zoomed-in look, great for portraits and nature.
- » **Super-telephoto:** Very zoomed-in look, perfect for distant wildlife and even for capturing a full moon!

Single-lens models

When someone mentions that their smartphone has a single lens, they're usually referring to what's called the rear, or back-facing lens, not the *selfie* lens that faces you and allows you to take a photo of yourself (more on selfies in Chapter 2). If your smartphone only has one lens, which is usually called a wide-angle lens, don't feel left out! Most of the great documentary, photojournalism, and street photographers of the past and present have created their best work with a single wide-angle lens. You can do the same.

Figure 1-1 shows off the small but powerful single wide-angle lens on the Google Pixel 4a. Keep in mind that the lens is the darker circle, and the white circle is the flash.

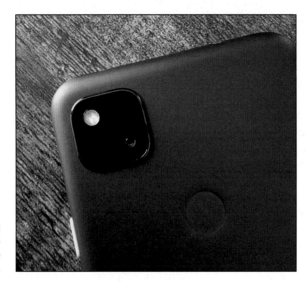

FIGURE 1-1:
The single-lens Google Pixel 4a.

Dual-lens models

Dual-lens Android devices are getting harder to find these days. The most popular options are single-lens and triple-lens combinations. Figure 1-2 shows an example of the Xiaomi Mi Mix 2S with its two lenses. This device, plus many other dual-lens devices have a wide-angle view from one lens, and what is often called by the manufacturers a *telephoto* view from the second lens. *Telephoto* usually refers to a view that appears more zoomed-in than what the human eye sees.

REMEMBER

If you have a DSLR camera or are familiar with traditional film photography, the use of the word *telephoto* by the manufacturers of dual-lens smartphones is sometimes a bit of a stretch. Often what they call the telephoto lens is actually what photographers call a *normal field of view*, which would be similar to a 50mm prime (non-zooming) lens in traditional photography terms. If you don't know what any of that means, no problem! All you need to know is that the wide-angle lens is great for architecture and landscape photography, and the second telephoto lens is better for portraits and general smartphone photography.

Triple-lens models

While not always the case, a triple-lens Android smartphone usually has an ultra-wide, wide, and telephoto lens combination. An ultra-wide lens fits in a lot of the

scene in front of you, such as whatever is in front of your feet, the landscape, and a lot of the sky. This camera type is great for vast, expansive landscape photos. The normal wide-angle lens is great for traditional street photography, photojournalism, and documentary work. The telephoto lens view is perfect for portraits and to a certain extent, wildlife.

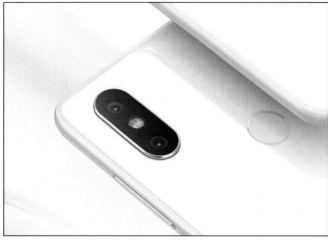

FIGURE 1-2:
The dual-lens Xiaomi wide-angle and telephoto lenses.

© Xiami Corporation

Figure 1-3 shows the triple-lens design of the Sony Experia 5 II. If you're familiar with full-frame DSLR or SLR cameras, the Experia's three lenses have focal lengths of 16mm, 24mm, and 70mm.

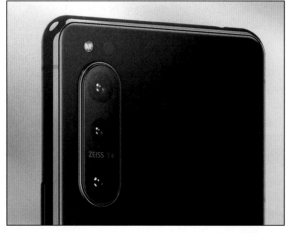

FIGURE 1-3:
The Sony Experia 5 II with its triple-lens camera combination.

© Sony Corp

Models with more than three lenses

Four lens Android smartphones are very popular, and there are so many great options to choose from. As of the writing of this book, the Samsung S21 Ultra 5G is probably the most highly regarded Android device for photographers, but of course that will change as new devices come on the market. Figure 1-4 shows the S21 Ultra's four lenses, which range from ultra-wide, wide, telephoto, and super telephoto views. Don't be fooled by what appears to be a fifth lens on this Samsung, which is actually a laser autofocus sensor. Many of Samsung's competitors have similar lens combinations and focal lengths. There are also five lens Android smartphones available, such as the Nokia 9 PureView and no doubt many more in the future.

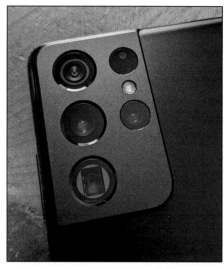

© MarkHemmings.com

FIGURE 1-4:
The impressive quad-lens Samsung S21 Ultra 5G.

It may be a bit hard to visualize what all the lens descriptions really mean without a visual example. Figure 1-5 shows the view from each of the Samsung S21 Ultra 5G's four lenses.

ultra-wide-angle 13mm

wide-angle 26mm

FIGURE 1-5:
The view from the four types of lenses on the Samsung S21 Ultra 5G.

telephoto 70mm

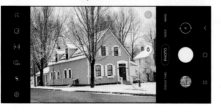

super-telephoto 240mm

© MarkHemmings.com

Taking a Look Around the Camera App

As the author of this book, I've been confronted almost daily with the struggle that each manufacturer has their own *take* on the Android operating system. That means that the appearance of your own Camera app may look slightly different than the three examples that I show you in this section. However, while the shapes and appearances of the icons look different between the manufacturers, the meaning of the icons are usually universal and easy to understand. For example, Figure 1-6 shows the typical view of a budget-friendly Motorola Camera app.

 Figure 1-7 shows the appearance of the Google Pixel 4a Camera app. The icons look different than the previously mentioned Motorola Camera app of Figure 1-6. Take a look at both figures and you see that extra camera options are visible at the top of the Motorola screen, but are hidden behind a downward-pointing arrow at the top of the screen on the Google Pixel 4a.

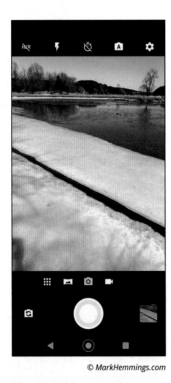

© MarkHemmings.com

FIGURE 1-6:
The Motorola Moto G7 Play smartphone Camera app appearance.

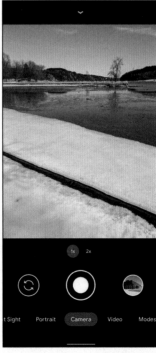

© MarkHemmings.com

FIGURE 1-7:
The Google Pixel 4a smartphone camera app appearance.

MORE

Figure 1-8 shows the appearance of the Samsung S21 Ultra 5G Camera app. Again, the icons look different than the two previously mentioned Android smartphones. This Samsung smartphone is considered a *flagship* model, which means that it's geared toward power-users and professionals. Even more camera option icons are visible, and many more are accessible at the bottom of the photo preview by tapping the More icon. Flagship models from any manufacturer have a lot of camera options to give the photographer as much manual control as possible.

To close the Camera app, Android manufacturers have different ways to go about it. For example, if you have a Google Pixel, place your finger or thumb at the bottom of your smartphone screen and swipe in an upward motion. Other smartphones have three icons at the bottom of your screen that perform functions such as opening your previous app and accessing all your apps.

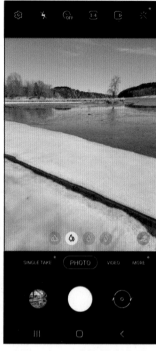

© MarkHemmings.com

FIGURE 1-8:
The Samsung S21 Ultra 5G smartphone Camera app appearance.

Taking a Picture

Regardless of what Android smartphone you own, the Camera app is always recognizable as an icon in the shape of a traditional camera. The Camera icon is most often visible on your home screen. Some Android smartphone manufacturers require you to long-press the Camera icon for about one second, others allow for a quick tap of the Camera icon, and still others require that you hold the Camera icon and then slide your finger in a slight upward motion. Figure 1-9 shows a typical home screen of a Google Pixel smartphone, with the Camera app at the bottom right.

Alternatively, if you're already within your Android device and you can see all your apps, simply tap the camera icon. Figure 1-10 shows an example of the Camera app icon within the app page.

With your Camera app open, find a good scene that you want to photograph and tap the large white shutter button circle, as shown in Figure 1-11. The term *shutter button* is a hold-over from traditional SLR and DSLR cameras, where the camera's shutter would physically open and close when the button was pressed. Smartphones don't have physical shutters like bigger cameras; however, the *shutter button* name has been adopted for smartphones.

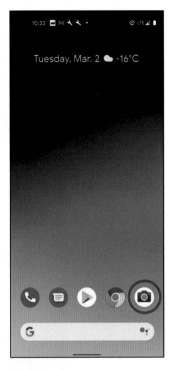

FIGURE 1-9:
A typical Google Pixel home
screen with the Camera app icon.

FIGURE 1-10:
The Camera app icon within the
apps page.

FIGURE 1-11:
Tap the shutter
button to take
a photo.

Viewing Your Photo

To view your photos, simply go to your Android apps page. Figure 1-12 shows a collection of apps, and when you locate the Google Photos app icon, tap it to open your photo collection.

REMEMBER

Even though you can access a newly taken photo within the Camera app itself, always close the Camera app and open the Google Photos app to access your photos. Opening your newly created photo from within your Camera app may open a non-Google photo editor. Some companies, such as Samsung, have their own photo collection app and image editor. For this book, I use Google's Photos app for image review and image editing.

When you open the Google Photos app, you see your most recent photos in the Today section of the app, as shown in Figure 1-13. At the bottom of the Photos app are three icons: Photos, Search, and Library. I cover all the features of Search and Library in later chapters.

Tap your most recent photo and it pops up in the photo review section of the app, as shown in Figure 1-14. You can flip through your most recent photos as well, simply by swiping your finger in a horizontal motion.

TIP

Use the pinch-to-zoom technique to see greater detail in your photo. Place your index finger and thumb on your photo and then widen the space between both of your fingers to zoom in, as shown in Figure 1-15. Do the opposite to zoom out.

FIGURE 1-12:
All your photos are stored in the Google Photos app.

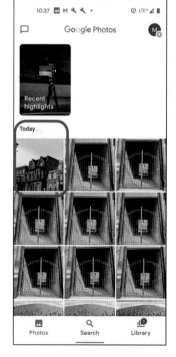

FIGURE 1-13:
Your recent photos are in the Today collection of the Photos app.

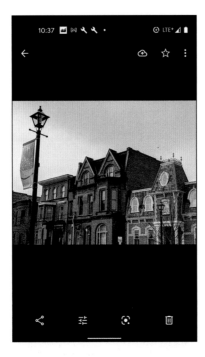

FIGURE 1-14:
Your photo review screen.

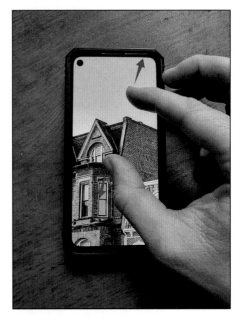

FIGURE 1-15:
Using the pinch-to-zoom technique to see greater photo detail.

Editing Your Photo

With a photo open in the review screen, tap the editing icon (see Figure 1-16) to access the photo editing tools.

Enhance is always a nice starting point to editing your photos. Tap Enhance in the review screen and the Google Photos app adjusts your photo to look its best, as shown in Figure 1-17.

After the enhancement, you may be prompted to choose to either save your edited photo or save it as a copy, as shown in Figure 1-18. Both options have pros and cons, which I explain in a number of upcoming chapters. If you like it, tap Save. If you still want to keep your original along with the edited version, tap Save as Copy. If you don't like the look of the edited changes, tap Cancel and then tap Discard. This takes you back to your original unedited photo. (Chapter 12 explains how to delete your saved photos.)

If you want to jump into the finer details of editing your photos, Chapter 11 is full of great tips and techniques to make your photos shine!

FIGURE 1-16:
Tap the editing icon to edit your photo.

FIGURE 1-17:
Tap Enhance for an automatic adjustment of your photo.

FIGURE 1-18:
Tap Save when done with your photo editing.

Sharing Your Photo

It couldn't be easier to share your photo! To the left of the photo editing icon in the review screen is the Share icon with three little connected dots, as shown in Figure 1-19.

FIGURE 1-19:
Tap the Share icon to open the Share Photo screen.

Figure 1-20 shows the Share Photo screen, and there are a lot of great sharing options that you can explore. Because Chapter 12 goes into photo sharing in greater detail, take a look at the most common sharing options: Messages and Gmail. If you use the Google Messages app, you can send your photo to any of your contacts after tapping that icon. If you want to email your photo to friends and family, by tapping the Gmail icon you're automatically taken to your Gmail account.

TIP

If you don't have a Google account, you won't be able to access Google Messages and Gmail. No worries! Chapter 3 is all about getting you set up for maximum Android smartphone functionality.

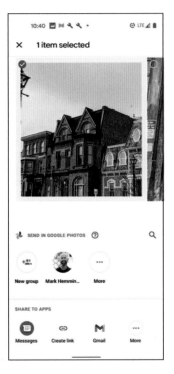

FIGURE 1-20:
The Share Photo screen has many photo sharing options such as sending photos to Gmail and Messages.

IN THIS CHAPTER

» Holding your phone properly

» Opening your camera in different ways

» Zooming in to your subject

» Photographing with the selfie camera

» Using your camera flash

» Setting your camera timer

Chapter **2**

Taking an In-Depth Tour of Your Camera

E ven the most basic and budget-friendly Android Camera app has more than enough technical and creative options to keep you photographing each day. This chapter gives you a walk-around tour of the Camera app, and the fundamentals of Android photography.

REMEMBER

Each Android smartphone manufacturer puts a different spin on the look of their own Camera app. This can be slightly frustrating for new users, but core functionality of the Camera app is pretty much the same across the Android smartphone world. One of the biggest differences you see in your Android device compared to another is the placement of the icons within the Camera app. For example, in Samsung Camera apps, the selfie icon is often on the lower right of the screen, whereas the selfie icon is often on the lower left of a Google Pixel screen. Regardless, the general concept of each icon is consistent and understandable between manufacturers.

Holding Your Phone Properly for Steady Photos

As an international photo workshop instructor, I often get asked by my partici-pants why their smartphone photos have a shaky appearance. I then proceed to ask them to show me how they take a picture with their phone. With arms fully extended I gently tap on their phone and show them the amount of shake that happens on their review screen. I then ask them to follow along with me as I show them the best ways to keep their smartphones stable while photographing in any location and condition.

TIP

One of the keys to creating sharp photos is to have a stable platform for your phone. To provide this stability, you can use a tripod, rest your phone on a stable surface, or use your own steady hands. But how do you make sure that your hands and arms are steady? The answer is simple:

1. **Pull your elbows into your ribcage to stabilize your arms.**

2. **Place your phone as close to your face as possible, based on your level of close sightedness and eye comfort.**

3. **Take a deep breath in, exhale, and when you're at the bottom of your exhale, take the photo.**

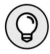

TIP

If your level of mobility allows for it, kneel to take your photo using one leg as a stabilizer.

Figure 2-1 shows how *not* to hold your smartphone, and Figure 2-2 illustrates the extra stability offered by moving your smartphone closer to your core. Figure 2-3 is an example of how you can make use of almost any type of stable platform, such as a fence, to rest your arms for even greater sharpness and image stabilization.

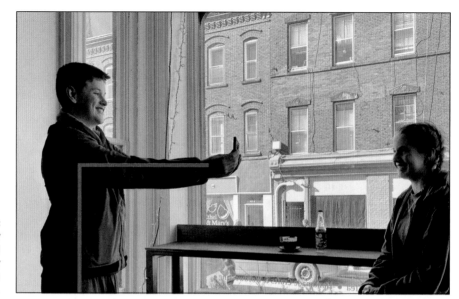

© MarkHemmings.com

FIGURE 2-1:
Arms fully
outstretched
potentially
causes camera
shake.

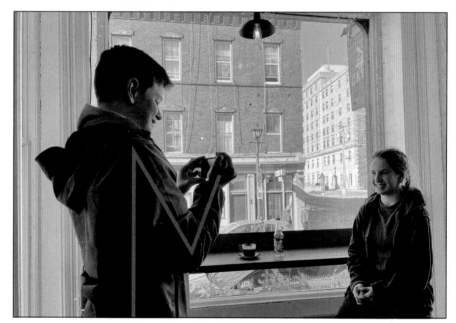

© MarkHemmings.com

FIGURE 2-2:
Bring your
camera closer
to your core
for steadier
photographs.

FIGURE 2-3:
Rest your arms
on a stable
platform for
shake-free
images.

© MarkHemmings.com

Next up! You can increase your success rate even further by holding your Android device properly. Of course, this advice is dependent on how large your hands are compared to the size of your smartphone, but following the examples in Figures 2-4 and 2-5 should give you excellent results.

Figure 2-4 shows a horizontal grip, where the left the thumb holds the base of the phone, the forefinger the top of the phone, and the mid-section of the middle finder rests on the side of the phone. On the right side, the bottom corner of the phone is pushed against the palm, the thumb presses the shutter button to take the photo, the pinky finger provides stability at the bottom of the phone, and the forefinger plus middle finger stabilize the top of the phone.

Figure 2-5 shows a vertical orientation, where the right hand does all of the gripping, and the left hand cups the right hand for even more stability. The left-hand thumb is the shutter button pressing finger.

If you feel that you need to reverse the grips because of right/left-handed preferences, no problem! All you need to care about is a stable grip.

With either vertical or horizontal grips, make sure you don't accidentally cover the lens with your hand or fingers!

REMEMBER

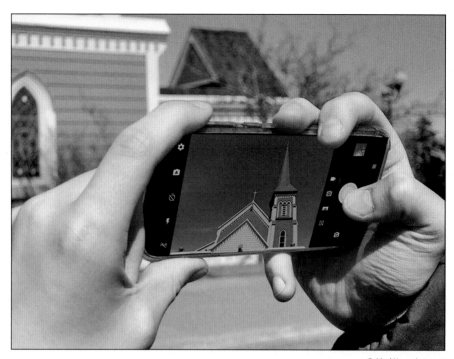

© MarkHemmings.com

FIGURE 2-4:
A stable
horizontal grip.

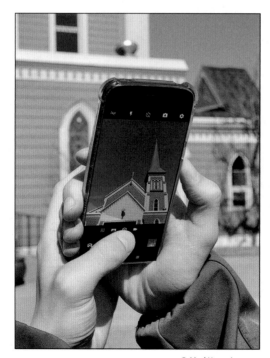

FIGURE 2-5:
A stable
vertical grip.

© MarkHemmings.com

Using Different Ways to Open Your Camera

Have you ever felt the disappointment of seeing a stunning photo opportunity, but as soon as you got your smartphone Camera app open you lost the scene? This happens all too often for photographers who can't quickly access their Camera app. Think of beautiful birds outside of your window, and just when you're ready to take the prize-winner, the birds fly away!

What follows are a few different ways that Android manufacturers allow you to open the Camera app other than the normal methods discussed in Chapter 1:

>> **Double-tap your power button.** Almost all Android device manufacturers allow for a camera quick-launch by double-tapping (or double-clicking) the power button. Also known by some manufacturers as the *Home* button or *Power key*, this button is usually situated close to the volume up/volume down buttons. Figure 2-6 shows a typical side power button (circled) next to the volume up/volume down button.

FIGURE 2-6: Double-click the power button to quickly open the camera.

© MarkHemmings.com

>> **For Motorola Moto devices, just twist.** Twist Gesture is a clever way to open your camera simply by laterally twisting your phone twice. You may need to set up Twist Gesture if it's not on by default for your own Moto smartphone. With your Camera app open, tap the Settings icon (looks like a circular gear), and then tap Quick Capture to the on position. Figure 2-7 shows the options available to choose between the rear-facing camera for normal photography, or the front camera for selfies. You can choose based on how many selfies you take in a day compared to how many normal photos you usually take.

>> **For Google Pixel 4 and later, use the Google Assistant.** If you own a Google Pixel phone and have already signed into your Google account (more on this in Chapter 3), you can open your camera to take a photo by saying "Hey Google, take a picture." This action is brought to you by Google Assistant, which you can turn on or off depending on your comfort level of having your device listen to your voice. After your command, the Camera app opens and initiates a three second timer countdown. This three seconds allows you to compose the image properly. Figure 2-8 shows the countdown in action just before my under-the-bridge photo was automatically taken. If you have a non-Google phone, Google Assistant may be available to you. Do a quick web search for *"Google Assistant for (your smartphone make and model)"* to see whether you can use this voice command for your own smartphone.

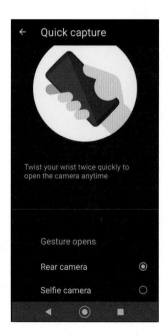

© MarkHemmings.com

FIGURE 2-7:
Motorola's Twist Gesture is a quick way to open either the selfie or rear-facing camera.

FIGURE 2-8:
Use the Google Pixel's "Hey Google, take a picture" voice command.

Zooming In to Your Subject

Single-lens Android device users will quickly realize that the wide angle of their lens is not so great at capturing small distant objects. Think of a bird in a tree, and how your scene is far too wide to even recognize what kind of bird it is. That's where zooming comes in! The term *zooming in* is borrowed from traditional larger cameras that have lenses that can physically zoom in and zoom out. By *zooming out* you can have a very wide looking scene where a lot is included in your photo, or you can *zoom in* to capture that small bird in the distant tree.

Originally, the ability of cameras to zoom either in or out was only done with a mechanical movement of metal and glass within the *zoom lens*, similar to the lens pictured in Figure 2-9.

© MarkHemmings.com

FIGURE 2-9: A zoom lens on a Nikon DSLR camera.

Mobile device cameras, such as your Android device, allow for *digital zooming*. Digital zoom doesn't rely on any physical movement of the camera lenses. In simplistic terms, it's an artificial expansion of pixels (millions of single bits of light information that make up your photo) that simulates the effects of a traditional zoom lens. In industry-speak, the term *digital zoom* refers to the artificial (but still

decent quality) telescopic effect where you can see small objects at a long distance away. The term *optical zoom* refers to your multi-lens Android device switching from one physical lens to another physical lens for more of a telephoto view of distant objects. Optical zoom is explained in greater detail in the upcoming section, "Trying optical zoom instead of digital zoom."

Using the digital zoom

To practice using digital zoom on one of your photos, give the following steps a try. If you have a multi-lens phone don't worry about which lens to choose; simply choose any lens to practice. Take a look at Figure 2-10, which shows the interior of *Catapult Coffee and Studio*, and two fingers ready to initiate a digital zoom.

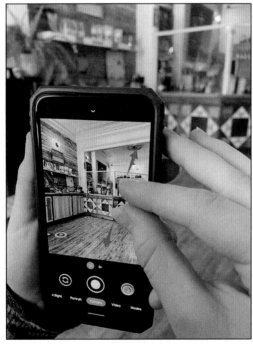

© MarkHemmings.com

FIGURE 2-10: Choose any scene such as this café to practice using digital zoom.

Digital zoom is initiated using the pinch-to-zoom technique, which allows you to view distant objects much closer.

1. **Open your Camera app.**

2. **Find a scene in front of you that has a distant object that you want to see closer.**

3. **Pinch your finger and thumb and place them on your screen.**

4. **Move your finger and thumb away from each other while still fully touching the screen.**

5. **Stop the zooming when you feel your subject is big enough within your composition.**

 If you zoomed in too much, pinch your finger and thumb together to zoom out a bit.

Figure 2-11 shows how the pinch-to-zoom technique is making the café counter appear closer and larger within the camera frame. This is because the thumb and finger are farther apart. Figure 2-12 illustrates the point of maximum digital zoom. That level of detail is pretty impressive, considering that the photo was taken with a single lens Google Pixel 4a!

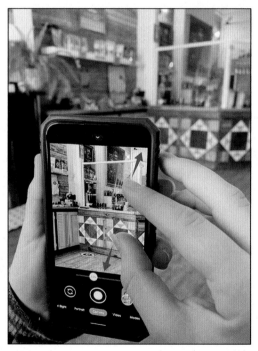

FIGURE 2-11: More zoom is possible with the increased distance between the thumb and finger.

© MarkHemmings.com

REMEMBER

Figure 2-10 shows an example of the finger placement needed to perform the pinch-to-zoom technique. Keep in mind that both your finger and thumb need to have constant contact with the screen during the entire zooming process, or it won't work. This pinch-to-zoom technique works for both zooming in prior to taking the photo, and also afterward when you're reviewing your photo.

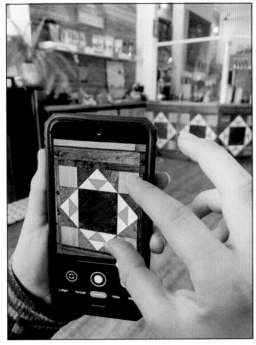

© MarkHemmings.com

FIGURE 2-12:
With the maximum digital zoom you can see small far-off objects appear quite close.

Trying optical zoom instead of digital zoom

If you have a multi-lens Android smartphone, you have the option of selecting a better-quality zoom. In the following example I use the four lens Samsung S21 Ultra 5G, but the concept works for any Android device that has two or more lenses.

Take a look at Figure 2-13. With each zoomed-in view a different icon is highlighted, plus a magnification number. On this particular Samsung, the lens zoom icons are in the shape of trees, showing a forest for the ultra-wide view, two trees for the normal wide view, a single tree for the telephoto view, and an icon showing a tree branch detail for the super-telephoto view. The graphic design of the icons on your particular Android device may look a bit different, but the concept is the same.

If you choose your zooming preferences based on those icons only, and not by using the pinch-to-zoom technique, you're using the optical zoom lenses, rather than the digital zoom options. Optical zoom lens choices usually produce better quality images than photos that are digitally zoomed using the pinch-to-zoom technique.

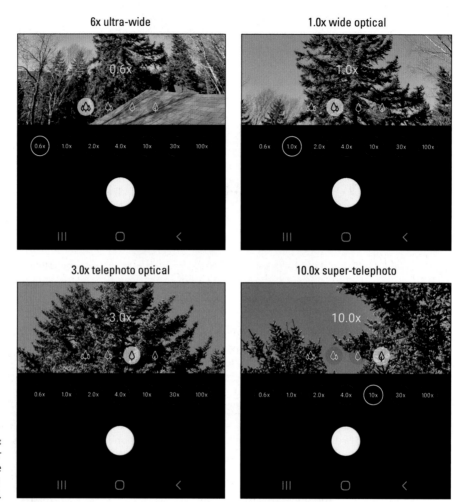

FIGURE 2-13:
The four lenses of the Samsung S21 Ultra 5G.

While it's true that choosing those optical zoom lens icons represent the best quality, use the digital zoom's pinch-to-zoom technique if you still need to get closer to a small distant object. You can always use digital zoom in conjunction with whatever optical zoom lens you choose. Essentially, do whatever it takes to get that amazing shot! Even though you lose some overall image quality with extreme digital zooming, you may want to remember this motto: "It's better to *get the shot* with technical imperfections than to miss the shot entirely."

TECHNICAL STUFF

At some point, you may hear the term *interpolation* when talking about digital zoom. Interpolation is a technical word that refers to artificially making a digital photo larger, or you could say making a photo appear to be zoomed-in much more than what the physical lens can naturally produce. Interpolation doesn't happen when you choose one of your optical zoom lenses.

REMEMBER

If you have a single lens Android device, and you see a 1x and 2x zoom option in your Camera app, the 2x option is considered a digital zoom, not an optical zoom. Optical zooms only exist on multi-lens phones. But don't let that dissuade you! Use the 2x digital zoom as much as you like to get the shot. In fact, if you look at Figure 2-12, the zoomed-in detail of the café counter design was a 7x digital zoom on a Google Pixel 4a. Each single-lens Android phone offers you some amount of digital zoom using the pinch-to-zoom technique.

Capturing Selfies with and without Background Blur

Taking a photo of yourself with the front-facing lens on your Android is popularly called a *selfie*. You hold your phone away from your face, and then when you like the composition (how you're framed in the photo), you take the shot.

Sometimes called the *selfie-cam*, the front-facing lens on your Android is actually quite useful for a number of different applications. But its greatest claim to fame is getting a good shot of you! Here's how to access the front-facing camera for your next selfie, with an example of what it looks like in Figure 2-14:

1. **Open the Camera app.**

2. **Tap on the intertwined arrow-circle icon at the bottom of the screen.**

3. **When you see yourself and like the composition, take the photo.**

After you take your selfie and review the photo, you may feel that it's not the best-looking self-portrait that you've seen. This viewpoint is understandable, as wide-angle lenses like this one tend to distort faces to the point of looking a bit rounder and heavier than in reality. While you can't do much about the physical limitations of wide-angle camera lenses, some digital solutions do at least make your selfie look a bit more professional!

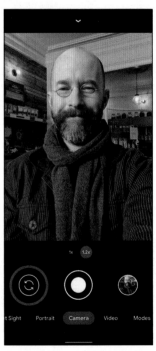

© MarkHemmings.com

FIGURE 2-14:
The selfie camera screen appearance from a Google Pixel 4a.

Follow these steps to activate Portrait mode, a mode that usually does a good job of creating better looking selfies. Keep in mind that most Android devices have Portrait mode, but not all. Chapter 4 has some advanced selfie tips to help you create even better selfies.

1. **Open the Camera app.**

2. **Tap the selfie icon to switch to the front-facing camera.**

3. **Tap Portrait at the bottom.**

4. **When you see a pleasant blur in the background, take the photo.**

Figure 2-15 shows what the background blur looks like when using Portrait mode.

Understanding When to Use (and Not to Use) the Camera Flash

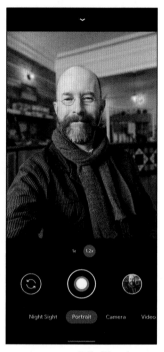

© MarkHemmings.com

FIGURE 2-15:
The Portrait mode creates a pleasing background blur behind you.

Using your camera's flash is usually a hit-and-miss scenario. Flash photography tends to make subjects look flat and uninspired; however, there are times when you may need an extra bit of light to brighten an unevenly lit subject.

You can easily access the flash by tapping the little lightning bolt icon in your Camera app, as shown in Figure 2-16. While this figure shows a Motorola smartphone camera, the flash icon graphic design is universal across all Android devices.

 If you can't see the flash icon immediately, simply tap the little downward pointing arrow, which reveals the flash icon, plus other camera functions. A number of phones such as the Google Pixel series hide some of their camera functions to provide a neater, cleaner looking camera appearance.

FIGURE 2-16:
The flash icon
set to the on
position.

Here are your flash options:

» **Flash Auto:** Choose this option if you're unsure of when your photos need a flash. Your phone activates the flash based on its assessment of the scene.

» **On:** Choose this option if you want to force the flash to fire for every shot you take, even if your photo may not really need the flash.

» **Off:** Never force the flash to fire, which is what most people use as the default.

To see how the flash works with your smartphone camera, follow these steps.

1. **Place any smallish object in a location that has the light coming from behind, similar to Figure 2-17.**

2. **Take a photo with the flash off.**

3. **Take the exact same photo with the flash on, as shown in Figure 2-18, and then compare the two images.**

When you compare Figure 2–17 with Figure 2–18, the subject looks dramatically different. Figure 2–17 has a harsher look and doesn't feel very organic. Figure 2–18 has no flash and feels warmer and more inviting. The problem with the no-flash photo is that the front of the camera shows off too dark because of backlighting.

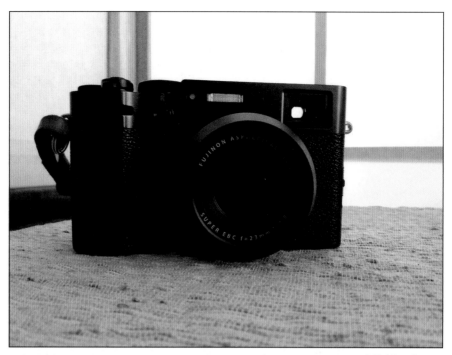

© MarkHemmings.com

FIGURE 2-17:
No flash used
for this photo.

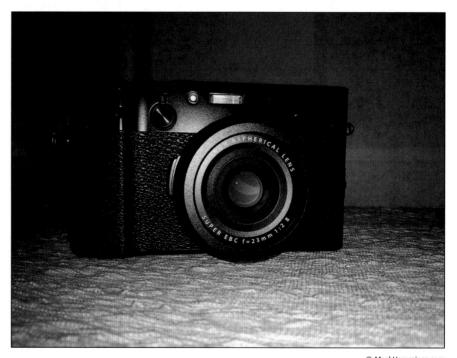

FIGURE 2-18:
Flash used for
this photo.

© MarkHemmings.com

TECHNICAL STUFF

The term *backlighting* refers to your subject (in this case my Fujifilm camera) being placed so that most of the light is illuminating its back instead of its front. This lighting scenario causes a light imbalance. So how do you fix this imbalance? One way is to use your flash, which provides what photographers call *fill-light*, or you can simply re-arrange yourself and your product. Try reversing the setup where your subject is illuminated by frontal light. Try using a window in your house.

Most of the time viewers prefer the photo without the flash. The primary reason for this choice is that a flash tends to flatten out the look of the object being photographed. What previously had a three-dimensional organic appearance now has a cold-looking, two-dimensional feel. A flash usually takes the viewer outside of what they're used to seeing with their own eyes, to a view that is far less appealing due to the harsh, artificial, and directional light source.

"But what about all those amazing images from photographers who use flash all the time? Why do they get such great results"? This question is valid. The term *on-camera flash* refers to cameras of any type that have the flash built into the camera body (such as all smartphone cameras that have flashes). Regardless of what Android make and model you have, the flashes on these phones are very close to the camera lens, which is not ideal for flattering light.

An *off-camera* flash setup is what the advanced amateurs and pros use for stunning flash photography. Their flash or flashes are not attached to their camera, and they have different ways to make sure that their flashes fire at the same time that they take their photo. Because their flash(es) are not illuminating the subject directly straightforward (as in your Android), the subject maintains its sense of *three-dimensionality* and organic look.

TIP

One exception to generally avoiding the flash is the front-facing selfie camera's flash. While it's technically not a flash but a full screen of continuous light, it produces remarkably good facial illumination when photographing yourself or you with a friend.

Give it a try . . . switch your camera to selfie mode, turn your flash to the on position (also known as *Selfie Illumination*), and then take the photo. A pleasing warm light fills your entire screen, which helps fill in the shadows on your face. Figure 2-19 shows how the selfie camera screen shines with a warmish-looking soft light.

© *MarkHemmings.com*

FIGURE 2-19:
The selfie camera's method for illuminating faces.

CHAPTER 2 **Taking an In-Depth Tour of Your Camera** 35

Photographing with the Camera Timer for Sharp Photos

Even when using a tripod, did you know that even the gentlest tap of your Android's shutter button can cause a certain amount of camera shake when the light is low? Your Android has a countdown timer that allows for a delay between the time that you tap the shutter button and the time that the photo is actually taken. This delay comes in a few different time options: Figure 2-20 shows the icons for a three and a ten second delay for some Android smartphones, and in Figure 2-21 two, five, and ten second delay icons for other smartphones.

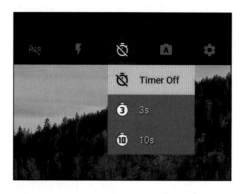

FIGURE 2-20:
Camera timer options in a Motorola camera.

TIP

The two or three second timer delay is popular for landscape, macro close-up and product photographers as it diminishes the chance of camera shake due to the photographer touching the phone. The ten second timer delay is useful for group family portraiture when you (as the photographer) need to set up your phone on a tripod, and then run to the group so that you can be included in the photo.

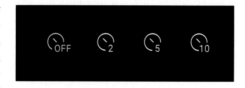

FIGURE 2-21:
Camera timer options in a Samsung camera.

Landscape photography using your timer

To avoid camera shake when doing landscape photography, activate the camera timer by following these simple instructions:

1. **Place your Android on a stable surface, ideally a small tripod as in Figure 2-22.**

2. **Open your Camera app and choose a timer.**

3. **Press the shutter button to take the photo.**

 When the two or three second countdown timer is done, the camera takes the photo.

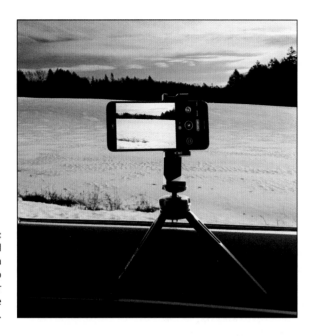

FIGURE 2-22:
Using a small tripod is a great way to stabilize your landscape photo.

 Some Camera apps hide their camera timer within a downward-pointing arrow. Tap the arrow to reveal the timer icon if needed.

TIP

The three second timer is better than the ten second timer for landscapes because even within ten seconds the lighting outside may change, ruining your brilliant landscape photo.

TIP

Did you know that many late-model Android phones allow for night photography? If you were wondering why the landscape photo in Figure 2-22 was very blueish, it's because the scene was lit by a full moon. To ensure sharp landscapes, your camera timer with a small table-top tripod is a winning combo!

Ready for a walk in the woods for some landscape photography? Chapter 5 contains a lot of useful landscape photo tips.

Family portraits

Follow these simple steps to create successful family portraits that include you in them:

1. **Gather your group within an attractive setting and flattering light, such as early morning or evening.**

2. **Put your camera on a tripod or propped up on a stable surface, such as a fence or large boulder.**

3. **Ask the group to save a space for you when it's time to get into the composition.**

4. **Tap the ten second timer, and as soon as you see the numbers start to count down, quickly join the group.**

5. **Count down audibly from ten seconds as soon as you press the shutter button.**

 Hopefully, your countdown prompts the group to smile just before the photo is taken.

Selfies with a tripod or stand

Selfies can be hit-and-miss, where often we are critical of how we look. For example, seeing such a large and close-up view of your face on the screen can sometimes feel a bit awkward. Maybe you feel that your face takes up a huge amount of the selfie photo! To remedy this problem, you can back away a bit from the camera to allow more of the background and surroundings into your selfie. Choose a tripod, a mobile device stand set on a stable platform, or a selfie stick to allow your camera to be further from your face. With your Android on a tripod or a stand, choose the three second timer. The three seconds gives you enough time to take your hand away from the camera and establish your wonderful smile! Chapter 4 has some extra tips and techniques to help you create even better selfies.

IN THIS CHAPTER

» **Opening and activating Google Photos**

» **Choosing photo storage options**

» **Deciding photo upload quality**

» **Transferring photos to a Mac or PC**

» **Watching for cellular data overuse**

» **Choosing location tracking privacy options**

Chapter **3**

Altering Your Camera's Settings and Storing Your Photos

This chapter is all about setting up your camera for success! You discover how to fine-tune your Android smartphone camera to create even better photographs, and also how to choose the best settings for your photo storage options. While this chapter isn't really about the physical act of taking a photo, it does set up your camera for an easier photography workflow by altering a few different Settings options.

REMEMBER

The term *photography workflow* is used a lot by pros and advanced amateurs. A photography workflow is every process and action from before a photo is taken, when it is edited, and finally when it is stored away for safekeeping. In this chapter, and this whole book, I show you how to work within the Google Photos workflow. While Samsung and a few other manufacturers have their own workflow options within their smartphones, Google's are universal and easy to share between all your devices.

Opening and Activating Google Photos

When signed in to Google and with photo uploads turned on, here's what you need to know when you take a photo:

>> When on Wi-Fi, the photo is automatically sent to the Google cloud computers.

>> Your photo lives in the cloud, which simply means a large data storage facility.

>> When you edit your photo on your smartphone, your editing changes sync with all your other Google devices.

>> You can have a particular photo remain both within your device and the cloud, or only the cloud.

You may wonder if it's worth the bother to have your photos go up to the cloud. Cloud storage is helpful for many reasons, but the one that is usually the most valued is based on theft, damage, and loss of your phone. If you have an unfortunate phone problem and you can't access your data anymore, no worries! All your photos and phone data are stored safely in Google's cloud.

Before setting up Google Photos so that your photos are safe, you may rightfully ask how secure and safe Google's cloud services are, and whether it can protect your valuable digital photos. While no cloud backup is 100 percent safe against natural or purposeful damage, Google has a very good data privacy track record. Still, you can always skip this step if you're not convinced. Your ability to create great photos isn't dependent on cloud storage.

To set up Google Photos to automatically send your images to the cloud, follow these initial steps to sign in to your Google account. If you know that you are already signed in to Google you can ignore the following steps:

1. **Open the Settings app on your app page, which looks like a gear or a cog.**

2. **Scroll down and tap Google Services, shown in Figure 3-1.**

3. **Tap Sign In to Your Google Account (see Figure 3-2).**

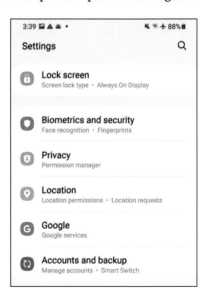

FIGURE 3-1:
Tap Google Services.

4. **Input the email or phone number that you used to set up your Google account.**

5. **Agree to the Google Terms of Service.**

6. **Turn on Back Up to Google Drive as shown in Figure 3-3.**

REMEMBER

There is a difference between the cloud back up services of Google Drive and Google Photos. Google Drive is a separate app and service that stores a lot of your phone data in the cloud. Google Photos backs up your photos and videos to the cloud, and also has built-in photo editing options.

7. **Tap Accept, as shown in Figure 3-3.**

The Google Services main page, shown in Figure 3-4, opens.

FIGURE 3-2:
Sign in to your Google Account.

FIGURE 3-3:
Tap Back Up to Google Drive, and tap Accept.

FIGURE 3-4:
The Google Services main page.

WARNING

Keep in mind that backing up to both Google Drive and Google Photos reduces your allotment of Google cloud storage space. This may not be a problem initially when you only have a few photos, but it may be an issue later on when you're capturing a lot of photos, videos, and other phone-related data. Google lets you know when you have almost filled your cloud storage allotment, and prompts you to buy more cloud storage, or reduce your cloud-based photo and video collection. As of the time of this writing, every Android user who signs up for a Google account gets 15GB (gigabytes) of free cloud storage.

Choosing Storage Options for Your Photos

Back up and sync appears quite a bit within the Google Photos ecosystem, as it's a major part of its plan to keep your photos safe and accessible. The next set of steps help you set up Google Photos for optimal backup processing. The Backup option is within the Google Services main page. (Refer to Figure 3-4 to see the Google Services main page.)

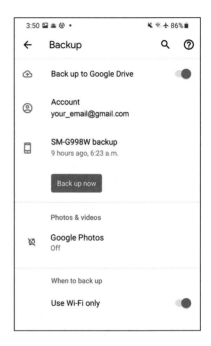

FIGURE 3-5:
Tap Google Photos.

1. **Tap Backup.**

2. **Within the Photos and Videos section, tap Google Photos. (See Figure 3-5.)**

3. **Shown in Figure 3-6, tap the gray Back Up & Sync button.**

 The button turns blue when activated.

4. **Tap Confirm to exit the Back Up and Sync page, as shown in Figure 3-7.**

 You're automatically taken to your Google Photos app, as shown in Figure 3-8.

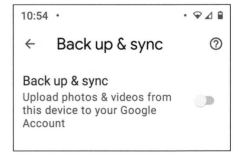

FIGURE 3-6:
Tap the Back Up & Sync button.

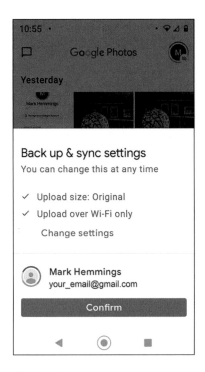

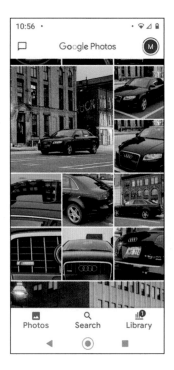

FIGURE 3-7:
Tap Confirm when done.

FIGURE 3-8:
The Google Photos app.

Deciding on photo upload quality

Google Photos offers two options for automatic cloud uploads, and these two options are based on a balance between photo quality and optimized digital file size reduction. You find these options in the Photos and Videos section of Google Photos (see the previous section). Tap Upload Size located near the bottom and then choose Original Quality or High Quality, as shown in Figure 3-9.

How do you choose between the two? It depends on your goals and available storage space.

Original Quality

Your photos and videos automatically upload to the cloud in their original, full quality with the Original Quality choice. This choice is always the best one to take if you can.

The downside is that original quality photo and videos can potentially eat up a lot of your free 15GB cloud storage space. You may need to buy more cloud storage at some point in the future if you choose the Original Quality option. The good news? Cloud storage is relatively cheap, and the benefit of having all your media at full quality is usually worth the extra cloud storage fee.

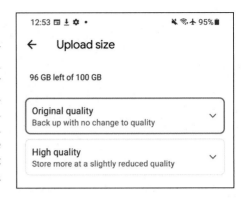

FIGURE 3-9:
Choose between Original Quality or High Quality.

TIP

If you plan to print your photos and showcase your videos to the public, Original Quality is for you. At some point you will most likely need to add a bit of paid cloud storage space, but it will be worth it.

High Quality

The High Quality option slightly reduces the quality of your original photos and videos. While this initially may sound like a bad idea, it does allow you to fit far more photos and videos into your cloud allotment than if you chose Original Quality. The reduced quality is done well enough that you may not even notice, as Google Photos does a very good job of manipulating your media to strike a good balance between quality and small file sizes.

TIP

If your photos and videos are primarily for yourself, and not the public, you will be more than happy with choosing the High Quality option. High Quality also becomes the cheaper option, as you can fit a lot more media into your Google cloud storage allotment.

At the time of this writing, if you own a Google Pixel smartphone, you have a really sweet deal. If you choose High Quality instead of Original Quality, then there is no limit to how many photos and videos you can sync, upload, and store. Keep in mind that this offer is valid only if the photos and videos are taken with your Google Pixel phone. It doesn't apply if you also own a phone from Samsung, Motorola, LG, or another manufacturer.

WHEN YOU NEED ADDITIONAL STORAGE

If you take a look at the top of Figure 3-9 you see the words "96GB left of 100GB." What that means is that I only used four gigabytes of storage space so far within my Google Photos cloud storage allotment. I personally chose the Original Quality option, which means that my account will become full much quicker than if I chose High Quality. However, because I am a professional photographer I can't risk lower quality photos and videos. The result of my choice is that I will need to purchase a higher tier of cloud storage space from Google. This additional purchasing of cloud storage space is offered by Google under the name *Google One*. At the time of this writing, Google One offers the following extra cloud storage space tiers: 100GB (gigabytes), 200GB, 2TB (terabytes), and 10TB. See www.one.google.com for prices in your local currency.

Managing on-device photo storage

If you decide to upload your photos to Google Photos, when you take a photo, that photo lives both within your phone and in the cloud (as soon as it uploads over Wi-Fi). There may come a time however, after thousands of photos and videos, that your Android smartphone runs out of space.

All smartphones come with built-in storage, with choices such as 128GB, 256GB and 512GB; some pro models top out at 1TB. While this won't happen for a while if you are new to Android smartphone photography, at some point you will fill up your phone's built-in storage.

REMEMBER

Built-in storage in a smartphone isn't the same as cloud-based storage. In a cloud-based storage scenario you are, in a manner of speaking, renting cloud space on Google's storage computers. You can always rent more space. Built-in storage refers to how many gigabytes of data (which includes photos and videos) that your particular Android phone can store inside it.

Google Photos has a tool that will free up a lot of space on your Android. It's called *archiving,* and when your photos are safely uploaded to the cloud, Google Photos removes the locally stored versions of those photos. Google Photos isn't deleting your photos; it's simply removing them from your device to free up space. Your photos can still be easily accessed for editing purposes, and you can also see and edit them at www.photos.google.com.

REMEMBER

If your phone has plenty of space remaining, there is no need for you to archive your photos. In my opinion, it's best not to unless you have to, as having a locally stored version of your photo, plus a cloud-based version of your photo, is always best.

Archiving all your photos

Photo archiving doesn't happen automatically by default; it's a tool that you choose to turn on. Follow these steps to archive all your older photos:

1. **Open the Google Photos app.**

2. **At the bottom right, makes sure you're in the Library section. (See Figure 3-10).**

 Also notice the Photos on Device section. This area shows that you're viewing locally stored photos.

3. **Tap Utilities.**

4. **Scroll down to the Organize Your Library section. (See Figure 3-11.)**

5. **Tap Free Up Space.**

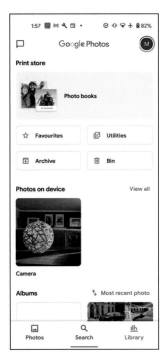

FIGURE 3-10:
Choose the Library section within the Google Photos app and tap Utilities.

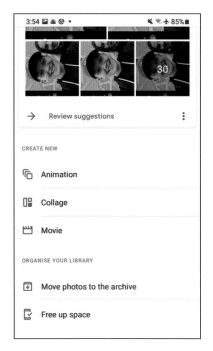

FIGURE 3-11:
Tap Free Up Space in the Organize Your Library section.

6. **Tap the blue colored icon that says Free up xx.xx GB, shown in Figure 3-12.**

7. **Tap Done when you see the confirmation message, as shown in Figure 3-13.**

 You're now taken back to the Google Photos main page, shown in Figure 3-14, with the Photos on Device section now missing. You're now viewing and manipulating the cloud-based versions of your photos, not any locally stored versions.

8. **Tap the Archive icon to view your archived photos.**

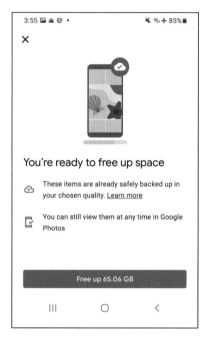

FIGURE 3-12:
Tap the blue colored Free Up icon at the bottom of the screen.

FIGURE 3-13:
Tap the Done button.

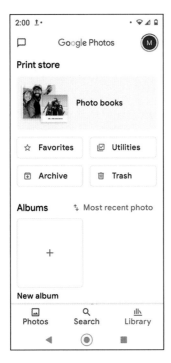

FIGURE 3-14:
The main
Google
Photos page,
with Photos
on Device
removed.

Choosing which photos to archive

If the idea of having all your locally stored photos removed in one fell swoop is unappealing, you can actually archive certain photos or videos. As videos usually take up more storage space on your smartphone, the following steps allow you to relieve your storage pressure while keeping most of your media on-device:

1. **In the Google Photos app, select the photos and/or videos that you want to archive. (See Figure 3-15.)**

2. **Tap the three-dot icon at the top right of the screen.**

3. **Tap Move to Archive as shown in Figure 3-16.**

4. **Tap Go to Archive.**

5. **Tap the Archive button to view your archived media, as shown in Figure 3-17.**

FIGURE 3-15:
Select the
media you
want to archive
and tap the
three-dot icon
at the top
right.

FIGURE 3-16:
Tap Move to
Archive.

FIGURE 3-17:
View all your
archived
photos from
the Archive
album.

Transferring photos to a PC or Mac

Some people like to have some of their photos downloaded if they use desktop photo-editing software such as Photoshop. Transferring your photos and videos to a desktop couldn't be easier! If your photos are backed up to Google Photos cloud storage, you can download them to your computer by following these steps:

1. **In your computer's web browser, go to** `www.photos.google.com`.

2. **Select your desired photos or videos individually.**

 They're marked with blue check marks, as shown in Figure 3-18.

 If you want an entire days' worth of photos, select the date, which auto-selects each photo within that day. See Figure 3-19 and how *Thu, 1 Apr* is selected.

 TIP

3. **To start the download of photos to your computer, click the three-dot icon at the top right of your screen. (See Figure 3-20.)**

4. **Choose Download, as shown in Figure 3-21.**

5. **Find your photos on your hard drive:**

 - *Mac:* Locate your Downloads folder, and your photos are in a newly created Photos folder. (See Figure 3-22.)

 - *PC:* Your photos are within a zipped Photos folder. This folder is accessible from within your chosen web browser's downloads section, often appearing at the bottom left of your browser's screen.

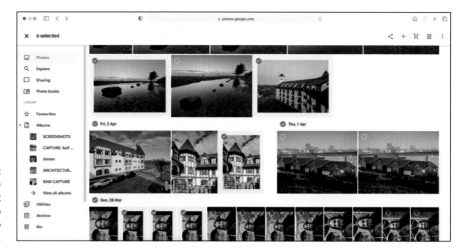

FIGURE 3-18:
Select the media that you want to download to your computer.

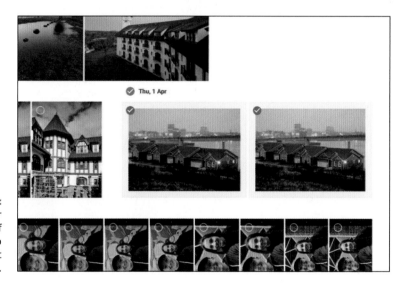

FIGURE 3-19:
For faster selecting of full-day photo shoots, select the date icon.

FIGURE 3-20:
Tap the three-dot icon at the top right of the screen.

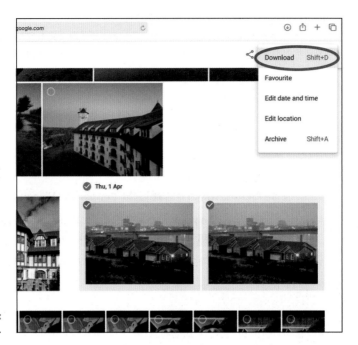

FIGURE 3-21:
Tap Download.

FIGURE 3-22:
For Mac users
the photos are
in your Down-
loads folder.

Being Mindful of Cellular Data Over-Usage

Have you ever been stung with a huge mobile phone bill because you unknowingly went over your monthly data plan? Google Photos' automatic backup is by default set to work only when you're connected to Wi-Fi. Still, it's always a good idea to

check once in a while to make sure that your backups are not being uploaded over non–Wi–Fi data. You check this by following these few simple steps:

1. **Tap the Settings app on your phone's main app page.**

2. **Scroll down and tap Google Services.**

3. **Tap Backup.**

4. **Make sure that the Use Wi-Fi Only button is selected, as shown in Figure 3-23.**

5. **Tap Google Photos, which is within the Photos and Videos section.**

6. **Near the bottom of the page, tap Mobile Data Usage (some Androids use the term Cell Data Usage), as shown in Figure 3-24.**

7. **Confirm that all three options are turned off, with a similar look as Figure 3-25.**

FIGURE 3-23: Make sure that the Use Wi-Fi Only button is active.

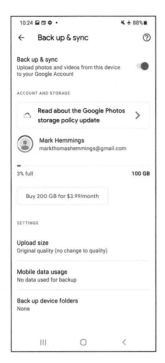

FIGURE 3-24:
Tap Mobile
Data Usage
(some devices
say Cell Data
Usage).

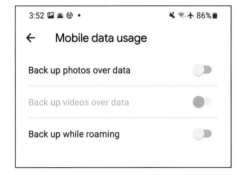

FIGURE 3-25:
If all button
icons are gray,
the options are
turned off.

Now think about when you do want backups to happen automatically over your mobile data plan when you're not near a Wi-Fi signal. Here are some scenarios that you may encounter in the future:

>> **Unlimited data plan:** If you have an unlimited data plan, you may decide to have backups happen over your mobile data. This ensures that every photo that you take is safe and backed up within a few seconds after taking the photo. You won't need to go to a Wi-Fi source for the automatic backups to happen.

>> **Travel:** If you purchased a generous data plan with a local SIM card provider in a foreign country, it may be wise to allow your photos to back up over your mobile data plan. The reason? If your phone is lost or stolen every photo is safely stored in the cloud almost as soon as you take the photo. A lot of professional photojournalists, documentary, and travel photographers are more than happy to pay for large data plan rental SIM cards as an insurance policy against losing their valuable images.

>> **Emergency:** While the word emergency might be a bit over-dramatic in this case, sometimes when it comes to needing your photos within the cloud, and not having Wi-Fi available, it can feel like an emergency. When you're in that situation, simply turn on mobile data backups, wait for the backup to complete, and then turn it off. With this temporary switch on and then off you won't be consuming too much mobile data.

To allow backups to happen over your mobile data plan when no Wi-Fi is available, follow these steps:

1. **Tap your Settings app on your phone's main app page.**

2. **Scroll down and tap Google Services.**

3. **Tap Backup.**

4. **Turn off the Use Wi-Fi Only button.**

 The button turns from blue to gray.

5. **Tap Google Photos, which is within the Photos and Videos section.**

6. **Near the bottom of the page tap Mobile Data Usage (some Androids use the term Cell Data Usage).**

7. **Turn on the options that you would like active.**

 When on, the buttons turn blue as shown in Figure 3-26. This means that data is now being used for backups.

The Mobile Data Usage page has three options for you to consider:

>> **Back up photos over data.** Turn on this option when you need your photos backed up to the Google Photos cloud service and don't have regular access to Wi-Fi. Depending on the data plan that you chose from your mobile provider, this could eat up only a small amount of data, or a moderate amount of your data allotment if you have a lot of photos.

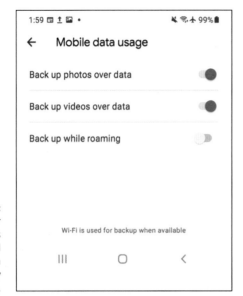

FIGURE 3-26:
When your
chosen buttons
are turned
on for data
backup, they
turn blue.

>> **Back up videos over data.** This option is fantastic, because Google knows that video files are a lot larger than photo files. So, if you only need your photos backed up using your mobile data plan, and your videos are not critical, then turn off this option. If you need the videos to back up with mobile data, then tap the button.

>> **Back up while roaming.** This option is potentially the most dangerous one. Roaming is when you enter another country using your own data plan from your mobile provider. If you visit another country and use your data, you're charged a hefty fee for data transmissions of any type. Even with a travel package that you pre-arrange with your mobile provider, you still should remember that having this option turned on may result in going over your package limits. Consider renting a local SIM card at your international destination airport if you plan on taking a lot of photos on your trip.

REMEMBER

Take a look at Figure 3-26 one more time. At the bottom, you see the following sentence: "Wi-Fi is used for backup when available." What this means is that if you choose to have your backups happen using your mobile phone's data, your phone switches to Wi-Fi as soon as a signal is found, and the backup finishes on Wi-Fi. This feature comes standard, and it helps to reduce your phone's data consumption.

Allowing Your Camera to Track Your Location

While it's true that going out to create photographs is far more fun than working on all this settings stuff, this final section is worth looking at. What you decide in this section is whether you want your camera to record your physical location when you take a photo. I've included a Pros and Cons summary to help you decide whether you want to allow camera location tracking:

>> **Pros:** With location permissions turned on, you always know where you took your photo in almost any location on earth. This is enormously helpful say, twenty years down the road when you're trying to remember where in Greece you photographed that incredible canal, for example. Location info can be stored within each photo's metadata. The term *metadata* in its simplest form means information tucked inside your photo that stores text information about that photo. Metadata that includes location information is fantastic for sorting your ever-growing photo collection.

>> **Cons:** Those who have concerns about privacy should choose to disable location tracking, as it's very easy for your device to create an accurate tracking model of every place you photograph throughout your day. While it's true that Google's camera states that the tracking only happens while the camera app is open, I'm sure that many readers may still may feel uncomfortable. If this is a concern, opt for no location tracking.

Follow these steps to make your own decision about location tracking:

1. **Tap your Settings app on your phone's main app page.**

2. **Scroll down and tap Apps (or Apps and Notifications on some devices).**

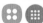

 The icon in the margin shows what the Apps icon looks like for Samsung (blue) and most other Android devices (orange).

3. **Scroll down and tap the word Camera.**

4. **Tap the word Permissions.**

5. **Tap the word Location.**

6. Choose a privacy setting.

Figure 3-27 shows the three options that you can choose from.

- *Allow Only While Using the App:* If you choose this option, all your photos contain useful location information that helps you with your photo collection management and archive workflow.

- *Ask Every Time:* If you choose this option, camera location tracking is set to the off position by default; however, you can say yes to tracking every time you open the camera. Choose this option if you're okay being tracked in some geographic areas, but not others.

REMEMBER

Some Android devices may not have the Ask Every Time option.

- *Deny:* If you choose this option your camera always has location tracking turned off. It stays off until you turn it on.

FIGURE 3-27: Choose one of three options based on your privacy comfort level.

Chapter **4**

Taking a Deep Dive into the Camera App

n Chapter 2, you discover how to take a selfie with and without background blur. This chapter goes into greater detail to help you create stunning selfies, both technically and creatively. I also cover panorama photos in this chapter so that you know exactly why you should use these options, and when to choose them to serve your creative vision. Finally, understanding photographic aspect ratios can be very helpful for creating images meant specifically for certain media. An aspect ratio for a photo created for a video project is different than an aspect ratio for a 4x6 print from your local photo lab. You discover all this and more in this jam-packed chapter!

Preparing to Take Selfies

When you have your camera app open, you can flip the lens view from the rear-facing view to the front-facing view. A selfie photo makes use of the front-facing camera lens. The selfie icons look slightly different from camera to camera, but all of them have a reversing circle motif.

Most Android manufacturers allow you to use the selfie camera within several camera modes, such as video, Portrait mode, time-lapse, and slow-motion video mode. In the following sections you discover the best ways to use the selfie camera within the Portrait mode, which allows for a lovely background blur behind your head. (For details on how to access the selfie camera, check out Chapter 2.)

Lighting and background

Follow these best practices to create a great selfie:

» Choose a background that shows a sense of place, such as this café scene, but isn't so visually distracting that it detracts from your face. Figure 4-1 is a good balance between a visually busy background and a background that doesn't detract from the selfie portrait.

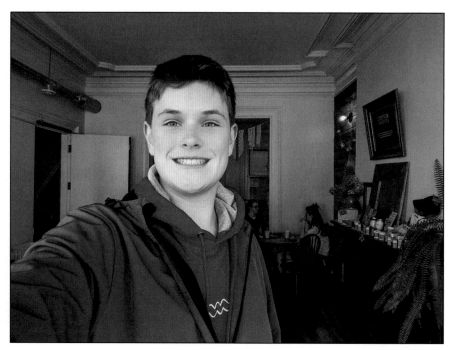

FIGURE 4-1: Backgrounds should look appealing but not pull attention away from your face.

© MarkHemmings.com

>> Make sure that the main light source is coming from in front of you for even facial illumination.

>> Overcast days or being in a shadowy area will produce the softest looking selfies.

>> Being in direct sunlight will look harsh and not very appealing.

>> Being illuminated by soft morning or evening light is very attractive.

>> If you're doing a selfie indoors, try to angle yourself so that your face is illuminated by a large picture window, as shown in Figure 4-2. The result of this window-facing selfie is shown in Figure 4-1.

>> If no window is available, try not to stand directly under a ceiling light, which causes harsh shadows under your eyebrows and nose.

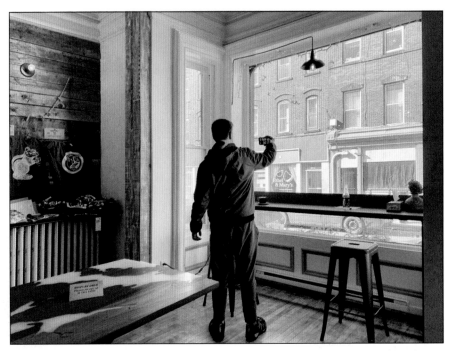

FIGURE 4-2:
Face a large window for indoor selfies.

© MarkHemmings.com

Selfie sticks and stabilizers

One of the greatest complaints about selfie-taking is that people are self-conscious about how they look when they take the photo. One major factor for this criticism is that their face is often disproportionately large within the composition. To help with this problem, use a selfie stick or a smartphone stabilizer to extend your phone farther away from your face.

TIP

When your phone is really close to your face a certain amount of unattractive lens distortion shows up in your photo. Extend your phone away from your face a little bit, and your face has a more natural looking appearance.

Selfie sticks

Selfie sticks are cheap and easy to use, and you can often find them at department stores or any type of store that sells electronics. They look like wands, as shown in Figure 4-3, and you can extend their distance by twisting the stick to various lengths.

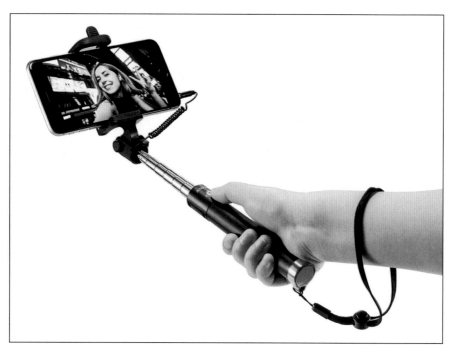

FIGURE 4-3:
A telescopic selfie stick by Anker.

© www.anker.com

REMEMBER

Selfie sticks are wonderful because they're small and lightweight, and you can take them anywhere. The only downside is that you need to keep your grip on them steady, as even the smallest level of wind can make your arm a bit unsteady when you're just about to take the photo. Selfie sticks tend to produce shakier photos when the light is getting low in the sky, or if you're indoors with low lighting.

TIP

Selfie sticks often have a trigger at the base of the stick that acts as a remote shutter button. This trigger is helpful as you won't need to reach all the way to your phone to tap the shutter button. Each selfie stick usually comes with instructions on how to set up the remote release for easy selfie taking.

If your selfie stick doesn't have a remote shutter button, no problem. Simply activate your two, three, five, or ten second timer, reposition your selfie stick so that you look good in the frame, and then be ready for your photo while the timer is counting down. (To find out how to access the self-timer, take a look at Chapter 2.)

Stabilizers

Technically called a *gimble*, this selfie solution is battery-powered and extremely good at giving you a stable apparatus for selfies, even if you don't have steady hands or if there is a breeze.

The gimble senses any movement while you're ready to take your photo, and it counteracts that movement near instantly to maintain a steady hold on your phone. These gimble stabilizers are a real boon for social media influencers, filmmakers, and mobile photographers.

The gimble stabilizer is an excellent choice for near-flawless selfies. Keep in mind that they're usually pricy, larger than selfie sticks, need battery power, and not as easy to pack around with you. However, the benefits highly outweigh those drawbacks.

The Osmo Mobile 4 is a fantastic gimble to choose if you're in the market for a battery-powered stabilizer. Figure 4-4 shows an example of the previous generation (but still excellent) Osmo Mobile 3 powered up and ready to roll.

FIGURE 4-4:
The Osmo
Mobile 3 gimble
stabilizer
powered up
ready to take a
selfie photo.

© MarkHemmings.com

Taking Selfies

With your background chosen and the light appealing, you're ready to create advanced selfies. To do so, consider the following steps, which are described in detail in the following sections:

1. **Choose the Portrait selfie mode.**

2. **Adjust the background blur amount.**

3. **Adding facial skin smoothening.**

4. **Choose your favorite selfie effect.**

5. **Add a Live Filter.**

6. **Choose to use or not use a flash.**

7. **Use a self-timer.**

8. **Adjust the selfie zoom to include your friend in the selfie.**

TIP

Adding a flash and using a timer are both helpful when you take a selfie. The flash is either an actual front-facing flash that fires at the same time that you take the selfie, or your entire phone screen illuminates with a bright warm-toned light. A timer can give you a few extra seconds to compose yourself and get that brilliant smile ready. See Chapter 2 to find out how to use both these features.

Choosing the Portrait selfie mode

To take a selfie, you need to switch to the selfie lens so that you can see yourself. To do so, tap on Portrait after you switched from the rear to front facing camera view.

Do you see a soft blurry background? If so, you're in Portrait mode, as shown in Figure 4-5. Keep in mind that this figure is from a Samsung device and your icons may look a bit different. Portrait mode is sometimes hidden by some manufacturers under the word *More*, under a 9 square icon, a square with a little head and shoulders icon, a downward pointing arrow, or by tapping the word Plus or the Settings icon within your camera app.

FIGURE 4-5: Portrait mode creates a soft background blur behind your head for pleasing portraits.

© MarkHemmings.com

Adjusting background blur amounts

Adjusting background blur amounts (sometimes called *depth control*) is a clever way to adjust how much background blur you would like in your selfies. Maybe you want a lot of background blur to mimic the look of a professional DSLR lens, or maybe you want less background blur to make out a bit of detail in the background.

REMEMBER

There are two ways to alter the amount of blur behind your selfie. One is prior to you taking the photo, and the second is after you take the photo when editing your images. Some Android devices allow you to adjust the background blur before the shot, and the following steps are for those devices. If you can't adjust the background blur prior to taking your photo, don't worry! Chapter 11 explains how to adjust the amount of selfie blur after you've taken your photo.

To access depth control for Android devices that allow for it, follow these steps when you're within the Portrait selfie mode:

1. **Tap a yellow icon.**

 Take a look at Figure 4-5 again. The figure shows the yellow circular icon used with some Samsung cameras to enter the selfie adjustment modes. Other manufacturers show a yellow slider, usually at the bottom of your composition.

2. **Scroll up and down (or left and right, depending on your camera layout), and choose the amount of blur that you feel looks the best.**

 With your blur adjustment slider found and your face within the camera frame, adjust the slider to the extremes. In one direction there will be no background blur, and the other direction will have a lot of background blur. Figure 4-6 shows the extreme amount of background blur. Pro-tip: The default amount of background selfie blur that the camera initially offers you is usually the best-looking option.

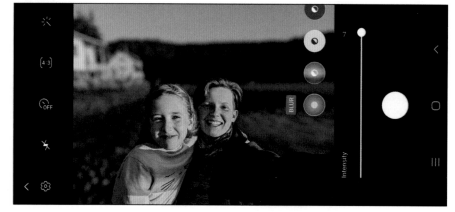

FIGURE 4-6:
An example of the blur slider set to the maximum amount of background selfie blur.

© MarkHemmings.com

Adding facial skin smoothening

While some Android devices don't allow you to alter the amount of background blur prior to taking a selfie photo, most allow for a certain amount of skin smoothing adjustment. Skin smoothening is pretty much self-explanatory in that you see a softening of texture only evident on your face. The rest of your photo remains unchanged.

TIP

Skin smoothening, also called Face Retouching, Face Beauty, or Skin Smoothness can be a double-edged sword. If overused you look plastic and fake. My advice is to use this tool sparingly to maintain a sense of reality.

Where you find Face Retouching depends on your smartphone manufacturer:

» For most Google Pixel devices, look for Face Retouching under the downward pointing arrow. Choose either Subtle or Smooth.

» For some Motorola devices on Android version 10, look for an icon with little stars overlaying a woman's hairstyle, similar to Figure 4-7.

» For many Samsung devices on Android version 11, tap the yellow magic wand icon. Figure 4-8 shows you the Skin Smoothness slider, set to a moderate level of 4.

FIGURE 4-7:
Face Beauty
Auto and
Manual
options for
some Motorola
devices on
Android 10.

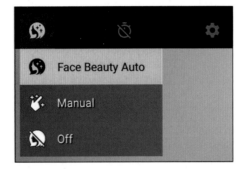

FIGURE 4-8:
An example of
moderate skin
smoothening
on a Samsung
device.

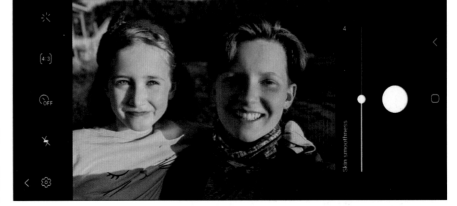

© MarkHemmings.com

REMEMBER

Not all Android cameras have a numbered scale like Samsung in Figure 4-8; however, the concept is usually the same for all the other Android manufacturers not previously mentioned. An adjustment slider is within your selfie Portrait camera, and by sliding the slider from left to right (or up and down), you can add and subtract the skin smoothening technique.

Choosing your favorite selfie effect

Selfie photo effects before you take the photo can be a lot of fun, as you can see the effect in real-time. As already mentioned however, some Android cameras only allow you to adjust the effect after you take the photo, when editing. If that is the case for your Android device, Chapter 11 has all the editing tools that you need for adjusting your selfie portrait.

REMEMBER

The ability to adjust selfie effects in real-time prior to taking the photo is a service from the Android manufacturer, and not necessarily Google's Android platform. What this means is that each manufacturer, such as Samsung, Sony, Google, and so on may have their own selfie effects and specific effect icons. If I were to illustrate all the selfie portrait effects or filters for every Android device on all recent Android versions, it would take up the space of many chapters! I therefore selected the effects found on a Samsung S21 series device with the hope of being as future-proof as possible.

Take a look at Figure 4-6 again, and beside (and above) Blur is another circular icon. Tap that circle to start the process of exploring selfie portrait effects.

>> **Studio:** Softens skin and mimics professional photo studio lighting. (See Figure 4-9.) As a bonus, at the bottom of the screen is a face illuminating slider, which is great for back-lit selfies such as this example. If your faces are too dark, use the slider to brighten only the faces. This face-brightening slider is available on all the effects.

>> **High-Key Mono:** Gives a black-and-white photo bathed in a beautiful wash of white light. (See Figure 4-10.) The higher you adjust the Intensity slider (on the right of the screen), the whiter the background becomes. Slide it all the way for a pure white background.

>> **Low-Key Mono:** Almost the opposite of High-Key Mono, your black-and-white selfie will have a high degree of fine-art contrast, and you can use the Intensity slider to make the background even darker, all the way to pure black. Figure 4-11 shows the Intensity slider set at 5, which makes the background look much darker than reality.

© MarkHemmings.com

FIGURE 4-9:
The Studio
effect
replicates the
lighting style of
a photo studio
environment.

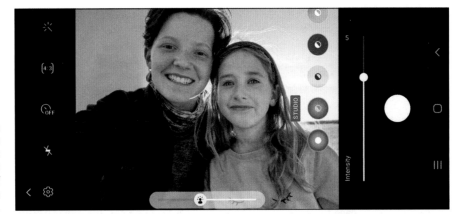

© MarkHemmings.com

FIGURE 4-10:
High-Key Mono
offers a black-
and-white
portrait with
a light or
completely
white
background.

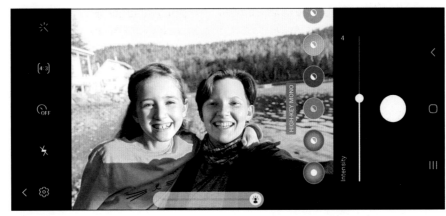

© MarkHemmings.com

FIGURE 4-11:
Low-Key
Mono is a
combination of
a dark or black
background
and a black
and white
portrait.

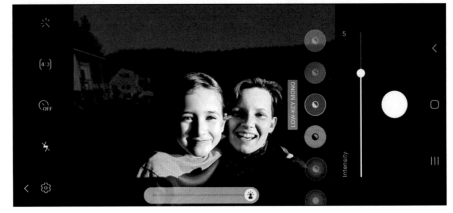

>> **Backdrop:** Creates a solid color background similar to what a green screen does for Hollywood movie effects. (See Figure 4-12.) This solid color works well for adding graphics and fake backgrounds in other third-party editing apps.

>> **Color Point:** This option makes the background black and white, while retaining the color of the people and their clothing. (See Figure 4-13.)

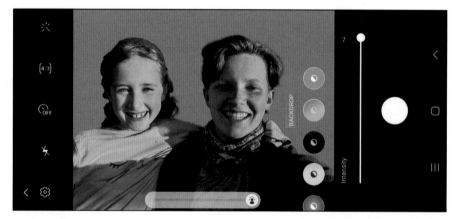

FIGURE 4-12: Backdrop adds a solid color to your selfie background, like a green screen in the movie industry.

© MarkHemmings.com

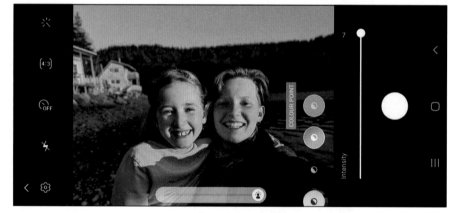

FIGURE 4-13: Color Point keeps the selfie color but makes the background black and white.

© MarkHemmings.com

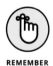

REMEMBER

You can always adjust the brightness of your face within each effect by using the slider at the bottom of the selfie screen. This option is helpful if the sun is shining behind you head, and not illuminating the front of your face.

Adding Live Filters to your selfies

If your Android camera doesn't allow for the selfie effects mentioned previously, it's possible that it does have a feature called Live Filters. A Live Filter simply places a filter over your image in real-time, so you can see what your photo will look like even before you take the photo. Live Filter icons look different from device to device, so the following steps are from a Motorola Moto G7 Play, with the Android 10 operating system:

1. **Open your selfie camera.**

2. **Look for the Photo Modes section, shown in Figure 4-14.**

3. **Tap Live Filter, which often has an icon that looks like stars within a square.**

 At the bottom of your screen are the different filtered versions of your selfie, as shown in Figure 4-15.

4. **Tap each Live filter option and choose the one that you like best.**

The teens in Figure 4-15 chose the Live Filter called Alpaca. These Google Live Filters are often offered in the following order: West, Palma, Metro, Eiffel, Blush, Modena, Reel, Vogue, Ollie, Bazaar, Alpaca, and Vista.

FIGURE 4-14:
Look for the Live Filter icon, often within a camera section called Photo Modes.

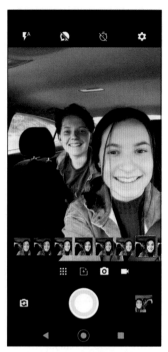

FIGURE 4-15:
The Alpaca Live
Filter in use.

© MarkHemmings.com

REMEMBER

These editing features are also available after you take the photo when editing. Don't feel that you're missing out if you don't have Live Filters available on your Android camera. Chapter 11 discusses photo editing with filters.

Adjusting selfie zoom to add your friends into the picture

Many Android cameras have a feature that slightly widens the selfie camera to accommodate two people within the same scene. Each Android manufacturer has a slightly different looking icon that represents the wider view.

With a Google Pixel 4a device, the default view is 1.2x shown in Figure 4-16, which is a good view for one person but maybe not wide enough for two people if you want to show off a bit of the background. When you and your friend are in the selfie camera frame, tap 1x to widen the selfie view, as shown in Figure 4-17.

TIP

While it's probably very rare that you would want to do this, you can zoom in to your face much more than 1.2x using the pinch-to-zoom technique. The reason that it's not so common to do this is because most people don't want the entire photo to be filled with just their head. A wider, normal head and shoulders composition looks better!

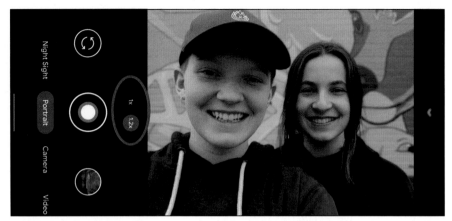

FIGURE 4-16:
The normal
selfie camera
view meant for
one person.

© MarkHemmings.com

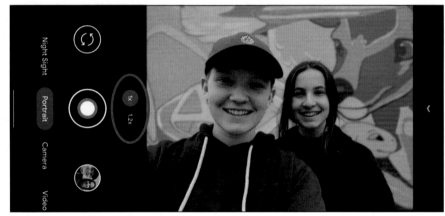

FIGURE 4-17:
The wider
zoomed out
view perfect
for two people.

© MarkHemmings.com

Considering Alternate Aspect Ratios

Most smartphone cameras produce a photograph with an aspect ratio of 4:3. The term aspect ratio refers to the ratio of an image's width to its height. For example, the standard 4:3 aspect ratio of your Android camera produces a horizontal photo that is 4 units wide and 3 units high. A unit can be measured in inches, pixels, centimeters, or any other linear distance metric.

For a real-world example, however, say your Android has a 12 MP (megapixel) sensor. Envision a horizontal photo taken with your camera as 4 megapixels wide multiplied by 3 megapixels high. 4 MP x 3MP = 12 MP. Imagine holding in your hand a photo print that is 4 inches wide by 3 inches high, which would be an example of the 4:3 ratio.

Table 4-1 lists the most common aspect ratios that you can use to take a photo.

TABLE 4-1

Aspect Ratio Options Available in Most Android Cameras

Aspect Ratio	Uses and Benefits
4:3 Horizontal, 3:4 Vertical	The sensor on most Android phones has this aspect ratio, which means that your 4:3 or 3:4 photo benefits from using the entire surface area of the sensor.
16:9 Horizontal, 9:16 Vertical	16:9 is perfect for still photos that will be inserted into an HD or 4K video or home movie production. 9:16 vertical is rarely used, but sometimes good for tall and narrow framed prints.
1:1 (Square)	If you're only photographing for social media, Instagram and Facebook work well with the 1:1 square aspect ratio. It's also very easy to buy square frames for wall art.
3:2 Horizontal, 2:3 Vertical	If you like traditional 4x6 inch prints from your photo lab, this aspect ratio prints perfectly with no need for cropping. Photos created for Pinterest look good in 2:3 vertical.

REMEMBER

Not all Android cameras have every aspect ratio listed in Figure 4-1. Your device may only have 4:3 and 16:9. Don't worry! You can adjust aspect ratios later when you edit your photos through cropping, which Chapter 11 explains. Simply use the standard 4:3 or 3:4 aspect ratio for all your photos, and then crop them later to suit your needs.

TIP

If you're unsure whether you should take pictures with alternate aspect ratios, I suggest that you don't bother with them. Use the standard 4:3 and 3:4 unless you have a specific reason to do otherwise, such as those listed in Table 4-1.

To access your camera's aspect ratio options, follow these steps:

1. **Open your Camera app.**

2. **On your camera's main screen, tap the 4:3 or 3:4 icon.**

 If you don't see 4:3 or 3:4, tap the downward pointing arrow for access.

3. **Choose your desired aspect ratio and take a test photo.**

4. **Take test photos using all the aspect ratios that your camera offers.**

5. **Review your tests to get an idea of what each ratio looks like.**

Figures 4-18 to 4-21 show each aspect ratio in case you don't have your Android camera with you to take test photos. I took these telephoto lens views of this classic pickup truck using my Samsung S21 Ultra 5G.

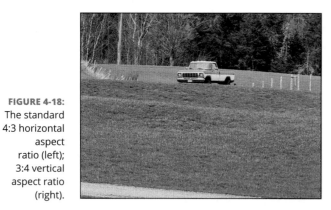

FIGURE 4-18:
The standard
4:3 horizontal
aspect
ratio (left);
3:4 vertical
aspect ratio
(right).

© MarkHemmings.com

FIGURE 4-19:
The 16:9
horizontal
aspect ratio
(left); 9:16
vertical aspect
ratio (right).

© MarkHemmings.com

FIGURE 4-20:
The 3:2
horizontal
aspect
ratio (left);
2:3 vertical
aspect ratio
(right).

© *MarkHemmings.com*

FIGURE 4-21:
The 1:1 square
aspect ratio.

© *MarkHemmings.com*

Creating Panorama Photos

A *panorama* is a long photo that is not very high in relation to its length. (See Figure 4-22.)

© MarkHemmings.com

FIGURE 4-22: Panoramic photos are longer than a standard horizontal photo.

Your Android camera allows you to create a panorama by capturing a very wide scene in front of your camera. As you slowly pan your camera from left to right or right to left, your camera is recording everything that it sees and then produces a very long final image. Think of a panorama photo as many vertical photos stitched together to form a single wide horizontal photo.

The value of creating panoramas is simply for the sake of good art. Do you love landscape photography and also enjoy seeing your work framed and hanging on a wall? If so, why not try creating a panorama landscape and then framing that gem with a custom panoramic frame and a signed matte? It will look fantastic hanging on your wall.

REMEMBER

You may be wondering why people even bother with panoramas when they can simply crop their photos to look exactly like a panorama. If you create a panorama from scratch, your final image has a higher resolution than a cropped normal photo. The higher the image resolution, the better quality for printing your panorama, framing it, and hanging it on your wall.

Horizontal panorama photos

Panoramas require you to move your Android camera slowly and steadily, and also in a relative straight line horizontally. The usual path is from the far left of your scene to the far right, but you can reverse that motion if you so desire. Here are some steps that you can take to create your first panorama masterpiece:

1. **Open your Camera app.**

2. **Tap Panorama.**

 If you don't immediately see the word Panorama, tap More (for Samsung), the 9-dot icon (Motorola), or a menu, settings, or Plus icon for other Android devices.

 On a Google Pixel phone, tap Modes (at the bottom), and then Panorama, as shown in Figure 4-23.

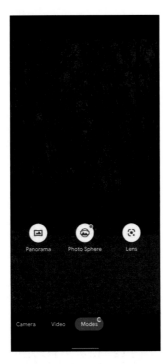

FIGURE 4-23:
Tap Panorama
to begin the
panorama
photo capture
process.

3. **Tap the shutter button and slowly move your Android camera horizontally.**

 In Figure 4-24 the composition starts from the far-left panning toward the right.

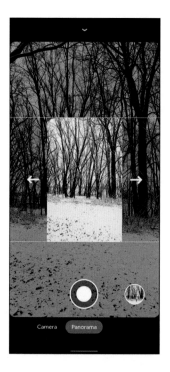

FIGURE 4-24:
Tap the shutter button, which starts the panorama photo capture.

As you move your camera horizontally you start to see the panorama take shape, as in Figure 4-25.

Try to keep your horizontal movements within the upper and lower white horizontal guidelines.

4. **When you feel that your panorama is wide enough, stop the recording of the panorama by tapping the shutter button. (See Figure 4-26.)**

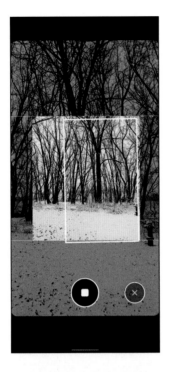

FIGURE 4-25:
As you move
your camera
horizontally,
the panorama
starts to
record.

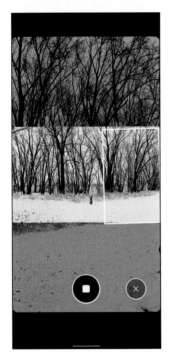

FIGURE 4-26:
When you're
ready to stop
the panorama,
tap the shutter
button.

And there you go! It's as simple as that to create frame-worthy wall art. Figure 4-27 shows a winter panorama with a fire hydrant using my Google Pixel 4a. Use panoramas for street scenes without people walking, cityscapes, and landscapes.

© MarkHemmings.com

FIGURE 4-27: The final result, a panorama from a Google Pixel 4a.

If you run into any problems, simply try the panoramic again. And keep in mind that if a lot of moving vehicles or people are in your scene, you may get some strange results. If you can create your panorama at a time when there isn't much movement in the general area, you get the best-looking final image.

Some Android devices allow you to use various optical zoom lenses to produce your panoramas. This gives you a lot of creative freedom to have a zoomed-in telephoto lens panorama or a wide-angle lens panorama, depending on the scene and your artistic preferences.

TIP

Vertical panorama photos

For a slightly distorted but cool looking effect, try a vertical panorama photo! Take a look at Figure 4-28 as a sample. The building has slight distortion (called barrel distortion), but that look has its place, and I think fits the scene.

FIGURE 4-28:
A vertical
panoramic
photographed
in an Eastern
Canadian
fishing village.

© MarkHemmings.com

To take a vertical panorama, rotate your phone so that it's horizontal instead of vertical and then follow the same steps as in the previous normal panorama instructions. The only difference is that you're moving your phone from low to high, instead of from left to right.

2

Having Fun with the Fundamentals of Photographic Genres

IN THIS CHAPTER

» **Levelling your camera**

» **Controlling exposure**

» **Choosing the best time of day**

» **Using a tripod**

» **Choosing the best lens**

» **Applying the Rule of Thirds**

Chapter **5**

Capturing the Perfect Landscape Photograph

L andscape photography is one of the most popular photography genres in the world. You would be hard pressed to find a person who hates a beautiful landscape scene. These images bring a sense of calm to the viewer, and they show off the best of our natural environment.

Note: Even if you aren't so interested in creating landscape photographs or can't do landscape photography because of mobility issues, you still might find this chapter useful. It contains many great tips and techniques that apply to almost all the photography genres that you encounter as an Android smartphone photographer.

Camera Considerations: Levels and Exposure

Landscape photography comes with a few challenges that are solved in this section. Keep reading to discover the best way to keep your camera level, and to adjust the brightness of your photo prior to tapping the shutter button.

Levelling your camera

No doubt you've owned a bubble-level in the past. Most construction rulers have them built-in, and those little green bubble levels help you gauge the level accuracy of a horizontal or vertical surface. While not all Android cameras have a built-in digital bubble-level, most late model devices include this useful feature.

REMEMBER

Landscape photography is particularly prone to uneven compositions. Have you ever photographed an ocean, and upon reviewing the photo realized that the horizon was slightly slanted to the right or left? To keep your landscape horizons perfectly level, turn on your level tool.

Figure 5-1 shows a landscape photo that I took this past spring when the river ice was beginning to melt. I took the photo thinking I had a level composition, but afterward realized that the photo was considerably uneven.

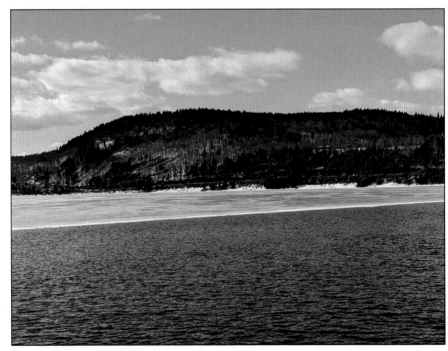

FIGURE 5-1:
Landscape photographs are often difficult to photograph completely level.

© MarkHemmings.com

Within my Camera app I turned on my level tool by going to my Motorola Moto camera settings (an icon that looks like a gear) and tapped the Leveler button as shown in Figure 5-2. For other Android devices the wording may be slightly different, such as Level, or for many Samsung Galaxy cameras Shot Suggestions.

FIGURE 5-2:
Within your
camera
settings,
tap Leveler
(or similar
wording).

I tried the photo again with my Google Pixel; this time with the level tool onscreen (see Figure 5-3) and found that I was 3 degrees off of a perfectly level landscape photo. I then slightly rotated my Pixel to 0 degrees that represents a perfectly level composition.

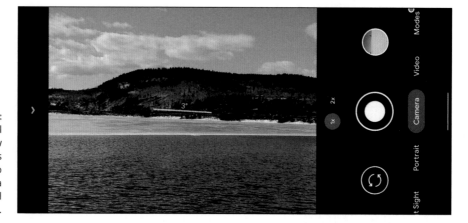

FIGURE 5-3:
The level tool
shows how
many degrees
you need to
rotate for a
perfectly level
photo.

TIP

Most late-model Google Pixel cameras have the level tool on by default. All you need to do is compose your landscape photo, hold the phone still for a few seconds, and then the yellow and white level tool appears in the middle of your screen.

Controlling exposure

Sunsets are a popular subject matter for landscape photographers, but a sunset photo usually comes with a tricky technical problem. Because the sun is so powerful it can often cause blown-out highlights. *Blown-out highlights* within photography means that the brightest areas of the photo lose texture and detail, resulting in blobs of unattractive light.

Take a look at the brightest section of the clouds in Figure 5-4. The yellow highlight section is far too overexposed. The rest of the photo looks great, but a correction is needed.

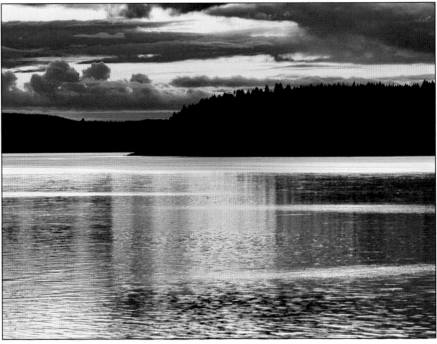

© MarkHemmings.com

FIGURE 5-4:
This landscape photo exhibits blown-out highlights, and should be underexposed and rephotographed.

To underexpose your photo (to make your photo darker), simply tap your screen and you see exposure adjustment sliders similar to Figure 5-5. For this example, I used my Samsung S21 Ultra and scrolled the exposure slider to the left to make my second photo darker. Other Android manufacturers allow you to do the same thing, but their sliders look slightly different.

After I took the photo, I was really happy with the results, shown in Figure 5-6. If you look carefully at the cloud highlights you see texture and detail, which means that the highlights are now not blown-out.

REMEMBER

While it's true that the rest of the photo also became darker, a darker overall photo with no blown-out highlights is better than a brighter overall photo that includes blown-out highlights. You can always adjust the darker areas of your photo later to make them a bit brighter when editing your photo. Chapter 11 explains how you can selectively make the shadow areas of your photo a bit brighter while keeping the highlights unchanged.

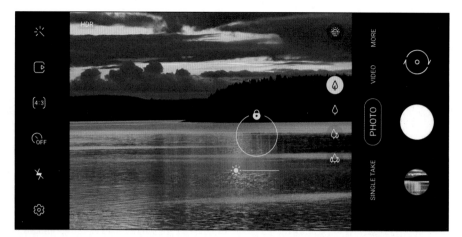

FIGURE 5-5:
Press anywhere on the screen and scroll the slider to adjust exposure.

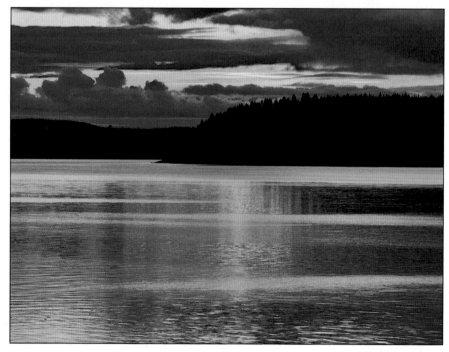

FIGURE 5-6:
With an underexposed reshoot the highlights on the clouds are no longer blown-out.

© MarkHemmings.com

Lighting Considerations

You may have heard photographers boasting about the *magic hour*. Magic hour is a term used by photographers and artists to signify the two times of day when the light from the sky is softer than usual and often excellent for landscape photography.

REMEMBER

The reason that there are two magic hours is because we have both a sunrise and a sunset. When the light is low in the sky and when it's below the horizon, the world takes on a peaceful, calm, and soft glow. It's magical!

Photograph during the magic hours

Before and after sunrise you encounter the morning magic hour. Before and after sunset, you witness the beauty of the evening magic hour. But it gets even better! Did you know that the magic hour can be further divided into the greatest two colors in the world of photography?

REMEMBER

Magic hour is often subdivided into *golden hour* and *blue hour*. Blue hour, as shown in Figure 5-7, is approximately a half hour before sunrise and a half hour after sunset. Golden hour is roughly a half hour after sunrise and a half hour before sunset.

The world has a rich blueish glow before the sun rises, and as soon as the sun peaks over the distant horizon, as shown in Figure 5-8, the world becomes washed in the most wonderfully embracing warm, soft light.

Similarly, in the evening, we experience golden hour before sunset, and when the sun sets over the horizon the world reverts to the most electric and brilliant blue tone! It's a landscape photographer's dream.

You may find one small problem with both magic hour morning and evening time slots: They disappear too fast! If only we could extend the duration a bit more to have even longer landscape photo shoots. As you've probably guessed, making use of the two magic hours per day can dramatically increase your landscape photography prowess.

Timing the magic hours

Now that you're a master at timing your next landscape photography adventure, all you need to do is set your alarm and get a good night's sleep. Arrive at your chosen location about an hour before sunrise, and you'll have set yourself up for photographic success.

FIGURE 5-7:
An example
of *blue hour*,
which occurs
before sunrise
and after
sunset.

© MarkHemmings.com

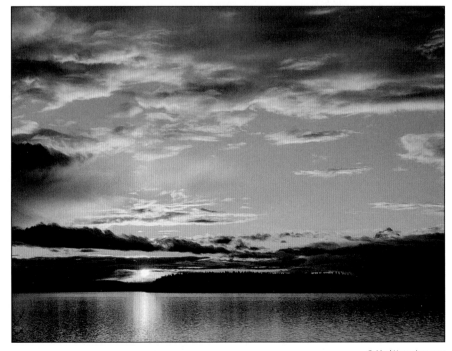

FIGURE 5-8:
An example
of *golden hour*
which occurs
after sunrise
and before
sunset.

© MarkHemmings.com

TIP

Every Android has a built-in weather tool powered by Google, and it conveniently tells you when the sun rises and sets for your home city or any worldwide destination that you add. You can access your sunrise and sunset times by tapping the weather section text, or by typing a sunrise query in the Google search bar.

Figure 5-9 shows the Google search result for my sunset query. Take a look at all of the other useful information that Google offers! Dawn, Solar Noon, Dusk, Length of Day, Remaining Daylight are all fantastic data points that photographers often rely on.

Gear Considerations

Professional landscape photographers rarely take photos without a tripod, as much of their work is done in the low-light hours of early morning or dusk. And they prefer to work with certain lenses over others. This section helps you with both accessory gear and lens choices.

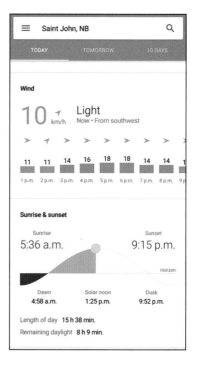

FIGURE 5-9:
Google shows your local sunrise and sunset times plus other useful information.

Steadying your Android camera with a tripod

Your Android camera is remarkably adept at creating a sharp photo without a tripod. However, if you have access to a tripod, why not make the most of those amazingly small yet sharp Android camera lenses?

TIP

Smartphone holders are usually plastic devices that clamp to your Android and screws onto your tripod's head plate. You can purchase these holders at pretty much any camera store and anywhere online. Search or ask for a "smartphone holder for a tripod."

Figure 5-10 shows a lightweight travel tripod with a smartphone holder attachment. By using a tripod for your landscape photography, you tend to slow down and think carefully about your composition. And you also have the time needed to check on things such as being perfectly level and having good exposure.

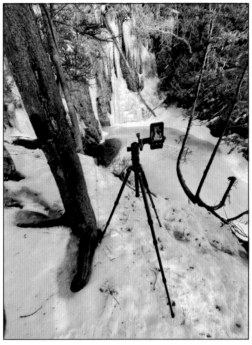

© MarkHemmings.com

FIGURE 5-10:
A lightweight travel tripod with a smartphone holder is perfect for landscape photography.

Figure 5-11 is a close-up shot of my tripod and smartphone holder, which can fit any size smartphone.

TIP

One of the biggest complaints that photographers have when talking about tripods is the inconvenience of carrying one around, and the extra weight when walking toward their scenic lookout. You can ease your burden if this sounds like you! Make sure that you choose a lightweight full-size tripod (either expensive carbon fiber or cheap plastic) and keep your tripod in the trunk of your car.

Plastic tripods can get weighted down with your camera bag or anything else that has some weight if you're concerned about tripod stability in windy conditions. As for convenience, by keeping your tripod in your car, you're more inclined to use it when you drive by the next breathtaking landscape scene!

REMEMBER

The best time to make use of a tripod is when the light is low, such as early morning and evening. But even better, some late model Android cameras also have a type of night mode where you can photograph in the dark! For example, Google's night mode is called Night Sight, an example of which is shown in Figure 5-12.

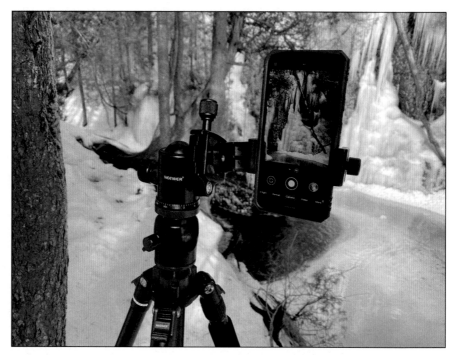

© MarkHemmings.com

FIGURE 5-11:
A smartphone tripod holder is adjustable to fit most device sizes.

© MarkHemmings.com

FIGURE 5-12:
Many newer Android cameras have some form of night mode that allows for dark and nighttime photography.

Notice how dark it was outside when I was photographing this landscape scene. My Google Pixel sensed the darkness, and a *Try Night Sight* notification popped-up on my screen. As I was using a tripod I knew that anything would help, so I switched from Camera mode to Night Sight mode (to the left of Portrait), and took the photo. Figure 5-13 was the result! I was amazed at how much light the Pixel was able to gather from the dark landscape scene. Even though it took a long time for the photo to be taken, it was worth the wait. Another benefit of using a tripod.

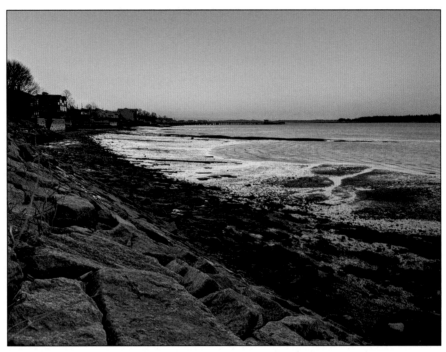

© MarkHemmings.com

FIGURE 5-13: By using a tripod with night mode, this brightened photo looks a lot better than the original darker version.

To find out whether your Android camera has night photography capability, do a Google search for "Does the (*your Android model name*) have night mode?". If yes, get a tripod and start creating landscape photos when the light is low or even very dark. And another cool feature that some newer Android cameras include is astro-photography, where the camera can photograph the starry night sky such as the Milky Way.

Choosing a lens (for multi-lens Android cameras)

The photo shown in Figure 5-14 represents a standard wide-angle Android camera lens view, which is the main lens on every Android device. This view is perfect for landscapes as a lot of the scene in front of you is included in the final composition.

Figure 5-15 is an example of what a telephoto lens view looks like (the Samsung S21 Ultra super-telephoto lens). The telephoto lens visually pulls in distant objects to make them appear larger in the frame.

© MarkHemmings.com

FIGURE 5-14:
A standard
wide-angle
lens view,
included with
all Android
cameras.

FIGURE 5-15:
The telephoto
lens view
makes distant
landscape
objects appear
larger in your
camera frame.

© MarkHemmings.com

When comparing both sample photographs, you see that there is a huge difference of *viewing angle* in the standard wide-angle lens and a telephoto lens. Landscape photographers tend to use their wide-angle lenses more than their telephoto lenses; however, if they want to showcase a specific detail (such as the old tree in Figure 5-15), then the use of either a digitally zoomed telephoto or optical telephoto view is perfect.

REMEMBER

Some multi-lens Android cameras come with an ultra-wide lens. If you have an ultra-wide-angle lens, practice using it for landscapes, as the extreme wide angle produces a very unique look.

Photography Tips for Your Next Outing

Landscape photography requires great light, a stable Android, and a composition that shows off the scene the best way possible. The word *composition* describes how photographers and painters present their chosen scene within the boundaries of their camera frame or painter's canvas. This section introduces and explains how the Rule of Thirds compositional grid overlay can help you compose your landscapes like a pro.

Applying the Rule of Thirds for better compositions

For better landscape compositions, you can add gridlines to your screen. Gridlines are like a tic-tac-toe grid overlaid on your camera screen so you can create both straight photos and follow the Rule of Thirds. If you haven't heard of the Rule of Thirds, then this section almost guarantees that you'll come home with stunning landscape photographs after your next photo shoot.

Figure 5-16 shows three different Camera Settings screens from a Motorola, Samsung, and Google smartphone. To activate your Rule of Thirds grid, look for wording similar to *grid type*, *gridlines*, and *assistive grid*. Each Android manufacturer has a different way to name the grid, but most often the word *grid* is included.

FIGURE 5-16:
Examples of
Motorola,
Google, and
Samsung grid-
line activation
buttons.

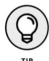

TIP

A classic Rule of Thirds landscape scene has the lower one-third of your composition being land. The upper two-thirds section is entirely sky. And finally, the main subject, such as the tree in Figure 5-17, intersects the Rule of Thirds vertical and horizontal lines. Figure 5-17 shows four different ways to incorporate the division of thirds, which you can mimic with your own photos. Notice how the snow either fills the bottom one third or the bottom two thirds, and the lone tree can be positioned on any of the four intersection points. For these figures, I've digitally enhanced the thickness of the gridlines so you can more easily see them. The gridlines are much thinner on the actual smartphone screen.

There you have it . . . the Rule of Thirds explained in a few paragraphs. But don't feel limited to just land and sky. You can also do a one-third, two-third, and three-third split such as the Samsung super-telephoto shot in Figure 5-18: The bottom one-third of the landscape is water, the middle third is land, and the top third is sky. The sailboat is an added bonus, as I placed it inline with the left vertical Rule of Thirds line. Feel free to experiment with the same Rule of Thirds theory when photographing vertically.

Framing an "L" shaped composition

A very simple use of the Rule of Thirds is an "L" shape, whereby a strong vertical subject such as a tree (see Figure 5-19) occupies the left vertical thirds-line, and a strong horizontal secondary subject such as the train bridge occupies the bottom thirds-line.

98 PART 2 Having Fun with the Fundamentals of Photographic Genres

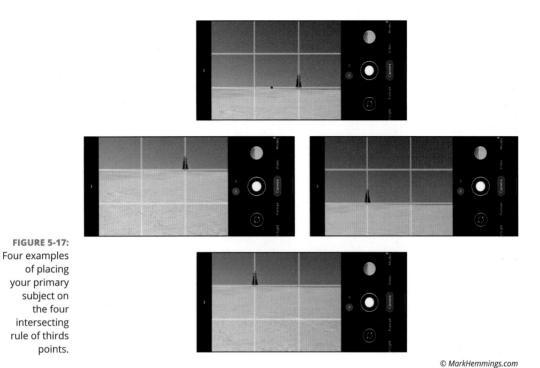

© MarkHemmings.com

FIGURE 5-17:
Four examples
of placing
your primary
subject on
the four
intersecting
rule of thirds
points.

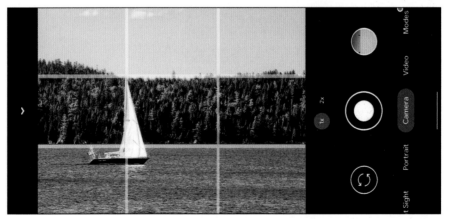

© MarkHemmings.com

FIGURE 5-18:
An example
of water, land,
and sky each
occupying a
horizontal
thirds section
of the
composition.

Positioning a primary and secondary subject

While it's true that this last example may be a bit tricky to capture, with a bit of maneuvering you can usually pull off a primary and secondary Rule of Thirds

composition. Figure 5-20 shows that the rock is the primary subject, meaning it's the most important object in the photo. The tree would be considered the secondary subject, meaning it's still visually important, just not as important as the rock. Both of these objects are placed on intersecting points.

© MarkHemmings.com

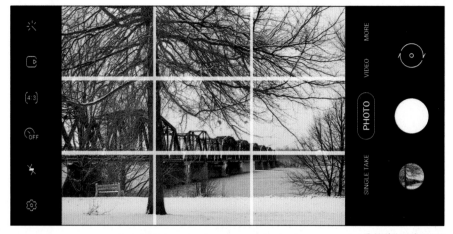

FIGURE 5-19: The "L" shaped composition includes a strong vertical and horizontal line in the camera frame.

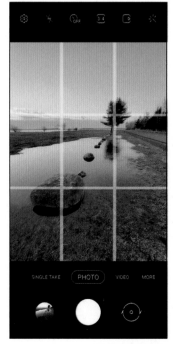

FIGURE 5-20: If possible, place the primary and secondary subjects on Rule of Thirds intersection points.

© MarkHemmings.com

Chapter **6**

Shooting Sports Photography

Regarding the expansive and intense world of sports photography, this chapter is written for what most non-professional photographers want to capture: Their friends on a ski slope, their teenager training for a big run, or their grandkids playing soccer.

So, think of this chapter as a way to record life's wonderful friends and family memories that just happen to be sports-related! These tips and techniques can help you build a wealth of great photos that serve as precious memories, and also be of a high enough quality for publishing or printing.

This chapter contains a lot of useful information even if you don't have much interest in sports. The techniques, such as Burst mode and time-of-day lighting, actually span many photography genres.

Camera Considerations: Using Burst Mode to Capture Motion

One of the first considerations that come to mind when you think of sports photography is the challenge of photographing a fast-moving person. Whether your subject is on a bike, within a race car, or shooting hoops, *getting the shot* can certainly be challenging at times.

TIP

Because of that challenge, it's best to set your camera up for *Burst mode*, which allows you to capture many photos in rapid succession, one after the other. With so many photos to choose from when reviewing the burst series, you can simply choose the best image out of all the options.

Take a look at Figure 6-1. The young woman is preparing for a trampoline flip. Because the flip happens so quickly, it would be very hard to capture her in midair. All I needed to do was press the shutter button on my Motorola camera, and hold down the button. By holding the shutter button and not letting it go, many photos are captured one after the other. When she finished her trampoline flip all I did was lift my finger off the shutter button to stop the photo captures.

FIGURE 6-1: For most Android cameras, press and hold the shutter button down for Burst mode photo capture.

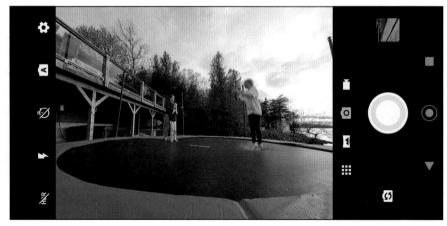

© MarkHemmings.com

Some Android manufacturers have a slightly different way to activate Burst mode. Many Samsung cameras require that you press the shutter button, and then slide the button to the right (for horizontal photos) or downward (for vertical photos). Figure 6-2 shows this shutter button motion for horizontal photos.

Recent model Google Pixel cameras have a slightly different take on Burst mode. When you press and hold the shutter button, the button turns red (see Figure 6-3) and a type of video recording starts. You can save this video clip or choose a single frame from the video clip to use as your favorite scene from your burst capture. Want to create more videos? Chapter 14 explains video capture in greater detail.

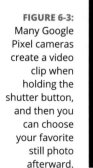

FIGURE 6-2:
Many Samsung cameras require a shutter button slide to the right to activate Burst mode.

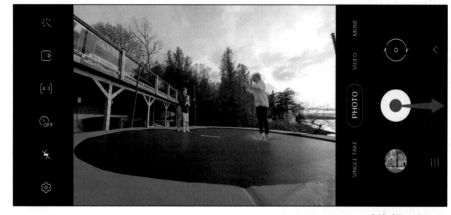

© MarkHemmings.com

FIGURE 6-3:
Many Google Pixel cameras create a video clip when holding the shutter button, and then you can choose your favorite still photo afterward.

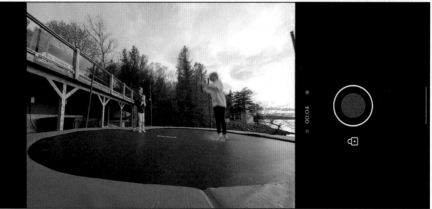

© MarkHemmings.com

After you finish your Burst mode capture, you have the option of choosing your favorite photo out of the many photos taken. At the bottom of the screen is a string of photo thumbnails that you can scroll through, as shown in Figure 6-4. I chose a single frame where the acrobat was upside down, and then tapped the Burst icon.

As you tap the Burst icon, a few options appear, similar to Figure 6-5:

>> **Set as Main Photo:** All your bursts remain, but your key (selected) photo is shown in your Google Photos collection.

>> **Keep This Photo Only:** All the other photos are deleted, and only your chosen key photo remains.

>> **Create Animation:** Create a fun looped video of the athlete! Note that this option isn't available on all phone models.

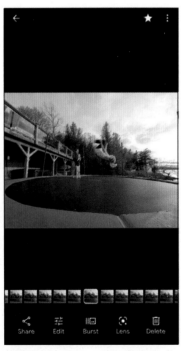

© MarkHemmings.com

FIGURE 6-4:
After your burst photo capture, you can choose your favorite photo and then tap the Burst icon.

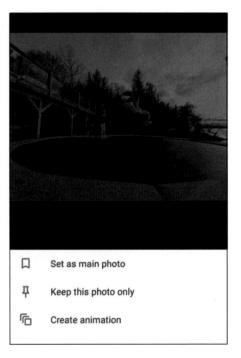

FIGURE 6-5:
You can set your selected best photo as the key photo, or have all other photos deleted except your key photo.

Gear Considerations

This section covers optional gear choices that may help you in your sports photography adventures. Keep in mind, however, that none of these items are mandatory. You can capture great sports photos with just your Android!

A tough smartphone protective case

Sports gear goes through a lot of abuse because of radical temperature shifts and also the risk of dropping gear due to fast action. Shown in Figure 6-6, a tough smartphone case may keep your Android safe from impact. Another feature of some cases that can be a real asset for when you are at heights is a finger ring attachment also shown in Figure 6-6. Not only is the case tough, but the attached finger ring allows for a very solid grip when using your camera in cold or adverse conditions.

FIGURE 6-6: Some smartphone cases are built tough for hard impacts and also have an attached finger ring for added grip.

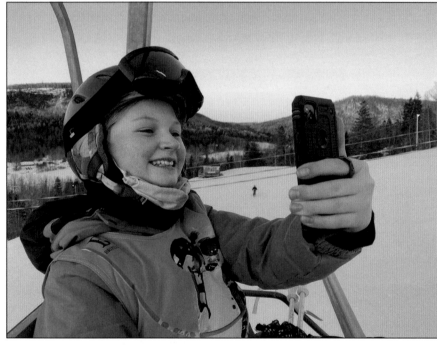

© MarkHemmings.com

A smartphone screen protector

If your smartphone case doesn't come with its own clear plastic or glass screen protector, take your Android to your local electronics store and ask for a durable stick-on screen protector. My suggestion is that you ask the staff at the store to do the installation. I've botched a number of screen protector applications due to a mix of sloppiness and impatience! The screen protector keeps your Android's glass screen safe in case you drop it on a hard surface.

Battery packs or battery cases

Bring along a battery pack to your next sporting event, especially if the event is quite long in duration or in a cold environment. Cold weather can deplete your phone's battery much quicker than warmer temperatures.

TIP

Don't bother with the cheap dollar store battery packs, as they degrade in performance very quickly. Invest some money into a quality battery back that has the appropriate power cable to fit your particular smartphone. Battery packs come in different shapes and sizes, and most often can fit easily in your pocket, similar to the one shown in Figure 6-7.

FIGURE 6-7:
Extend your phone's battery life in the cold with a battery pack.

© MarkHemmings.com

Touch-sensitive gloves in cold weather

Most clothing stores that sell winter clothes include gloves where the thumb, fore, and middle fingers are touch sensitive. Touch sensitive means that you can freely use your phone while wearing gloves during cold days.

Lighting Considerations

The following sections offer a few tips to help you maximize your creative and technical lighting skills. The term *lighting* is used in the photography and film industry to explain how pro photographers manipulate or control light to illuminate the subject perfectly. In your case, however, it mostly means how you can situate yourself to take advantage of how the natural light hits subjects.

Photographing into the setting sun

Photographing into the sunset adds a sense of artistry to sports photography. One of the most popular of such scenes is the serene shot of a kayak or canoe drifting into a gentle sunset. The only problem with sunset shots similar to the one shown in Figure 6-8 is that the sun can become blown-out. The sun looks like a huge blob of light with no detail!

Now, if you wait a few minutes until the sun hits the horizon, as shown in Figure 6-9, your sun appears more realistic. No more blown-out highlights!

Don't forgot about the beautiful soft light that happens the very moment that the sun dips just below the horizon. If you can keep your camera stable enough, you can get a winning shot with soft, pastel-like colors as in Figure 6-10.

Capturing team sports with the sun behind you

While this tip may sound absolutely basic, I still see countless team sports photos where the mom or dad photographs their kids out on the field from the shadow side of the field. Their child's faces are in shadow and are difficult to see. The easy fix, shown in Figure 6-11, is to simply walk to the other side of the field so that the sun is to your back. When you are between the sun and the kids on the field, they're illuminated perfectly in your photo.

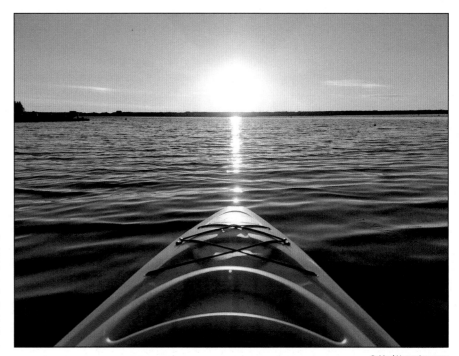

FIGURE 6-8:
Photographing
into the setting
sun can often
result in the
sun looking like
a blown-out
blob of white
light.

© MarkHemmings.com

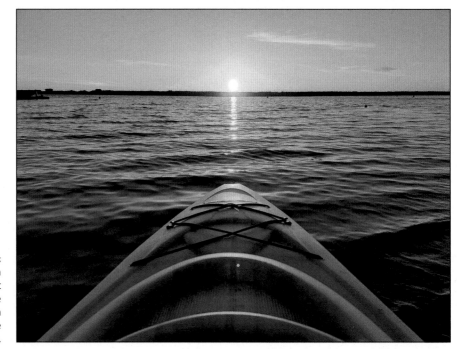

FIGURE 6-9:
Photograph
the sun as it
just hits the
horizon for a
more accurate
appearance.

© MarkHemmings.com

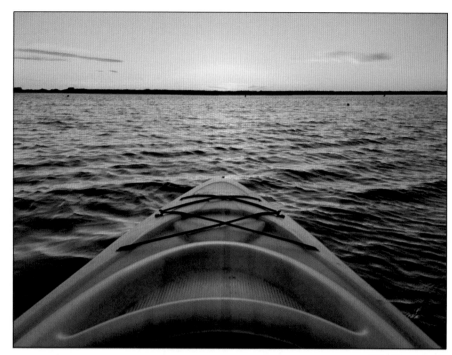

FIGURE 6-10: Photograph the same kayak or canoe scene just as the sun dips below the horizon for pastel colors.

© MarkHemmings.com

FIGURE 6-11: Change your position so that the sun is hitting your back when photographing a game on a field.

© MarkHemmings.com

Using the setting sun for portraits

Golden hour photography is not just for landscape photos. While it's not always possible due to scheduling, try your best to plan your outdoor sports portraits when the light is low to the horizon. I placed my model (in this case my dad!) so that the setting sun was directly behind his head, as in Figure 6-12. Normally this placement would create a dark silhouette, but with rapid advancements in high dynamic range (HDR) technology, mid-range Androids such as the Google Pixel 4a and others produce a wonderful soft and pleasing portrait.

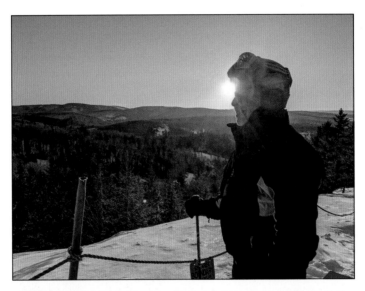

FIGURE 6-12: For late model Android cameras, you can place your subject between you and the setting sun for soft portraits.

© MarkHemmings.com

Incorporating cool and warm color tones

The color blue and the color yellow are opposites on the photographer's color wheel. What this means is that photos that exhibit both a cool and warm tone within the same image often elicit a positive emotional response in the viewer. In Figure 6-13 you see the interplay between the cool blue hues of the ski slope and the warm-toned evening light of the distant mountain. When possible, plan your sports photography around sunrise or sunset to take advantage of the warm and cool color mix.

FIGURE 6-13: Cool blueish color tones go well with warm yellow/orange/red colors.

© MarkHemmings.com

Choosing high contrast lighting

As you get better at sports photography with your Android camera, you may be asked to do paid photo shoots to showcase a product or service. If the subject matter has a light and airy feel, such as a cute photo of a 5-year-old practicing soccer, make sure that your lighting style is soft and calming. As in Figure 6-14, if your product has an aggressive feel, like these Rogue weightlifting plates from

the Fundy CrossFit gym, try high contrast lighting with deep shadows and bright highlights. Position your products or people within the harsh light that streams in from a window for a more graphic, punchy look and feel.

© MarkHemmings.com

FIGURE 6-14: If your sport is aggressive in nature, try harsh direct sunlight through windows for a high contrast look.

Photography Tips for Dynamic Sports Photos

As with all photographic genres, sports photography has its own set of best practices. I chose the tips and techniques in the following section, specifically to help you quickly and easily create better smartphone sports photos.

Using your Portrait mode

Sports photography almost always contains at least one portrait or selfie of the athletes or participants. Popular sports apps such as Strava encourage you to post

photos of your run or bike ride. So, why not make your sports photos look their very best by using the Portrait mode? As in Figure 6-15 of my daughter and I finishing an 18 mile run, it creates a soft blur behind your athletes. Chapter 2 explains how to create Portrait mode background blur.

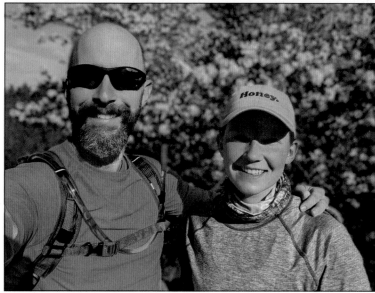

FIGURE 6-15: Portrait mode background blur makes athletes look even better!

© MarkHemmings.com

Allowing the subject to enter the composition

In Figure 6-16 you see two photos of a runner, one where there is more space behind the runner, and the other where there is more space in front of the runner. Have the athlete enter the composition where there is more space in front of them for a better sense of visual flow.

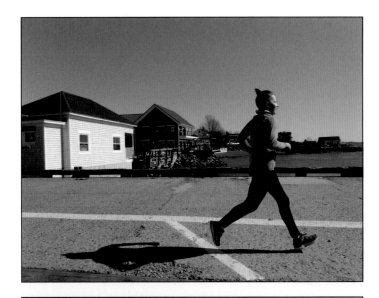

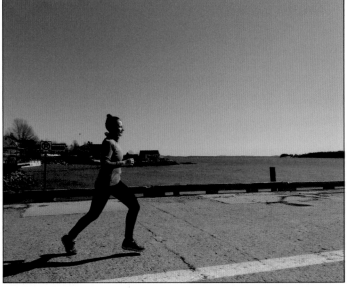

FIGURE 6-16: It's sometimes more appealing to have more space in front of the athlete, as if they're running *into* the picture instead of out of the picture.

© MarkHemmings.com

The previous tip is not just for human athletes; it also works for objects such as sailboats or any vehicle. Figure 6-17 shows a digitally zoomed-in sailboat sailing into the picture space instead of sailing out of the picture. Notice that there is more space in front of the sailboat, which creates an overall harmonious feel to the photo.

© MarkHemmings.com

FIGURE 6-17:
Vehicles such as sailboats also benefit from entering *into* the picture space.

Choosing curved backgrounds

Art theorists rightfully claim that the human mind is attracted to curves placed within paintings and photographic compositions. Figure 6-18 shows a runner running on a slightly curved road through a beautiful, forested mountain. The curve in the road allows the viewer of the photograph to explore the entire picture after they appreciate the primary subject. Try to find curved sections of the road for any road race such as cycling, triathlons, marathon running, and car or motorcycle racing.

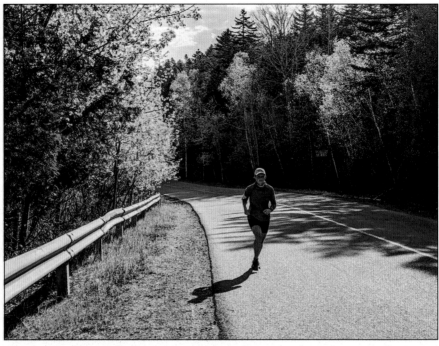

© MarkHemmings.com

FIGURE 6-18:
Look for
curved
sections of the
road for any
road racing
photographs.

Framing your athletes

Sports photographers often add a touch of artistry to their compositions by framing their subject. *Framing* is a technical term in photography that refers to multiple visually strong objects that surround the primary subject. Framing tends to push the viewer's attention straight to the main subject, which in your case is the athlete(s).

Figure 6-19 shows a traditional framing setup, whereby the beach occupies the lower section and the two vertical trees visually enclose the kayakers. The beach and trees frame the kayakers, which leads the viewer straight to the most important part of the image.

© MarkHemmings.com

FIGURE 6-19:
Choose any
visually strong
objects such as
trees to frame
your athletes.

Creating negative space

The term negative space refers to a large section of your photograph having no identifiable subject matter. Further, the primary subject, such as the skier in Figure 6-20, tends to be small in size in relation to the overall image. The snow is the negative space within this skiing photograph, and its job (visually speaking) is to help the viewer appreciate the scale of the surroundings. If there was no negative space, simply a telephoto zoomed-in view of the skier, it would be harder to judge the expanse of the ski slope.

TIP

Use negative space to showcase a sense of scale, but to also introduce a touch of fine art to your photography. Other examples of negative space could be a large brick wall with a small flower, a massive pure blue sky with a small airplane, or a snowy white field with a lone pine tree in the distance.

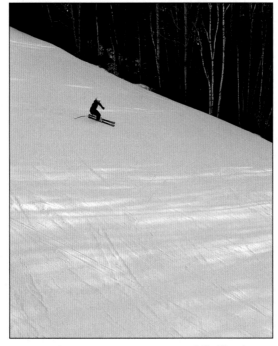

FIGURE 6-20:
For a sense of scale and artistry, use a lot of empty, negative space within your composition.

© MarkHemmings.com

IN THIS CHAPTER

» **Knowing when to use portrait mode**

» **Understanding lens compression**

» **Dealing with interior backlighting**

» **Using shadows to create artistic portraits**

» **Photographing from a lower position**

» **Creating better pet photos**

Chapter **7**

Saving Memories through Family and Individual Portraiture

This chapter is all about capturing the fun and memorable moments of family life, and great looking portrait photos of friends. By the end of this chapter you pick up some new techniques to help keep the visual legacy of your friends and family for future generations!

Camera Considerations: Portrait Mode and Lenses

In this section, you discover two important camera considerations that can help you with better family and friends' portraits. Portrait mode has its benefits and drawbacks, and so does your lens selection.

Knowing when to use Portrait mode

In Chapter 4, you discover how to activate Portrait mode and how it's great for creating a pleasing background blur behind your subject's head. Portrait mode is fantastic for family photography, but it does have its limitations. Take a look at the photo in Figure 7-1. Because my niece was moving around with so many quick arm and head movements, it was difficult for my Android to capture her with Portrait mode blur. Because she wouldn't stay still while playing with her older cousin, I opted for the normal Photo mode instead.

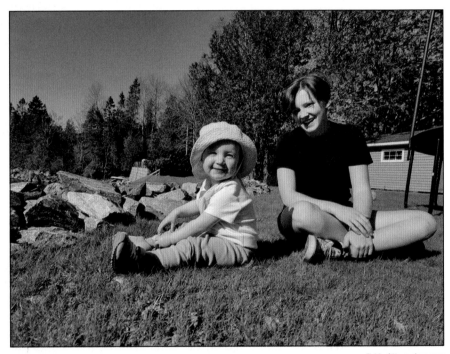

FIGURE 7-1: A standard family photo without Portrait mode background blur is best when people are moving erratically.

© MarkHemmings.com

Figure 7-2 tells a different story as the toddler was sitting perfectly still leaning on her older cousin. That meant that they were prime candidates for Portrait mode. This type of family photo, where everyone remains relatively still, is perfect for Portrait mode's dreamy background blur.

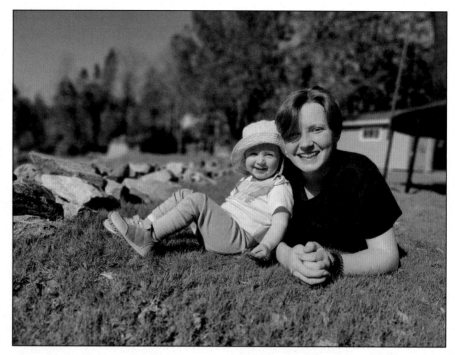

© MarkHemmings.com

FIGURE 7-2:
Portrait mode is perfect for family photos and portraits when the subject isn't moving too quickly.

Understanding lens compression

The term *lens compression* is common in the world of DSLR and mirror-less photography. When you use a telephoto lens with your smartphone, lens compression reduces distortion, as well. For the first example, take a look at Figure 7-3. I photographed these cousins relaxing in a chair using my Samsung S21 ultra-wide angle lens. Notice how their legs appear elongated and larger than their natural proportions. Ultra-wide angle lenses always make whatever is closest to the camera appear far larger than reality. Because their legs are physically closer in distance to my camera than their heads, they appear unnatural and stretched.

Figure 7-4 is up next, where I backed myself up a bit and chose the normal wide-angle lens. This type of lens view comes standard with all smartphone cameras. If you compare Figure 7-4 with Figure 7-3 you see that their legs are less visually stretched, but their proportions are still not perfect. Again, because their legs are closer to the camera, they still don't look completely natural.

TIP

As an interesting side note, Figure 7-4 shows square overlays. Many Android cameras use this autofocus aid to help you see where the autofocus is targeting.

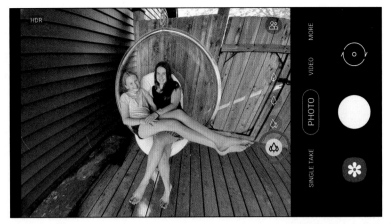

© MarkHemmings.com

FIGURE 7-3:
Distortion is quite visible for portraits using an ultra-wide-angle lens.

© MarkHemmings.com

FIGURE 7-4:
Distortion is mildly visible for portraits using a standard wide-angle lens.

For the third example shown in Figure 7-5, I moved back even farther and chose the telephoto lens. If you take a careful look, you now see that their bodies are proportional. The combination of me as the photographer moving backwards and choosing a more telephoto (or zoomed-in) view allowed the lens compression effect to remove the proportion distortions. Telephoto lenses tend to visually *flatten* an image, which is why portrait and family photographers rarely use wide-angle lenses during their photo shoots. Lens compression, by using a more zoomed-in view, makes people look proportional and natural.

For a refresher on different Android camera lens choices flip to Chapter 1.

© MarkHemmings.com

FIGURE 7-5:
No distortion
is visible for
portraits using
a telephoto
lens.

Gear Considerations: Editing Tools for Better Compositions

While you may want to consider using a tripod for group family photos when indoors or in low light outdoors, your Android alone should be sufficient for most of your people pictures. But for fine-tuning your images, the photo-editing tools within the Google Photos app can help you tighten your compositions. See Chapter 11 for more about the editing tools available to you.

Figure 7-6 shows a cute photo of cousins laughing and having fun together. Their interaction is really engaging, but too many visually distracting elements detract from the photo. The glasses at the bottom of the composition, the empty space above their heads, and someone's knee and elbow to the right of the frame.

With a simple vertical cropping almost all the visual distractions are gone, as shown in Figure 7-7.

Maybe a horizontal cropping would be better? If so, Figure 7-8 shows a relatively distraction-free composition.

TIP

Becoming familiar with the crop tool options, as explained in Chapter 11, is invaluable for keeping your family and friends portraits clean from visual clutter.

FIGURE 7-6:
An example of
a great family
photo but
with too many
distractions.

© MarkHemmings.com

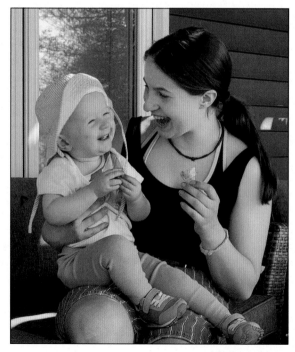

FIGURE 7-7:
A cropped
vertical photo
with far fewer
distractions.

© MarkHemmings.com

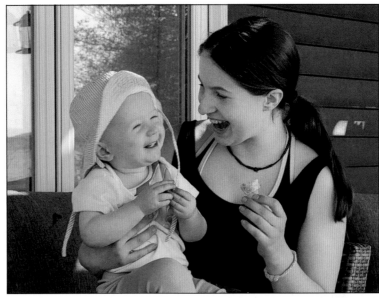

© MarkHemmings.com

FIGURE 7-8:
A cropped
horizontal
photo with
far fewer
distractions.

Lighting Considerations

If you've ever heard the maxim "Photography is all about light," you may be wondering about the other aspects of photography that aren't light related. What about gear? What about a good-looking subject? What about technical skill? Yes, all of those are pieces to the puzzle, but photography in its fundamental form is a game of manipulating light to create a desired photographic result.

To that end, this section is chock-full of lighting tips to help you present your family members in the best possible manner. Everyone wants to look good in family photographs, and you can be that rare shining light that presents your family in a way that they can be proud of.

Avoiding certain types of interior lighting

Photographing friends and family indoors when electric lights are on can often produce unsatisfactory results. Old-school fluorescent bulbs, for example, can often provide an ugly color cast to a person's skin. I found these two bulbs in a hardware store that illustrate the point perfectly. One of the bulbs shown in Figure 7-9 has an orange color cast and the other a green color cast. If I was photographing a person under this type of lighting the results wouldn't be very good unless I converted my photo to black and white afterward.

© MarkHemmings.com

FIGURE 7-9:
An example of
mixed electric
light colors
that may result
in unflattering
interior
portraits.

TIP

When photographing inside your house in the daytime, try to use only natural window light. If at night, you need to use electric lights, but at least choose lamps and lights that are the same. For example, only use all LED lights instead of mixing lightbulbs. Each type of lightbulb produces a slightly different color cast in your photos. When all the lightbulbs are the same brand and color temperature, you have much better skin-tone results for your portraits.

Dealing with interior backlighting

When we have family dinners, we can't always expect the prime conditions for preserving the memories with our cameras. One of the big problems that occurs frequently is photographing the family when windows are behind the group. This backlighting can cause your Android camera to underexpose your photo. With underexposure the group member's faces can become too dark, even with advanced camera exposure technologies.

If you have a similar family meal photo as in Figure 7-10, this is what you can do. Simply raise your camera high until you can't see the bright sky through the windows. When the bright sky is removed from your composition, your photo enjoys a better shadow/highlight ratio. The family member's faces are illuminated nicely, and the photo has fairly even exposure.

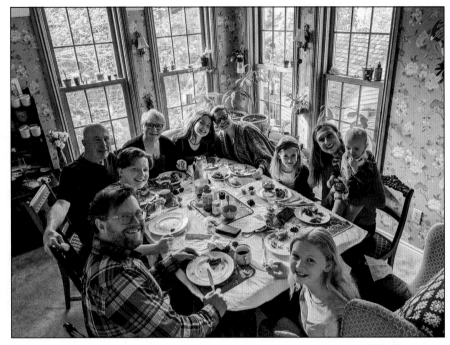

© MarkHemmings.com

FIGURE 7-10:
To reduce the overpowering brightness of the sky, position yourself so that the sky is not visible through the windows.

Creating silhouettes for artistic family portraits

The exact opposite of backlighting, is creating a photo with black silhouettes and no detail, as the one shown in Figure 7-11. To create an unusual and creative family portrait, simply place them between you (as the photographer) and strong sunlight. This backlighting scenario ensures that the group appears as silhouettes. While it's true that you won't want the majority of your group photos to be silhouettes, from time to time creating family photos like this is fun.

Using shadows to create artistic portraits

If you have a sunny day with harsh, direct sunlight, why not practice creating shadow portraits? Figure 7-12 shows a photo that I took of my own shadow being cast on a building.

© MarkHemmings.com

FIGURE 7-11:
Place your
group between
you and strong
sunlight to
create
silhouette
family and
friend group
portraits.

© MarkHemmings.com

FIGURE 7-12:
A photo of my
shadow that
I took while
walking past a
building.

To create a fine art shadow portrait, I simply cropped the photo and converted the image to black and white, as shown in Figure 7-13. Cropping and black-and-white conversion is discussed in Chapter 11.

© MarkHemmings.com

FIGURE 7-13:
With cropping
and black-
and-white
conversion
I created a fine
art shadow
portrait.

Placing family members in the shade for even light

Harsh, direct sunlight portraiture usually only works well for supermodels and young people who have great complexions. For the rest of us, portraiture for both humans and family pets is best done in the shade or on overcast or cloudy days.

Figure 7-14 shows Bilbo, my friend's dog, under a trampoline. I wanted to photograph Bilbo but the sunlight outside was a bit harsh, which created shadows that weren't flattering. Bilbo then decided to cool off in the shade of the trampoline, which provided the perfectly soft light I needed to capture a pet portrait.

Figure 7-15 shows the result, an evenly exposed portrait free from harsh, direct sunlight that causes unflattering shadows.

FIGURE 7-14:
Choose
overcast days
and/or shady
areas for
family or pet
portraits.

© *MarkHemmings.com*

FIGURE 7-15:
Choose
overcast days
and/or shady
areas for
family
portraits.

© *MarkHemmings.com*

REMEMBER

No doubt you won't always have the shade of a trampoline for all your future portrait sessions with your friends and family! All you need to do is be aware that harsh sunlight isn't very flattering, and that you can get softer portrait results in the shade of a house or when a cloud covers the sun.

Photographing from a lower position

Most portraits that you take every day are at eye-level, as that is the most comfortable position to take photos. Figure 7-16 is an example of a standard, eye-level portrait.

FIGURE 7-16: An example of a standard eye-level portrait.

© MarkHemmings.com

If you change your position so that you're lower than the people being photographed (see Figure 7-17), you visually empower the subjects. You can see this lower-to-higher placement in pretty much every single fashion photo ever taken. When flipping through fashion magazines the models always seem to be tall and imposing, don't they? In reality they could be just slightly taller than average height, but because the photographer shoots from a lower position, they appear visually empowered and tall. Give it a try on your friends the next time you are out on an adventure!

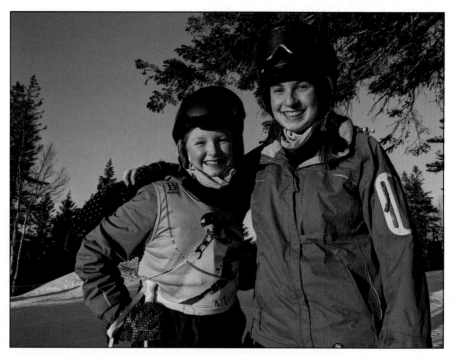

© MarkHemmings.com

FIGURE 7-17: An example of a portrait where the photographer is lower than the portrait subjects.

Photography Tips for Your Next Portrait Session

The following sections explain tools at your disposal to present your family members in the best light possible. With a few technical tips mixed with creative techniques, by the end of this section you'll have new artistic ways to capture your family and friends.

Taking multiple photos at your location

Even though the following tip is simplistic and quite basic, a reminder is needed from time to time. When friends and family members are exploring a location, such as the fishing village shown in Figure 7-18, take many different shots while they explore. Each shot will have a different feel to it and visual story, which is especially true with the natural inquisitiveness of children. I took about ten photos of the cousins trying to find shells in a fishing village, and the two images that you see are my favorites.

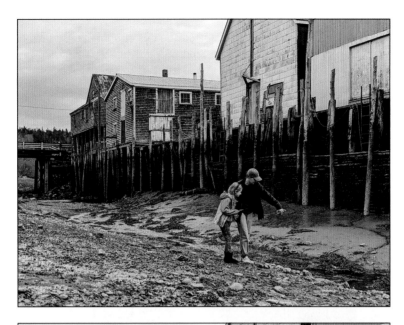

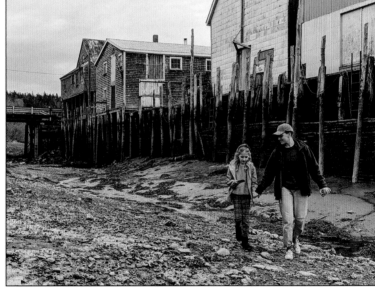

© MarkHemmings.com

FIGURE 7-18: Take many exploration-type photos as each image will have a different feel and visual story.

Avoiding objects sticking out of people's heads

Have you ever heard this complaint? "I have a telephone pole coming out of my head!"

To avoid the telephone pole coming out of your family member's head, or as in Figure 7-19 the tree coming out of my daughter's head, always double-check to make sure that everyone's head has a visually clean background. All you need to do as the photographer is slightly change your position if you encounter a similar situation.

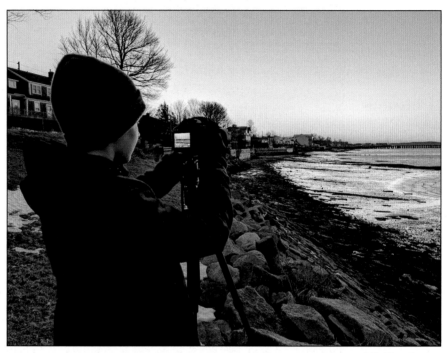

© MarkHemmings.com

FIGURE 7-19: Watch out for items in the background that appear to be coming out of someone's head.

TIP

If you can't move around to avoid the distraction, use Portrait mode as the blurred background reduces the negative effect of the distracting object.

Composing small for artistic portraits

You can add an artistic flare to your portraits by surrounding the subject with a vast landscape. It's an easy process and quite effective. Simply move away from your friend and use a wide-angle lens. When people appear small in a landscape photo your viewers can appreciate the scale of the landscape. Figure 7-20 is an example of a landscape-style portrait that really shows off the grandness of rock and ocean.

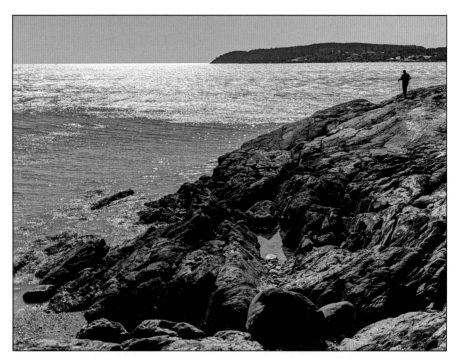

© MarkHemmings.com

FIGURE 7-20: To show landscape *scale*, compose your friends or family members so they are small in the overall composition.

Including family member's interests

It's amazing how many people neglect documenting their family involved in their hobbies and other interests. Sports usually gets a lot of screen time, but quieter endeavors are often neglected. Each year as children or grandchildren grow up, try to get at least one photo of them doing or being involved in their favorite hobby, such as the teenage artist enjoying a gallery exhibit shown in Figure 7-21. Their hobbies will most likely change over the years, and your visual record of them will be a highly cherished memory for decades to come.

Practicing close-up portraits

Did you know that your Android camera can capture close-up details? While you probably won't be collecting eyeball portraits of friends and family very often, it's a fun thing to try once in a while. It also trains you to be steady when doing normal close-up photography with subject matter such as flowers, insects, and other small objects. Figure 7-22 shows a close-up photo taken with a Samsung S21 camera.

FIGURE 7-21:
Artistic portrait documenting a family member's appreciation of gallery art.

© MarkHemmings.com

FIGURE 7-22:
Your Android is remarkably good at taking close-up photos.

© Aren Hemmings

Including mirrors for hands-free selfies

Always look for mirror photo opportunities within every location that you are in, and especially make use of elevator mirrors. You can create some unique hands-free selfie portraits within those multi-mirror tiny spaces.

If you place your smartphone in a shirt pocket like I did it in Figure 7-23, you can capture a selfie without holding the camera. Simply set your camera countdown timer (see Chapter 4), place your smartphone in your shirt pocket, and smile! While it's true that the top part of your phone will still be visible in the final shot, it's a lot better than the millions of selfie photos that you see online, where the person is holding their smartphone close to their face when using a mirror.

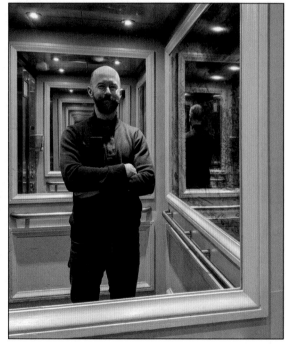

FIGURE 7-23: Mirrored elevators and your smartphone in a pocket allow for hands-free selfies.

© MarkHemmings.com

Using food as bait for pet photos

Have you ever tried to photograph your pet, but realized that it was a lost cause because your pet was running around too much? Entice your pet to stay within a visually uncluttered area of your house by using food. Figure 7-24 shows our family pet rabbit Joey eating watermelon in the exact place that I wanted to photograph him.

FIGURE 7-24:
Place food where you want to photograph your pet.

© MarkHemmings.com

When Joey was full and happy, I removed the watermelon and quickly got the shots I needed! (See Figure 7-25.) Joey with a television in the background showing a slideshow of our collection of various Joey photos.

© MarkHemmings.com

IN THIS CHAPTER

» Using exposure control

» Protecting your smartphone

» Understanding the different directions of light

» Photographing into the sun

» Leaving space for text

» Composing using geometric forms

Chapter **8**

Photographing During Your Travels and Vacations

Travel and vacation photography encompasses everything from a trip around the world to a weekend vacation in the town next to you. As there is such a diversity of photo opportunities you encounter when you leave your own city, this chapter includes general tips and techniques that should apply to most all of your travels. Even if you're unable to travel, or have no desire to travel, many of the photographic concepts introduced in this chapter are transferrable to many other photographic genres.

Camera Considerations: Multiple Lenses and Exposure

This section showcases a few examples of how you can operate your camera to benefit your diverse travel photography experiences. While it's true that the camera considerations that you discover in this section aren't unique to travel and

vacation photography, they potentially have a greater importance due to the fact that you can't return later to do a re-shoot when you get home from your trip!

Photographing the same scene with multiple lenses

If you have a multi-lens Android get in the habit of photographing the same scene with all your available lenses. At the time of this writing a lot of Android manufacturers prefer to sell single or triple lens devices. If you have a single-lens smartphone, get in the habit of photographing the first shot with your standard lens, and then try a 2x digital zoom for the second shot. If you have a multi-lens Android, make use of all the lenses to capture a series of photos of a single scene as shown in Figures 8-1 and 8-2.

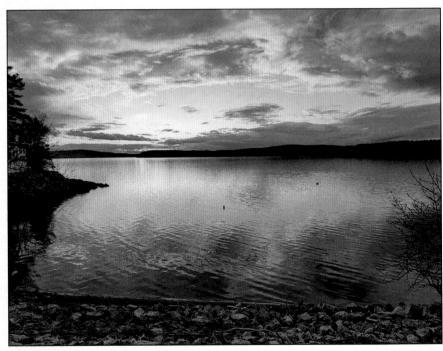

© MarkHemmings.com

FIGURE 8-1:
A standard wide-angle lens from a Samsung S21 Ultra smartphone.

REMEMBER

Because you will only be in your vacation location for a brief time, when you get back home you don't want to feel disappointed that you didn't get enough creative variations on that stunning travel photography scene.

FIGURE 8-2: A super-telephoto second shot of the same scene as Figure 8-1, which allows for two creative expressions within one location.

© MarkHemmings.com

Quickly using exposure control for fleeting subjects

When you're traveling or on vacation you may encounter the dreaded *group tour rush*. What could be more frustrating than seeing the perfect shot, but the tour bus driver is ready to drive off to the next location? When I teach my international photography workshops I always explain to my participants that speed and quick reactions are critical to capture a photo of moving objects.

Figure 8-3 shows an unedited photo of a seagull and a rainbow. When I saw that fantastic scene I stopped the car, rolled down the window, underexposed the photo, and then got the shot before the gull took off. As I've adjusted my exposure countless times, I know how to make my photo brighter or darker within a second. I would encourage you as well to practice your exposure adjustment speed prior to your vacation trip, so when you encounter a photo opportunity that may just fly away at any second, you will have the fast reaction time needed to get the prize winning image.

REMEMBER

See Chapter 5 for a refresher on how to make your photo brighter or darker before you take the photo.

© MarkHemmings.com

FIGURE 8-3:
Practice
changing the
exposure
quickly prior to
your vacation
photo walks
and drives.

Gear Considerations

Fortunately, there aren't too many expensive extra gear items needed for travel and vacation photography. However, in this section I explain what I use when I travel so that I am always assured that I did my best to both protect my Android device and can also get the best shot in low light conditions.

Protecting your Android smartphone

I take my Android smartphone everywhere I go, which also includes when I am kayaking or sailing. Take a look at Figure 8-4. What do you think of my new sailboat? Just kidding (unfortunately!), as I was in my humble kayak when I took this photo of someone else's stunning sailboat. While I was taking my Samsung S21 Ultra out of my lifejacket's zippered pocket to capture this shot, I fumbled with it and almost lost it overboard.

If you have any water related activity on your vacation or travels, consider a dedicated waterproof housing for your smartphone (see Figure 8-5). Options are actual cases that are designed to fit your specific phone make and model, and others that are high quality clear plastic bags. Make sure that you attach a small flotation device that will keep your Android floating if you drop it overboard.

© MarkHemmings.com

FIGURE 8-4:
It's very easy to
lose or damage
your smart-
phone when
doing water
or adventure
sports while
travelling.

© MarkHemmings.com

FIGURE 8-5:
An example of
a waterproof
smartphone
pouch.

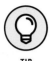
TIP

Ask your local camera or electronics store for their selection of waterproof phone pouches, or search online if you need to order one. Make sure that the size of the pouch will fit the size of your phone. Even though most mid-range and pro smartphone models have a water resistance rating, why take the chance?

Packing a tripod

A tripod isn't critical for travel photography, as most often you'll be with family and have enough baggage as it is. However, if you can afford the space and weight, a travel tripod is perfect for those early morning and late evening photos.

On a winter vacation trip to a resort town called St. Andrews we got up early for a photo shoot. Some used DSLR cameras, as shown in Figure 8-6, and I used my Google Pixel 4a. I too used a tripod, which allowed me to capture a sharp photo in very low light (see Figure 8-7).

FIGURE 8-6:
A DSLR photographer using a travel tripod early in the morning.

© MarkHemmings.com

TIP

Tripods are especially useful for all city or streetscape photos just prior to sunrise or after sunset, as the shop windows will have a warm color tone from the interior lights, but the outside ambient light will have a soft blue color tone. The blue and yellow color combo always work well together!

© MarkHemmings.com

FIGURE 8-7: An Android photo taken with a tripod for maximum sharpness in low light.

Lighting Considerations

The beauty of travel, either for vacation or for adventure, is that you're pretty much guaranteed to encounter types of light that you're not used to in your own hometown. The following sections contain a sampling of types of light that you may encounter on your travels.

Front light

Front light is a description of the direction of light whereby the sun is behind you, and the subject you're photographing is directly in front of you (such as this Canadian lighthouse in Figure 8-8). You'll get nice even illumination with front light, but sometimes this type of light is less dramatic, as front light often reduces the effect of visual depth and three-dimensionality.

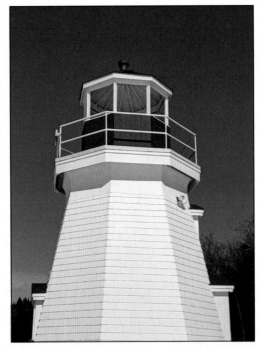

© MarkHemmings.com

FIGURE 8-8:
When you are between the sun and the subject you're photographing, the subject will be front-lit.

Back light

Back light, or sometimes called *backlighting*, refers to light hitting your subject from behind. That would mean that the subject being photographed is between your camera and the sun. Take a look at the lighthouse in Figure 8-9. The sun is directly behind the top of the lighthouse, which creates a bit of a halo effect. Try this technique when you want to create silhouettes of your travel scenes. This particular photo didn't become a silhouette mainly because the lighthouse is painted white. If the lighthouse was painted a darker color or black, the backlighting would in turn produce a silhouetted image.

Side light

Side light is fantastic for travel photography, as almost all objects lit by side light have a sense of three-dimensionality to them. When the sun is low in the sky and hits the left or right side of your subject there will be shadows cast on the darker side. This bright and dark combo creates a sense of visual depth that's very attractive. See Figure 8-10 for an example of side lighting.

FIGURE 8-9: Back light occurs when the subject is between the sun and your camera.

© MarkHemmings.com

FIGURE 8-10: Side lighting is often created by low sunlight that hits the right or left side of your subject matter.

© MarkHemmings.com

45-degree diagonal light

Diagonal light describes a light source, such as the sun, that hits the subject at an approximate 45-degree angle. Figure 8-11 illustrates how the sun and the fishing boat are perfectly angled such that the sun hits the other side of the boat at about a 45-degree angle.

© MarkHemmings.com

FIGURE 8-11: A visual example of how the sun hits the boat's other side at a 45-degree angle.

Figure 8-12 shows the same boat from the sunny side, and how the 45-degree angled light picks up the boat's textured rusting steel perfectly. Use diagonal light to show off the texture of rough or uneven surfaced objects.

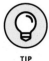

TIP

When travelling, you will most likely encounter 45-degree diagonal light early in the morning after sunrise or in the evening prior to sunset. If you encounter diagonal light on a series of buildings, such as the classic architecture shown in Figure 8-13, try to photograph into the sun instead of *with* the sun.

Check out the sketch in Figure 8-14 for a visual explanation, based on the same houses shown in my photo in Figure 8-13. When you photograph facades using these angles, you allow for a sense of visual depth. That great looking depth effect is lessened if you photograph in the same direction that the sun is shining.

© MarkHemmings.com

FIGURE 8-12:
Diagonal light
shows off the
surface texture
of your subject
matter.

© MarkHemmings.com

FIGURE 8-13:
When possible,
photograph
diagonally lit
scenes into the
sun instead of
with the sun.

FIGURE 8-14:
A diagram showing low sunlight shining on buildings at 45-degrees, and the photographer on the other side also angled at 45-degrees.

Blue and golden hour light

In Chapter 5, you discover how magic hour can be sub-divided into blue and golden hour. In travel photography, it's extra relevant to make use of these atmospheric lighting conditions, as your location's mood and feel will be radically altered simply by your time-of-day choices.

My family and I went for a weekend vacation to Grand Manan, a small but photogenic island on the east coast of Canada. We stayed in an off-grid B&B in a place called Dark Harbour that was only accessible at low tide! I thought this was unique, so I decided to capture the location many times through the day, especially with blue and golden hour light. Compare Figures 8-15 and 8-16. There's quite a dramatic shift in mood within a one hour time span isn't there?

TIP

When on vacation try and capture your surroundings in both types of magic hour light.

Lens flares from photographing into the setting sun

A lens flare is a blob of colored light that often shows up when you're photographing into the sun. Take a look at my covered bridge photo of Figure 8-17. The setting sun produces a lens flare that covers some of the bank and also covers a part of the river. If you find lens flares in your travel photos don't worry! There is nothing wrong with your Android camera. In fact, you can see lens flares as a type of artistic addition to your photographs.

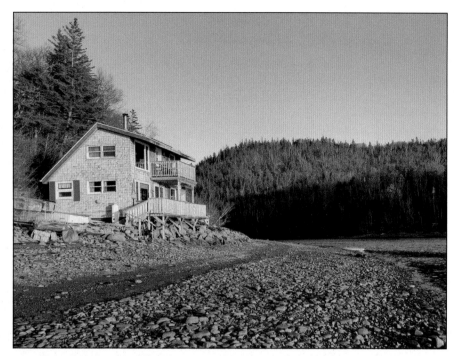

FIGURE 8-15:
An example of golden hour light 30 minutes prior to sunset.

© MarkHemmings.com

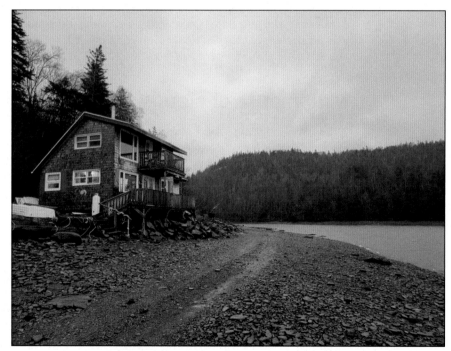

FIGURE 8-16:
An example of blue hour light 30 minutes after sunset.

© MarkHemmings.com

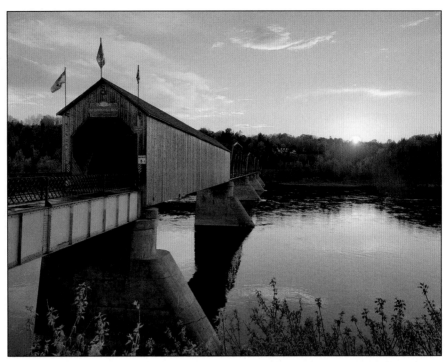

© MarkHemmings.com

FIGURE 8-17:
Lens flares usually show up when including the sun in your composition.

TIP

If, however, the lens flare is distracting and not artistic looking, wait a few minutes for the sun to get even closer to the horizon. This creates a different looking lens flare and also keeps the sun from becoming too white and blown out.

Making use of cloudy days

Figures 8-18 and 8-19 are almost identical Samsung S21 Ultra photos, but with one subtle difference. Take a look at the bottom third portion of the photos — the section that's all trees. I was able to capture two variations of this photo simply by waiting until the clouds shifted a bit. When you're photographing on days that flip between sun and cloud somewhat quickly, wait for a few minutes and get the same scene with different lighting. I often get fantastic versions of the same photo simply by waiting for 10 minutes until the light changes.

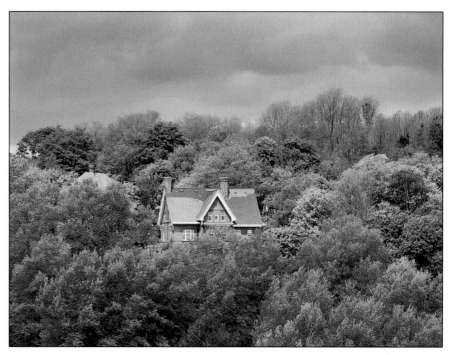

© MarkHemmings.com

FIGURE 8-18:
The clouds
blocked the
sunlight on the
lower trees
section.

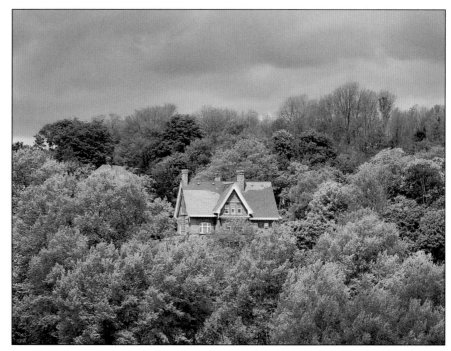

FIGURE 8-19:
A break in the
clouds allowed
for the lower
section of trees
to become
illuminated.

© MarkHemmings.com

Photography Tips for Your Next Trip

These sections include a series of tips used by top professional travel photographers. As you go through each tip and sample photo, keep a note of which techniques resonate with you and how you can implement them on your next trip.

Leaving space for text

Have you ever been asked to have your photo published in a community newspaper or magazine? Or maybe a graphic designer is working on a poster for a travel destination, and your photo fits the bill perfectly? I suggest that for each photo that you take while on your trip, you capture one or two more variations that includes plenty of empty space for graphic design text.

Take a look at Figures 8-20 and 8-21. After I captured a super-telephoto shot of the river ferries up close, I took these two additional photos (horizontally and vertically) with plenty of empty sky space for text. Now, if a tourism company wants to use my photo to promote the area, they have the choice of either horizontal or vertical format, plus a lot of space for the addition of text.

FIGURE 8-20:
A horizontal travel photo with plenty of empty space for graphic design text.

© MarkHemmings.com

© MarkHemmings.com

FIGURE 8-21: A vertical version of the photo, also with space for text.

Placing s-curves in your compositions

An *s-curve* is one of the oldest compositional techniques in the history of art. Think of a painting of a garden with a path winding through it, or a forest trail. These pathway scenes almost always have a curve to them, and rarely are straight-lined.

An s-curve is pleasing to the eye, and they're found often in nature and in urban environments. Figure 8-22 shows a city road scene where the road exhibits a curve that leads the viewer's eye throughout the picture space. Keep in mind that the curve doesn't need to be in the exact shape of the letter *S*.

An s-curve doesn't always need soft curves. Figure 8-23 shows a super-telephoto image of water current creating a sharp edge s-curve that leads the viewer's eye directly toward the old fishing shack.

When going out for a photo session on your next trip keep an eye open for s-curve designs, either naturally created or manufactured. Use these curves to help the viewer of your photo visually travel through the picture space.

FIGURE 8-22:
S-curves lead
your viewer's
eyes through
your photo.

© MarkHemmings.com

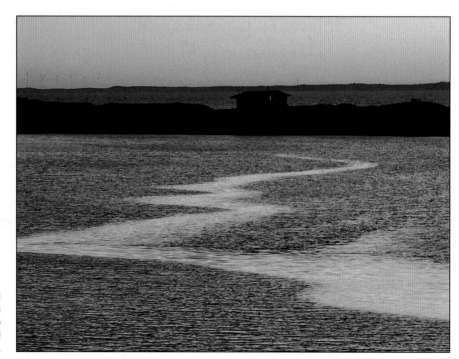

FIGURE 8-23:
S-curves can
have sharp
edges as well
as soft curves.

© MarkHemmings.com

Composing using geometric forms

The strategic use of geometric forms such as triangles, circles, rectangles, and squares can really add visual value to your compositions. Check out Figure 8-24, which shows my travel photo from a city called Moncton on the east coast of Canada. When I looked at this early morning scene, the first thing that came to mind was the rich collection of geometric forms such as triangles.

© MarkHemmings.com

FIGURE 8-24: A cityscape composition that is made of up of a lot of geometric shapes such as triangles.

To help with visualization, Figure 8-25 shows the same photo but with triangle overlays. Try to see geometric forms within your compositions, and place yourself in a position that best presents those shapes. It's a fun exercise, and you usually come up with better, stronger photos as a result!

Reviewing newly discovered businesses

Did you just enjoy the best sushi of your life while in Japan? Or maybe the sweetest baklava while in Greece? If you had a really positive experience at a local business while travelling, take a moment to give that establishment a positive review on Trip Advisor, Google, Facebook, Yelp, and any other review site. Local establishments can greatly benefit by your reviews, which allow them to provide for their families and continue to produce great products and services.

© MarkHemmings.com

FIGURE 8-25:
Triangles and
other angles
overlaid to
help visualize
how geometric
forms are
often a part of
photographic
compositions.

When travelling I seem to have a built-in radar that guides me to high quality cafes. That internal voice steered me to Newton's café (see Figure 8-26) while on a Grand Manan Island vacation. The barista made me a delicious cappuccino, so I was very happy to post a review describing my good experience.

Searching for faces

Here's a fun assignment for you. When travelling, give yourself a challenge to locate as many faces as possible, both in the natural and manufactured environment. I have a fun collection of faces from many of the countries I've photographed in during the past two decades. I saw this old fishing shack (see Figure 8-27), and was happy to have another face to add to my collection. Fun fact . . . the technical name for this type of photo is *visual anthropomorphism*. See how many times you can use that name within a year!

FIGURE 8-26:
Help local
establishments
by posting
reviews
when you're
travelling.

© MarkHemmings.com

FIGURE 8-27:
For fun,
consider
creating a
collection of
travel photos
that look like
faces.

© MarkHemmings.com

Chapter **9**

Creating Dynamic Still Life and Product Photography

S
till life photography encompasses a lot of genres, so many in fact that an entire book could be expanded from this chapter alone. Flower arrangements, crafts, products, and food photography can be considered still life. While it may be a stretch to consider interior and exterior architecture as still life, I've included a few architectural examples in this chapter in case you want to show off your interior design skills or want to get into real estate photography.

Camera Considerations: Creating Background Blur

A *still life* photograph is usually an inanimate object whereby the photographer aims to capture the object in an artistic manner. Still life photos are often created to be framed and presented at galleries or hanging on walls in people's homes.

Still life photos can also be used commercially. Think of a product photo, such as a handmade mug that a potter photographed for online sales purposes.

Still life and product photography doesn't really have any unique camera considerations that you need to know prior to capturing your first image. The main technique that you'll probably want to make use of, however, is choosing whether to add Portrait mode background blur to your image.

In Chapters 2 and 4 you discover how to use Portrait mode to create background blur. For this chapter, dealing with non-human objects, you can use Portrait mode to create a similar background blur behind your still life or product photo.

Figure 9-1 shows an outdoor photo of one of my Darren Emenau mugs. While trees are usually a nice background for products and still life photos, this background feels uninspired.

© MarkHemmings.com

FIGURE 9-1:
A decent product photo, but the background isn't the best.

Figure 9-2 shows the same scene but with Portrait mode turned on. Because the background is now blurred, the trees look far better and the mug really stands out.

© MarkHemmings.com

FIGURE 9-2:
Portrait mode blurs the background and visually accentuates the subject.

TIP

There's another way to get background blur if your Android has a telephoto or super-telephoto lens. Choose the most telephoto lens you have and get as close to your still life subject as possible. The photo in Figure 9-3 has a slight background blur, but this time the blur is not from Portrait mode. When you use a telephoto lens and get close to your subject, the background shows a moderate amount of background blur.

FIGURE 9-3:
Background
blur by using
a super-
telephoto lens
and by getting
close to the still
life subject.

© MarkHemmings.com

Gear Considerations

Still life and product photography can be done cheaply. Backgrounds are easy to find, and the only thing you may want to invest in is a tabletop tripod. This section explains both background selection and tripod options to help you get the best possible still life photographs.

Choosing the background for your product

When creating still life photos for either artistic or commercial purposes, always ask yourself if your choice of background complements your subject. Take a look at Figure 9-4. I wanted to photograph a bar of soap from my friends at Catapult Creative, so I simply looked around my house for a background that inspired me. I found that background in the form of the welcome mat on my front porch!

REMEMBER

Backgrounds can be anywhere, and all you need to do is ask yourself whether the background visually competes with or complements the subject.

The next step is to make sure that your product has decent natural light hitting it, and then take the photo (see Figure 9-5). It's that simple!

FIGURE 9-4: Look for backgrounds that are visually compelling but don't distract from or visually compete with the subject.

© MarkHemmings.com

FIGURE 9-5: Position your product for the best looking natural light.

© MarkHemmings.com

Using tabletop tripods

I walk around with a tabletop tripod every single day. If I'm in a dimly lit interior or it's dark outside, I want to get the sharpest photo possible. The reason I can walk around with a tripod at all times is because I choose very small tripods for my smaller still life or product photos.

Figure 9-6 shows my tabletop tripod in action photographing a family card game at a café. As you can see, the legs of the tripod are not even as wide as my smaller sized Motorola phone.

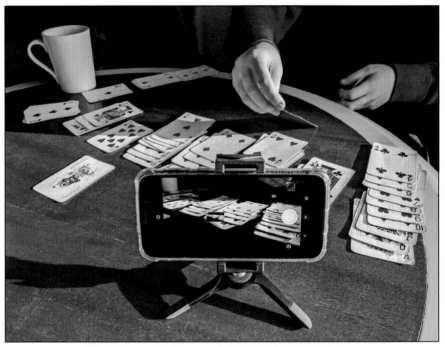

FIGURE 9-6:
A tabletop tripod supporting an Android phone for sharp still life photos.

© MarkHemmings.com

Figure 9-7 shows what the tripod looks like with the phone detached.

Figure 9-8 shows what the tripod looks like folded up, small enough for your pocket.

This tripod is made by a company called Joby (`https://joby.com`), which is well known for its mobile device tripods. As there are countless sizes and options for small tripods, you won't have a problem locating the perfect option for you.

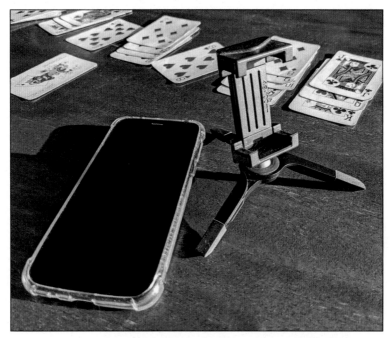

© MarkHemmings.com

FIGURE 9-7:
The small size
of the tabletop
tripod.

FIGURE 9-8:
The tabletop
tripod
folded up.

© MarkHemmings.com

Lighting Considerations

Product and still life photos rely heavily on artistic lighting, which is what this section is all about. Think of artistic lighting as a way to illuminate your still life subject in a way that goes far beyond a normal camera flash illumination. Your goal is to create artwork that is worthy of framing and hanging on your wall!

Using raking light for products

I was asked to photograph the stitching artistry of the cowboy boots shown in Figure 9-9. The boots themselves didn't need to be photographed, just the fine stitching. So, I looked around my house for a window that had sunlight streaming in, and positioned the boot so that the light was hitting the stitching at a very slight angle. This angle is called *raking light*, where the sun rakes, so to speak, along the surface of the subject.

FIGURE 9-9:
Cowboy boots positioned for slight-angled raking light coming from a window.

© MarkHemmings.com

Figure 9-10 shows the close-up photo that I took with my Google Pixel 4a. Because the sunlight is at such a slight angle to the surface of the stitching, the stitches have a three-dimensional quality that would be lost with any other type

of lighting. Also notice the fine texture of the leather, which also would be hard to appreciate without raking light.

© MarkHemmings.com

FIGURE 9-10: The close-up photo of the stitching, accentuated by raking light.

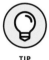

TIP

Your Android camera can often get better close-up results than your larger DSLR camera. DSLR and mirrorless cameras have a harder time getting macro close-up shots such as the one in Figure 9-10 unless you have special macro close-up gear.

Positioning for sunset light rays

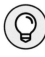

TIP

If you're interested in the most dramatic frontal light, I suggest placing your still life object within direct sunlight. But it can't be any type of sunlight! The best conditions arise when the sun is low in the sky and streams into one of your windows.

I bought these flowers for my wife and thought the colors would make a great photo to send to her. So, I looked around my house for a window that had early evening sunlight streaming in and placed the vase within the ray of light. (See Figure 9-11.) Notice how the rest of the room is dark, which doesn't matter because I only wanted to capture close-ups of the flowers, not the entire vase. Also notice the shadow of my hand holding my Google Pixel 4a!

© MarkHemmings.com

FIGURE 9-11:
For dramatic front lighting, place flower arrangements in a ray of light shining through a window.

Figure 9-12 shows the result of my close-up shot of the flowers. Even though front lighting is often not as dramatic looking as other types of light, I still have some shadow depth because I wasn't completely photographing the flowers straight on. Rotate your vase slightly to get the best-looking flowers, and then take the picture.

Another example of using the same type of light, but this time switching to side lighting, is for food and drink still life photos. (See Figure 9-13.) My family and I were in a café called Honeybeans in St. Andrews, Canada. My wife ordered a Valentines inspired heart candy latte that I thought would make a great food product photograph. Side lighting for your food photography works perfectly, and all you need to do is wait for a cloudless morning or evening, look for the window with the best light, and arrange your food styling so that you have an uncluttered background.

Side lighting also works wonderfully for larger products such as the cardboard cut-out deer head shown in Figure 9-14. Regardless of what your product or still life is, or what size it is, you can make use of window light and low sun to get professional level photographic results.

FIGURE 9-12: The photographic result of front lighting by placing the flowers within window sun rays.

© MarkHemmings.com

FIGURE 9-13: Side lighting through a window is perfect for food product photography.

© MarkHemmings.com

© MarkHemmings.com

FIGURE 9-14: Side lighting through windows works for almost any product or still life, regardless of product size.

My last example is to show off dramatic window lighting that you can control. Figure 9-15 shows the stunning design work of a Mexican pillow that we brought home from our last photo workshop held in the city of San Miguel de Allende. I wanted to photograph the pillow's design with dramatic light, so I placed it near a window, but then added shadows to the left and right side of the pillow. This shadow creation accentuates the middle of the pillow and is easily done by blocking the left and right side of your window with any dark colored material. If you angle the material that's blocking parts of your window, you can force the light to fall on your product any way that you like.

Exterior architecture photography

Exterior architecture photos of buildings are best done before sunrise and after sunset. Make sure you turn on all the lights on the inside of the building, which will balance perfectly with the ambient evening light coming from the sky. Figure 9-16 shows my Google Pixel photo of the *On The Boardwalk* restaurant at dusk. The sky and the electric lights have the same luminosity (level of brightness), which is perfect for exterior building photographs. Use this tip if you ever need to sell your house, as real estate photos need to quickly catch potential buyer's eyes.

© MarkHemmings.com

FIGURE 9-15: Product photography with shaped light due to blocking parts of the window.

© MarkHemmings.com

FIGURE 9-16: Photograph building exteriors at dawn or dusk when the interior and exterior light has equivalent brightness.

Interior architecture photography

If you can quickly run back inside the building you're photographing after you capture the exterior, you can get the same lighting effect for your interior photos. Figure 9-17 shows the interior of the same restaurant shown in Figure 9-16, and my job was to photograph the interior design work by Acre Architects. With my Samsung S21 Ultra and using a tripod, I was able to balance the light brightness levels of both the outside and the inside using dusk light and interior electric lights. You can do the same!

FIGURE 9-17: An interior scene that has a perfect light brightness balance between the outside and the inside.

© MarkHemmings.com

Creating Beautiful Still Life Photos

In this next section I have a few remaining tips and tricks to help you with neatening up your still life, food, and product photos.

Positioning your background for equidistance

Placing still life objects such as flower arrangements in front of doorways and windows is a fantastic idea. The only tricky part is making sure that your symmetrical background has *equidistance* on both sides of the door or window frame. Figure 9-18 shows a flower arrangement in front of a door, and you can see with my arrows that the left and right sides of the door frame have an identical distance. In other words, make sure your door or window is perfectly centered within your composition.

FIGURE 9-18: Position your background such that the door or window is perfectly centered.

© Adrienne Hemmings

Photographing through a window

There are many times that you want to photograph a still life scene outside your window, which is what I wanted to capture with the beautiful snowy landscape shown in Figure 9-19. To successfully photograph through a window, make sure that the interior room lights are turned off, and gently place your Android camera lens so that it's touching the windowpane. The closer your lens is to the windowpane, the less chance reflections ruin your still life photograph.

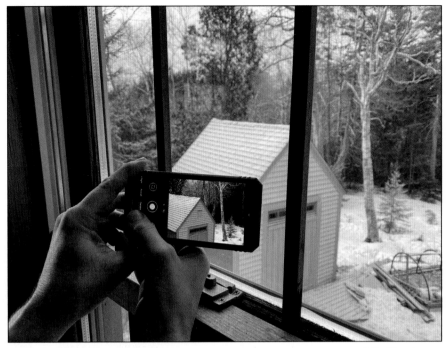

© MarkHemmings.com

Photographing food

Each time I travel to Japan to teach photo workshops I fill up on ramen, my favorite Japanese food. I have a nice still life ramen food photography collection now! When not in Japan, I enjoy Tokai Ramen where I live on the East Coast of Canada. When photographing my favorite foods, either commercially or for my own creative outlet, I photograph from an aerial (overhead) perspective as in Figure 9-20. Another effective way to show off the plated food in the best possible light is from a 45-degree angle, shooting in a slightly downward direction. The advantage to a 45-degree angle food shot is that you can also display the beautiful plate or bowl.

FIGURE 9-19: Touch your camera lens to the windowpane glass to avoid window reflections.

© MarkHemmings.com

FIGURE 9-20: Photograph plated food from an aerial perspective.

Chapter **10**

Taking It to the Streets: Photographing Strangers

S hould you photograph that person walking down the street without their permission? Or would that infringe on their privacy? Photographing strangers in urban environments is a controversial topic, as issues such as privacy and consent are legitimate factors that should shape your decision-making process.

I deal with these ethical questions in this chapter, as well as offer tips and techniques for creating the best possible street photos using the most unobtrusive means possible.

Camera Considerations: Choosing Lenses and Locations

Street photographers tend to maintain self-imposed limitations on their art form. Some refuse to use any lens except a wide-angle, others use any lens but refuse to do any alterations to their photos afterwards. My suggestion is that you don't place any street photography constraints on yourself until you get very comfortable with the genre. In this section, you discover camera lens options and camera placement for ideal street photographs on your own terms.

Choosing your lens

In the world of street photography, you may encounter purists who maintain that a wide-angle lens should be the only lens used when photographing on the streets. Figure 10-1 shows a wide-angle view of a teenager battling the wind and rain on a backstreet. Because a wide-angle lens was used for this shot, the viewer can appreciate the urban environment as well as how the subject interacts with her surroundings. Don't worry about power lines, phone cables, or garbage cans in your composition. Urban street photography is meant to be messy!

FIGURE 10-1: A wide-angle lens allows the viewer to appreciate both the subject and the urban environment.

© MarkHemmings.com

A zoomed-in telephoto lens choice, as shown in Figure 10-2, may be a better choice when you're starting out and don't feel comfortable getting close to strangers.

© MarkHemmings.com

FIGURE 10-2: Choosing a telephoto lens instead of a wide-angle lens is often helpful if you're concerned about being too invasive.

While I usually limit myself to a wide-angle lens for my street photography, I have also experimented with telephoto and super-telephoto street photography while writing this book. Because of limited pages available in this chapter to show examples of street photography using all available lenses, I've uploaded a lot of examples for you to compare on my Instagram profile at www.instagram. com/markhemmings. Notice how wide-angle street photos allow an appreciation of the urban scene, whereas telephoto angles visually push the viewer's attention straight to the main subject.

Selecting your location

Street photographers find great success in first finding a cool looking location, and then waiting for people to walk into their frame. Figure 10-3 shows Canadian street photographer Adam Bunce helping me illustrate this technique.

© MarkHemmings.com

FIGURE 10-3: Position yourself angled toward a dynamic background.

1. **Locate a visually dynamic background.**

 See Figure 10-3 that shows Adam positioned for a potential street photo at Rogue Coffee Co.

2. **Do a test shot without people, just to see if you like the composition.**

3. **Spend the time to capture people walking past you. Start photographing as they enter your camera's frame and continue until they exit your frame.**

 Figure 10-4 shows me walking past Adam's camera. He kept on photographing until he felt he had enough shots to choose from. If you prefer to use Burst mode to capture the person walking past, Chapter 6 explains how to activate Burst mode.

4. **After reviewing all the photos, select your favorite(s).**

 Adam and I thought that the image in Figure 10-5 would be the choice for inclusion in this chapter, as the placement of the peace sign and my face is somewhat funny.

FIGURE 10-4: Take a lot of photos of people passing by so you have multiple options to choose from.

FIGURE 10-5:
Our chosen
photo based
on the neon
sign, selected
from a
collection of
ten street
photos.

Photo by Adam Bunce

REMEMBER

Street photography is an art form that is unplanned and unstaged. The value of street photography as an unstaged photography genre is the wildly diverse types of unique images you can capture. There will never again in the history of the world be the same street photo taken than the one you just took!

Gear Considerations

When it comes to extra gear purchasing needs, street photography is notoriously inexpensive. In fact, the less gear you have, the better, as the last thing you want while creating urban street scenes is to lug around a heavy bag. Keep it small and light!

My favorite piece of street photography gear is from a company called Wotancraft (`www.wotancraft.tw`), makers of the finest camera and lifestyle bags. I constantly use Wotancraft's nylon canvas sling pouch when photographing. Figure 10-6 shows the relative size of their 3.5 liter bag that I use as a sling pouch. I sometimes use it as a waist pack as well, but I prefer the bag in a slung position.

FIGURE 10-6:
The Wotancraft
nylon canvas
waist pack/
sling pouch,
perfect
for street
photography
gear.

© Don Hemmings

Here's a collection of gear I bring with me when I plan to shoot street photography (shown in Figure 10-7) from left to right:

>> I always pack a lens cleaning cloth. Smartphone lenses usually don't have lens covers, which means they get dusty and dirty quickly.

>> My Wotancraft nylon canvas waist pack/sling pouch.

>> Android smartphone.

>> Two tabletop tripod pieces that attach together. Street photographers rarely use tripods, but I pack one just in case I'm in a café or similarly dark environment and feel that I would like to get a few interior shots. If I know that I won't be stopping anywhere indoors for a break, I will most likely leave the tripod at home.

>> I don't like having my keys, wallet, and wireless earbuds in my pants pocket, so I throw them in my sling pouch as well.

>> A wall socket adaptor with a USB-C power cable, plus a battery pack. If I am only out for a one or two hour street photography session, I probably wouldn't need these power options. However, as I sometimes shoot video, I pack these power supplies if I have a long street photography shoot day planned. I power up my Android when I take a break at a local café.

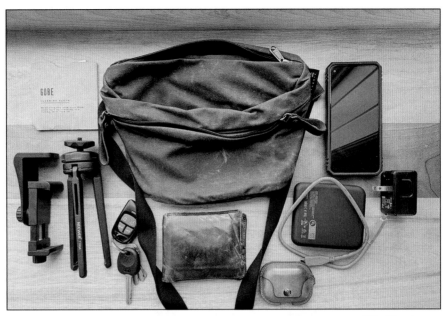

© MarkHemmings.com

FIGURE 10-7:
A collection
of street
photography
related gear.

Lighting Considerations

Street photography is less about gear and more about light. This section helps you master the harsh, direct light that falls into urban spaces. Harsh light usually isn't desirable for most photographic genres but is highly prized by street photographers. Follow these steps to create dramatic harsh–light street photos:

1. **Find a street scene with an alleyway that has direct angled sunlight shooting through onto the sidewalk. Take a test photo to make sure you like the overall composition.**

 Figure 10-8 shows an example of a harsh light ray hitting the sidewalk, and also a visually interesting background.

2. **In your camera settings make sure that Auto HDR is turned off. If your camera has Scene optimizer, turn that off as well.**

 See Figure 10-9 for camera settings typical of many Samsung devices. If neither of those options are listed within your camera settings, don't worry about it; just skip this step. The reason you want to turn off HDR is to increase the contrast of your photo. HDR decreases the contrast, which is great for most applications but not for high contrast harsh-light street photography.

FIGURE 10-8:
Look for an
alleyway with
direct angled
sunlight
shining onto
the sidewalk,
and then take
a test photo.

© MarkHemmings.com

3. **Recompose your scene so it's exactly the way you want it, as in Figure 10-10.**

4. **Reduce the exposure by long-pressing anywhere on your screen, and then scroll your exposure adjustment slider to make your photo darker.**

 If you see a padlock icon as in Figure 10-11 you know that each subsequent photo that you take will maintain the exact same exposure. The reason you want the photo darker is to make sure that the person's face is exposed properly. In addition, a darker background will have a more artistic feel.

5. **When you see a person walking toward you, start photographing using Burst mode. Keep using Burst mode until the person passes the light ray and reenters the shadow area.**

 Burst mode is introduced in Chapter 6 if you need a reminder on how to create many continuous photos within a quick time frame.

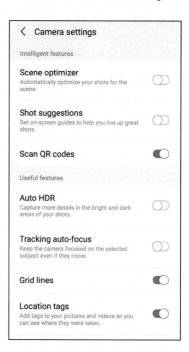

FIGURE 10-9:
If available on your Android, turn off
Auto HDR within camera settings.

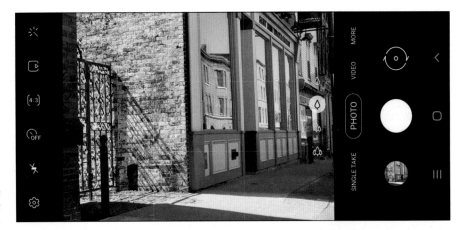

FIGURE 10-10:
Recompose
your scene.

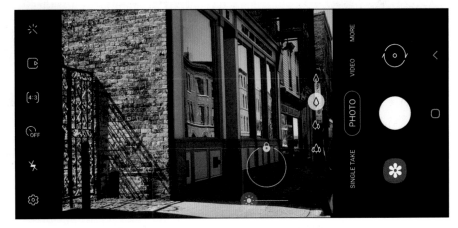

FIGURE 10-11:
Reduce the
exposure by
pressing the
screen and
then adjusting
the exposure
slider.

6. **Within the Google Photos app scroll through your burst photos and choose your favorite.**

 Your choice should be based on how the light hits your subject, and how their stride looks. Figure 10-12 shows my favorite photo out of the 27 photos that I took.

7. **Tap the Burst icon. Then choose Keep This Photo Only if you don't care to keep the other burst photo images. Choose Set As Main Photo if you don't want all the other photos to be deleted.**

 After you select your chosen Burst mode photo your final image appears, and hopefully you love the results! Figure 10-13 shows the choice that I made where the man is exposed perfectly and shows a purposeful stride.

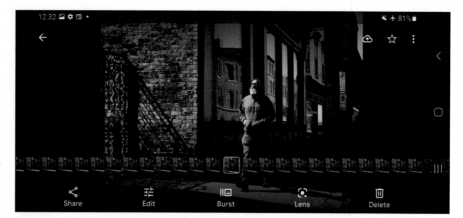

FIGURE 10-12:
Within the
Google Photos
app select
your favorite
photo out of
the many burst
photos that
you took.

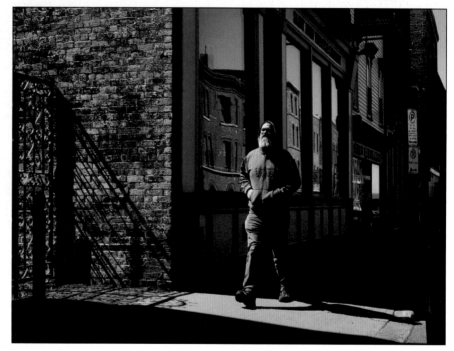

© MarkHemmings.com

FIGURE 10-13:
The final photo
after the Burst
mode selection
process.

Street photographs also look great in black and white (see Figure 10-14). Chapter 11 explains a few different ways you can convert your color photos to black and white, as well as cropping unwanted sections of a photo along any of the four edges.

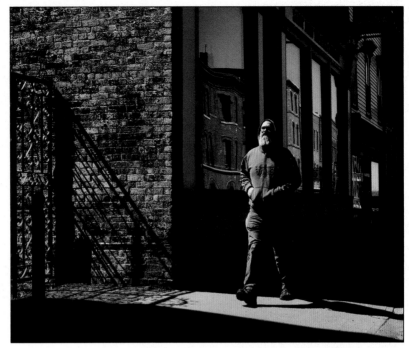

© MarkHemmings.com

FIGURE 10-14:
The chosen
street photo
converted
to black
and white,
a traditional
street
photography
appearance.

REMEMBER

If you can, show the person the photo and ask their permission to post it. This decision should be based on the ethical factors explained at the end of this chapter. Interestingly, this street photo that I took was of a friend of mine! After I reviewed the shot, I looked closely at the person's face and realized who it was, but he was gone around the corner by that point. So, I texted him the photo and asked him whether I could post the photo on my Instagram page. I suggest coming up with your own set of ethical parameters for posting photos of strangers, and how you will deal with asking or not asking permission for sharing your images publicly.

Tips for Your Next Street Photography Session

As with most photography genres, street photography has well-established best practices. This section contains some tips, techniques, and also the philosophy or ethical parameters of photographing people you don't know.

Using arrows for conceptual street photography

Have you ever noticed how many arrows are painted on streets or show up on street signs? They're everywhere! Street photographers often use arrows to create conceptual, narrative-based images that rely on metaphor and story-telling. I took the street photo in Figure 10-15 on a foggy early spring morning making use of an arrow. Why is the man going in the opposite direction of the arrow, toward the angel statue memorial? Can a story be told based on the visual elements of this photograph? Whenever possible, create your street photos so that your viewers can create their own narrative.

FIGURE 10-15: Use arrows in your compositions to add narrative and story-telling elements to your photos.

© MarkHemmings.com

Considering the flow of your composition

Henri Cartier-Bresson is generally regarded as the pioneer of street photography. He would often compose his street photos so that the main subject interacted with the surroundings with a sense of *flow*, or movement. Do a Google search for "Bresson Hyères, France," and you can find one of his many famous street photos of a cyclist along a curved street. Figure 10-16 shows my example that illustrates a similar curved visual flow.

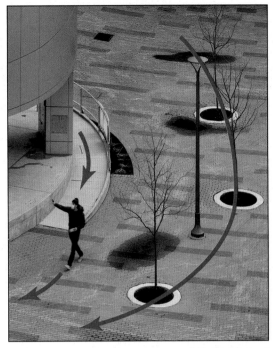

© MarkHemmings.com

FIGURE 10-16: When possible, compose so that your subject travels through the picture space with a sense of curved *flow*, or movement.

Converting your composition to black and white

My street photo shown in Figure 10-16 has many aspects that I'm not thrilled with, such as the water marks, the puddles, and the uninspired lighting. When I create less than stellar street photos, I often convert them to black and white, which reduces some of the distractions. Figure 10-17 shows a simple black-and-white conversion that I feel makes the street photo a bit more visually appealing. You can do the same with your current collection of photos with the Google Photos app! (See Chapter 11 for black-and-white conversion strategies.)

Choosing design-based backgrounds

Late model Android devices with telephoto and super-telephoto lenses can really zoom in to your subject, which is great for aerial street photography. I took the photo shown in Figure 10-18 from my hotel room window looking down on an intersection. I composed the photo so that the crosswalk and the stop line formed a strong triangle, and the man's shadow would be included in the image. I also like how he is engaged in something, which resulted in him pointing a finger. Why is he pointing? Who knows! That's the beauty of street photography's story-telling aspects.

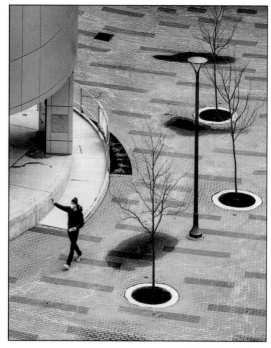

FIGURE 10-17: Convert your color street photo to black and white if the lighting is flat and boring.

© MarkHemmings.com

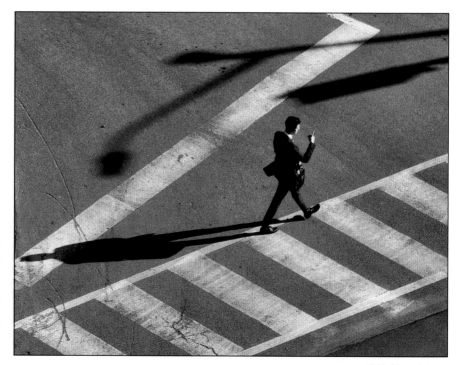

FIGURE 10-18: Look for design-based backgrounds for street photography, making use of triangles for example.

© MarkHemmings.com

Appreciating the mundane

Street photography is somewhat polarizing, where one viewer absolutely loves a mundane street scene, and another dismisses it as a simple snapshot. Figure 10-19 shows a street scene in my home city. The two roofers are taking a break from their tar work, and a cyclist rides by looking through a window. While there may not be a strong narrative element to this photo, there is certainly a historical record aspect to this image that will be appreciated decades and possibly centuries in the future. The street photographer takes the mundane and creates a historical record that is quite valuable culturally speaking.

FIGURE 10-19: Capture mundane scenes, expecting them to have cultural and eventually historical value.

© MarkHemmings.com

Maintaining anonymity using scale and shadows

If you're concerned about being obtrusive when photographing strangers, simply shift your focus to playing with shadows, silhouettes, and scale. I took the photos shown in Figure 10-20 knowing that the person walking would be a silhouette, and not illuminated by the sun. I composed so that he would be small in the photo to show a sense of large scale, and I waited until he walked between the windows to take the shot. Privacy is protected, and the overall photo shows off the scale of my home city's streets very well.

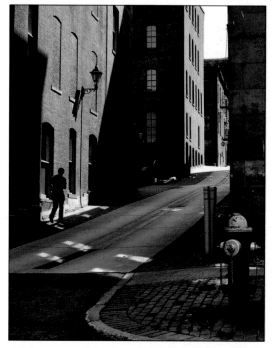

FIGURE 10-20:
Plan your compositions so that the subject is in shadow and use a wide-angle lens to show a sense of scale.

© MarkHemmings.com

Being sensitive to people's privacy

What follows is a non-exhaustive list of parameters or considerations that hopefully helps you in deciding what is appropriate for street photography and what you may be best to walk away from:

» Know the local laws before you start photographing. Does the country or municipality that you're photographing in legally allow for street photography? If not, can you photograph people but just not show recognizable features?

» When you're photographing people within their urban environment, are you conscious of not making them look foolish or embarrassing? Unless you're a photojournalist who is covering a specific story, it's best to show people in either a neutral or empowering light.

» Street photography is almost always unplanned, so it's rare that you'd ask someone's permission and then take the photo. But always try to show the person the photo that you just took after the fact, and delete it if they're uncomfortable with the shot.

» When you're in cities that have strong political or religious views, always do your research to understand what the ethical parameters should be for photographing people on the streets. You should do this even if the country has no laws against street photography.

» Street musicians and buskers deserve tips, so if you photograph anyone offering music or are performing, show them some appreciation by offering them a donation.

» If you're planning to photograph within a conflict zone, you'll probably be working within photojournalistic parameters rather than street photography parameters. *Photojournalism* is a different photographic genre than street photography and has very different industry-specific rules and norms. Photojournalism is not within the scope of this book, but it's a worthwhile genre for you to study. A photojournalist is a photographer who has training in journalistic writing, and their photos usually support a written piece of news destined for publishing in print or web.

3

Editing, Organizing, and Sharing Your Photos

IN THIS CHAPTER

» **Using the Google Photos app editing tools**

» **Applying filters**

» **Cropping a photo**

» **Editing your photography**

» **Editing your Portrait photos**

Chapter **11**

Editing with the Google Photos App

While it's true that some Android manufacturers offer their own photo editing tools, the Google Photos app is the one I use for this book, as Google Photos is available to everyone — even if you have Apple products. You can take a photo on your Android smartphone and then edit it on your iPad or Mac, or even a family member's iPhone, if you so desire.

REMEMBER

An interesting thing happened to me while writing this chapter. I had the chapter pretty much written when a request popped up on my Google Pixel 4a as a reminder to update to a newer version of Android 11. Suddenly I had a few new photo editing tools at my disposal! Even though I had to do some rewriting, I was happy that I could add some extra value to this photo editing chapter. So, keep in mind that by the time this book is published, Google may have added even more editing tools that I haven't included. If that is the case, you have even more ways to express your creativity.

Using the Google Photos App Editing Tools

It's time to edit your incredible photos! In Chapter 1 you discover how to open your Google Photos app and the editing section of the app. When you tap the little icon that has three horizontal slider adjustment bars, you're ready to jazz up your images.

The Google Photos app offers a bunch of filters to enhance your photos. If you're not logged into your Google account, you have access to only the Dynamic, Enhance, Cool, and Warm filters, which I discuss how to use in this section. (Turn to Chapter 2 if you need to log in.) If you're logged into your Google account, you have access to other filters (for example, Vivid, West, Palma, Metro, and Eiffel), which I cover in the "Applying Filters" section.

REMEMBER

All filters essentially work the same way. Play around and see what you like. Just remember to save your original (see the "Choosing between Save and Save as Copy" section) so you can always go back to it.

Choosing a filter

The Google Photos app offers four different primary filters to enhance your photos. (In fact, Chapter 1 introduces the Enhance auto adjustment filter.) Tap Suggestions at the bottom of the app to access them. In addition to the Enhance option, there are also these three filters:

» **Dynamic** enhances your photo with brighter, bolder colors plus added contrast.

» **Warm** removes some blueish color from your photo and often produces a peaceful feeling.

» **Cool** adds blueish color to your photo that often adds a sense of drama.

Figure 11-1 shows how all three of these filters enhance your photos.

Saving changes

REMEMBER

Depending on which filter you choose, you either have the option to Save or Save Copy (see Figure 11-2). Some filters only allow you to save a copy, while other filters give you the Save option.

Dynamic	Warm	Cool

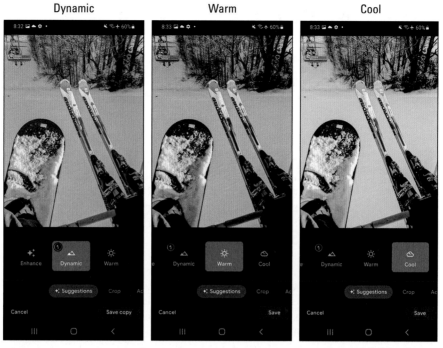

© MarkHemmings.com

FIGURE 11-1:
Three of the
primary filters
the Google
Photos app
offers.

FIGURE 11-2:
Some filters
allow for the
Save option,
while others
have a Save
Copy option.

If your filter only offers the copy option (or you choose to copy), you see the duplicated photo with the filter applied next to the original photo, as shown in Figure 11-3.

If you choose to save only, tap Save, and the Google Photos app again asks whether you want to save or copy. With Save, the filter is applied to your original photo; with Save as Copy, the filter is applied to a copy of the original.

TECHNICAL STUFF

The technical name for the Save option is called *non-destructive editing*, which means that the editing applied to the original photo is completely reversible if desired.

Choosing between Save and Save as Copy

REMEMBER

It's very difficult to forecast which photo filters allow you to apply a filter to an original photo or only to a copy. It may seem hit or miss where one photo on your Google Pixel allows for a save, but that same photo on your Samsung Galaxy Tab forces you to save as a copy. My advice is to roll with whatever option suits you best. And when you're given no option, an edited copy of your photo is created, which can be a type of safety net. Take a look at Table 11-1 for a pros and cons comparison of the two saving options.

© MarkHemmings.com

FIGURE 11-3:
The copied snowboard and ski photo has more saturated colors because of the Dynamic filter.

TABLE 11-1 **Pros and Cons of Save or Save as Copy**

	Pros	Cons
Save	Editing is applied to the original photo. Takes less space. If your photos stays with the Google Photos app, you can always revert to the original, non-filtered state.	The ability to revert to the original is only possible if you keep your photos with the Google Photos app. If you export your photo to another photo app or social media platform, and delete the original photo, you only have the filtered photo.
Save as Copy	The ability to make changes in a non-Google photo app or social media platform because the original is safe. Make multiple copies with as many edits and filters as you like.	The edited copy takes up additional space, which counts against your Google Cloud allotment of 15GB.

Applying Filters

To add a sense of drama and artistry to your photo, try using Google's excellent filter collection. A filter is a mixture of color and tonal adjustments created by software and app developers to help enhance the look of your photos. When you apply a filter, you see an immediate change to your photo.

REMEMBER

You need to be logged into your Google account to access these filters.

Follow these simple steps to apply a filter to your chosen photo:

1. **Tap the Edit icon located at the bottom of the screen.**

2. **Choose Filters, which is to the right of Crop and Adjust, shown at the bottom of Figure 11-4.**

 By default, you have no filter added, as in the None check mark in Figure 11-4.

3. **Tap the filter of your choice.**

REMEMBER

 When you choose one of the filters, you can further fine-tune the look of your filtered photo by using the tools described later in this chapter in the "Editing Your Photography" section.

4. **Tap Save or Save Copy.**

© MarkHemmings.com

FIGURE 11-4:
Choose Filters as soon as you're within the Edit section.

Vivid

The Vivid filter boosts color vibrancy but without looking unrealistic. Too much color vibrancy tends to look ridiculous if you have people in the photo, which is why this filter is designed to stay within reality, yet with saturated colors. Figure 11-5 shows an example of what the Vivid filter looks like. Use this filter for extra color punch when humans are within the photo.

West

The West filter increases shadow brightness for a flat look, while adding a touch of blue to the photo. This look is popular with some styles of wedding and fashion photography. Figure 11-6 shows an example of what the West filter looks like.

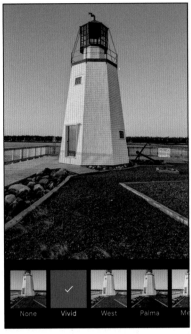

© MarkHemmings.com

FIGURE 11-5:
The Vivid filter with its extra (but realistic) color vibrancy.

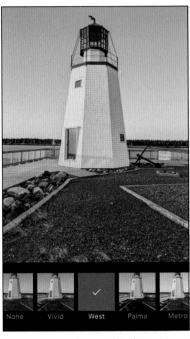

© MarkHemmings.com

FIGURE 11-6:
The West filter with its brightened shadows and slight blueish tone.

Palma

The Palma filter adds a bit of warmth to your photo for a more cheerful appearance. Contrast is slightly increased as well, which makes the photo feel a bit more punchy. Figure 11-7 shows an example of what the Palma filter looks like.

REMEMBER

If you're unfamiliar with the term *increased contrast* or *high contrast*, it refers to the shadow areas becoming darker and the brighter areas becoming brighter. The reverse is true for *low-contrast* photo editing.

Metro

The Metro filter is similar to the previously mentioned West filter but with a slight blue color cast. Figure 11-8 shows an example of what the Metro filter looks like. Fashion photographers tend to use this look frequently.

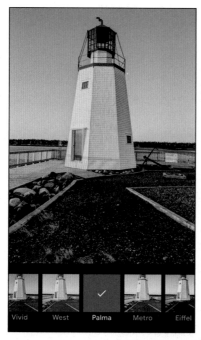

© MarkHemmings.com

FIGURE 11-7:
The Palma filter adds a bit of contrast and warm tones to your photo.

© MarkHemmings.com

FIGURE 11-8:
The Metro filter with its blueish color tone.

Eiffel

The Eiffel filter is a medium contrast black and white filter. Use this option for a general all-purpose filter to black and white conversion. Figure 11-9 shows an example of what the Eiffel filter looks like.

Blush

The Blush filter adds a slight pinkish hue to your photo. The slight addition of pink shows up the most in the lighter sections of your photo, such as the white paint of the lighthouse. Figure 11-10 shows an example of what the Blush filter looks like, and is useful for energetic, youthful type photographs of people.

© MarkHemmings.com

FIGURE 11-9:
The Eiffel filter with its all-purpose medium contrast black and white conversion.

© MarkHemmings.com

FIGURE 11-10:
The Blush filter with its slight pinkish hue.

Modena

The Modena filter is a *matte* filter. A matte filter radically increases the *luminosity* (the adding of brightness) of a photo's shadow and dark areas. In addition to boosted shadows, the filter also reduces visible detail in the shadow areas to provide for a fine-art color image. This filter is very popular with wedding, lifestyle, landscape, stock photography, and on-location family portraiture. Figure 11-11 shows an example of what the Modena filter looks like.

Reel

The Reel filter radically increases contrast and the saturation of colors. While it may be a bit too over-the-top for most situations, use this filter when your photo seems a bit dull. Reel gives your photo the double-espresso caffeinated boost that it needs! Figure 11-12 shows an example of what the Reel filter looks like.

© MarkHemmings.com

FIGURE 11-11:
Modena is a matte filter, where shadow areas are brightened with visible detail reduced.

© MarkHemmings.com

FIGURE 11-12:
The Reel filter boosts both contrast and color saturation.

Vogue

The Vogue filter is the least contrasty black and white filter. (The Eiffel black and white filter, shown earlier in Figure 11-9, is moderately contrasty.) The Vogue filter is great for black-and-white portraiture as the contrast is low. A lower contrast black and white is very forgiving for portraits and shows off a person's face in the best light. Figure 11-13 shows an example of what the Vogue filter looks like on the lighthouse; however, it really shines when used for portraiture.

Ollie

The Ollie matte filter is almost identical to the Modena matte filter of Figure 11-11. The only real difference is that Ollie adds a cooler blueish color cast for added drama. Figure 11-14 shows an example of what the Ollie filter looks like.

© MarkHemmings.com

© MarkHemmings.com

FIGURE 11-13:
The Vogue filter is a lower-contrast black-and-white filter great for portraiture.

FIGURE 11-14:
The Ollie filter is a cool blueish toned matte filter.

Bazaar

The Bazaar filter has high intensity color saturation, but not as much radical contrast levels as the Reel filter. (Refer to Figure 11-12.) Figure 11-15 shows an example of what the Bazaar filter looks like. Because of its slightly higher than average contrast levels and jacked-up color saturation, this filter would look great for landscape photography!

Alpaca

The Alpaca filter is a slight matte filter with a bit of added cyan and a touch of green in the shadow areas. Figure 11-16 shows an example of what the Alpaca filter looks like. Because this filter is not realistic, you would use this for more artsy style images.

© MarkHemmings.com

© MarkHemmings.com

FIGURE 11-15:
The Bazaar filter has very high color saturation with a slight addition of contrast.

FIGURE 11-16:
The Alpaca filter has a very slight matte look, plus a bit of cyan and green added to the shadow areas.

Vista

The Vista filter is the highest contrast black and white filter. Google Photos currently has three black and white filters, and this high contrast version is perfect for fine art photography, street photography, and fashion photography. Figure 11-17 shows an example of what the Vista filter looks like with its deep and dark shadow areas, plus bright highlight areas.

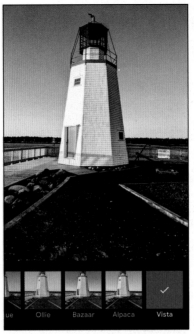

© MarkHemmings.com

FIGURE 11-17:
The Vista filter is the highest contrast black and white filter within Google Photos.

Cropping a Photo

REMEMBER

The term *to crop a photo* simply means that you're cutting away at least one side of your four-sided rectangular or square photograph. Cropping your photo is an effective way to concentrate the viewer's attention to the most important part of your photo.

Professional photographers use cropping all the time. If any part of their photo is visually distracting or is non-essential, they often just crop the image to get rid of the distraction. You can do the same!

Using the Auto Straightening tool

The Auto Straightening tool is a feature that intelligently scans your photo and alters it slightly to straighten it. Keep in mind that if the Google Photos app doesn't think that it's up to the task, you won't see the Auto Straightening tool. The following steps only work if the app believes that it can actually give you good straightening results. Follow these steps to apply a filter to your chosen crooked photo:

1. Choose a crooked photo similar to Figure 11-18.

2. Tap the Edit icon located at the bottom of the screen.

© MarkHemmings.com

FIGURE 11-18: A crooked photo that can be straightened using the Auto Straightening tool.

3. Tap the Crop icon at the bottom of the screen, as shown in Figure 11-19, and then tap Auto.

 You now see the Auto icon in blue, and the photo is straightened as in Figure 11-20.

4. Examine your photo to see whether the straight architectural lines within the photo are now actually straight, as in Figure 11-21. If all looks good to you, tap Save or Save Copy.

But what if you don't like Google's straightening suggestion? No problem! Simply tap the Blue Auto icon to revert to the original non-auto straightened image.

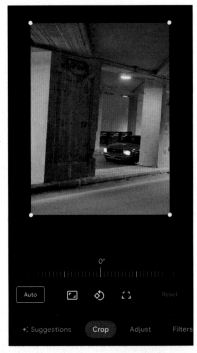

© MarkHemmings.com © MarkHemmings.com

FIGURE 11-19:
Tap the Auto button at the bottom left of the screen.

FIGURE 11-20:
The blue Auto button shows that the Auto Straightening tool has done its job.

Adjusting the crop handles

Now it's time to do some manual cropping. Cropping the unneeded parts of your photo really strengthens your image, as you only include the most important part of the scene. Choose a photo in your collection that has empty space that really doesn't need to be there. For example, after 220,000 miles on my beloved Audi A4 Turbo, it was time to put it up for sale. I took a great cover shot for my car ad, but there was too much useless parking lot pavement in the foreground, shown in Figure 11-22. This is where manual cropping comes to the rescue! Follow these steps to crop your own photo:

1. **Within the editing section, tap Crop.**

2. **Adjust the crop handles as needed:**

 - *Vertically:* Place your finger on one of the crop handles and drag up or down, as shown on the left in Figure 11-22.

 - *Horizontally:* Place your finger on one of the crop handles and drag to the left or right, as shown on the right in Figure 11-22.

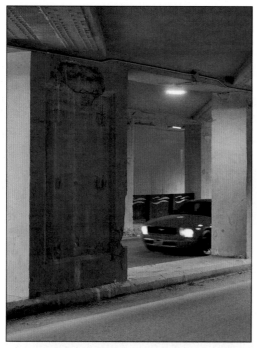

© MarkHemmings.com

FIGURE 11-21:
Your crooked
photo should
now be
straight.

FIGURE 11-22:
Within the
Crop tool slide
one of the
corner crop
vertically or
horizontally
handles to
initiate the
crop.

© MarkHemmings.com

3. **When you have the manual crop looking the way that you want, tap the blue Save Copy button at the bottom right of your screen.**

If you don't like the look of your crop, tap the Reset button to start over.

You newly cropped photo is now available to view within your Google Photos albums. Figure 11-23 shows the final cropped image (which incidentally helped me sell the car within 24 hours!).

© MarkHemmings.com

FIGURE 11-23:
A cropped photo showing only the most important elements.

Rotating your photo

From time to time you may need to slightly rotate your photo. Think of a beautiful photo of the ocean, but you have the horizon a bit crooked. Large bodies of water lie perfectly level, so by rotating your photo by a few degrees, you get the leveled photo that you're looking for. But rotation is not just for water! Maybe you photographed a product such as a café's espresso and cookie but feel that a rotation is needed. Follow these steps to use the manual photo rotation tool:

1. **Within the Crop section, place your finger on 0° as in Figure 11-24.**

2. **Scroll either left or right with your finger.**

 Figure 11-25 shows the rotation at -40°.

 Compared to Figure 11-24, notice how the demi-tasse coffee cup handle and cookie in Figure 11-26 are now rotated.

3. **When you like the look of your rotation, tap the Save or Save Copy button at the bottom right of your screen.**

 If you don't like the look of your rotation, tap the Reset button shown in Figure 11-26 to start over.

© MarkHemmings.com

FIGURE 11-24:
Place your finger on 0°.

© MarkHemmings.com

FIGURE 11-25:
Scroll left or right with your finger to rotate to your liking.

REMEMBER

Rotation reduces the visible area of your photo, which in turn reduces the resolution (height x width measurement) of your digital photo. This is not a big deal as it's always better to get your photo looking the way that you want than to be worried about image resolution. If you compare Figure 11-24 with Figure 11-26 you see that the rotation tool crops into the photo. If you are okay with this tighter crop, your rotation is a success.

Understanding crop aspect ratios

The term *crop aspect ratio* can be described as the relationship between the width and length of an image, where a crop preset conforms your photo to fit a desired frame.

For example, Pinterest prefers a vertical photo upload with an aspect ratio of 2:3. However, when you take a vertical photo with your Android smartphone the ratio is most likely going to be 3:4. This section helps you understand aspect ratios and how to create various aspect ratio crops.

© MarkHemmings.com

FIGURE 11-26:
The photo is now rotated, and this example is at -40°.

3:2 OR 2:3?

Don't be confused if your editing tool mentions 3:2 when you think it should be opposite, such as 2:3 because you have a vertical photo. To save space, some editing apps don't make a distinction; they simply list an aspect ratio such as 3:2 for both horizontal and vertical photos. 3:2 means that the photo is a horizontal image, and 2:3 means that the photo is a vertical image. Or another example, if you have a horizontal 10"x8" framed photograph hanging on your wall, it's described as having a 5:4 aspect ratio. If you took that framed horizontal photo off your wall, and rotated it so it hangs vertically, the aspect ratio would then be described as 4:5.

Within the Crop section, tap the Aspect Ratio icon as shown in Figure 11-27.

You now have access to the following aspect ratio crop options, as shown in Figure 11-28: Free, Original, Square, 16:9, 4:3, and 3:2.

>> **Free** allows you to create any aspect ratio that you like. See the earlier section, "Adjusting the crop handles," if you need to adjust the crop handles to experiment with this option.

>> **Original** maintains the original aspect ratio of your photo. As most Android phones create photos with a 4:3 or 3:4 ratio, by using this option you're most likely locked into a horizontal 4:3 or vertical 3:4 aspect ratio when adjusting the crop handles. Use this preset to crop out a few distracting parts of your photo at the outer edge, but still retain the original shape of your rectangular image.

© MarkHemmings.com

FIGURE 11-27:
Within the Crop section, tap the Aspect Ratio icon.

FIGURE 11-28:
The aspect ratio preset crop options.

» **Square** forces a perfect square aspect ratio crop, which is great for square shaped frames for your wall or for Instagram. See Figure 11-29 for an example.

» **16:9** in the vertical format (technically described as 9:16) is not all that popular, but useful for tall narrow subject matter. Envision a fine art vertical framed photo of a beautiful tree on your wall, for example.

» **4:3** usually doesn't appear any different than the Original aspect ratio, as most Android smartphone sensors are manufactured with a 4:3 aspect ratio. When you move the crop handles, the original 4:3 horizontal or 3:4 vertical aspect ratio is maintained.

» **3:2 horizontal** and **2:3 vertical** is a North American standard aspect ratio crop, useful for photo lab prints in the standard 4"x6" print size. Figure 11-30 shows the slight left and right 2:3 crop compared to the original 3:4 photograph.

FIGURE 11-29:
Square creates a square shaped crop for your photo.

FIGURE 11-30:
3:2 horizontal or 2:3 vertical is one of the most popular aspect ratio crops due to the standard 4"x6" prints you get at a photo lab.

REMEMBER

Even though my example photo of the office tower building is vertical, you can also experiment with horizontal aspect ratio crops! Try the following steps to change the orientation from vertical to horizontal (also from horizontal to vertical):

1. **Choose a vertical photo and tap the 16:9 aspect ratio.**

2. **Tap the aspect ratio icon once again.**

3. **Tap the Flip to Landscape option, shown in Figure 11-31.**

 You now have access to the horizontal 16:9 aspect ratio, as shown in Figure 11-32, which is perfect for photographs destined for YouTube videos, home movies, plus any HD or 4K TV viewing.

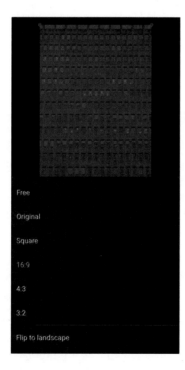

FIGURE 11-31:
Tap Flip to Landscape to change the orientation of the aspect ratio crop.

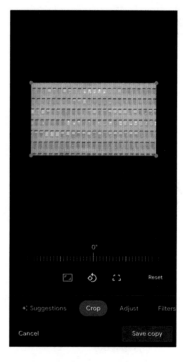

FIGURE 11-32:
When flipped to landscape, the vertical photo is now editable with a horizontal aspect ratio crop.

TIP

Use these steps not only for the 16:9 aspect ratio, but also to flip the orientation of the 4:3 and 3:2 ratios. As you would expect, there is no option to flip the orientation for a square aspect ratio, as a square photo is neither a landscape nor a vertical image.

REMEMBER

Even though the terms *crop* and *aspect ratio* are technically not the same, people often use those terms to describe the same thing. Someone might say, for example, "I prefer a 16:9 crop for my photos as I am a filmmaker." They could also say "I prefer a 16:9 aspect ratio for my photos as I am a filmmaker."

TECHNICAL STUFF

Cropping a photo is an action that you *do*, and a photo's aspect ratio is the width by height relationship of the rectangular or square shaped image. Think of aspect ratio as a formula such as $W:H$, where W represents the width of a photo and H represents the height of a photo. A 16:9 aspect ratio is made of 16 units of width, and 9 units of height. Or to flip it to a vertical photo, a 9:16 aspect ratio is made of 9 units of width, and 16 units of height. The unit can be made of any measurements such as inches, centimeters, pixels — even miles. Imagine a 16-mile wide and 9-mile-high photograph!

Rotating your photo 90 or 180 degrees

You can create some really thought-provoking abstract and fine art images by using the 90° rotation tool. Take a look at Figure 11-33. I took this super-telephoto street photo outside of my hotel window and was really happy with the results. It had a nicely designed composition, the shadow of the cyclist added to the photo, and the Samsung S21 Ultra was able to photograph successfully through a slightly dirty window.

I was wondering, however, whether I could make the shot even better. So, I tried the 90° rotation tool twice, which flipped the photo upside down! Take a look at Figure 11-34 to see the result.

Rotating your photo by 90° increments is quick and easy:

1. **Within the Crop section, tap the Rotate 90° tool. (Refer to Figure 11-33.)**

2. **Tap twice if you want a 180° rotation as shown in Figure 11-34.**

3. **Choose to Save or Save as Copy at the bottom right of your screen.**

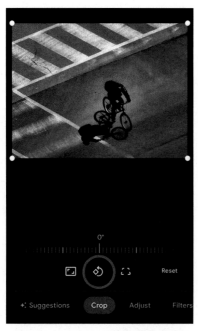

© MarkHemmings.com

FIGURE 11-33:
Tap the Rotate 90° icon to initiate a rotation.

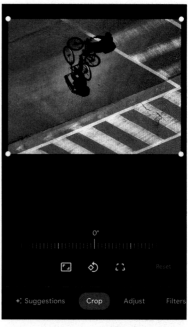

© MarkHemmings.com

FIGURE 11-34:
Tap the Rotate 90° icon twice for a full 180° rotation that flips your photo upside down.

TIP

You may be wondering why anyone would want to rotate their photos, and what good could come from it. The answer lies in the strange and wonderful world of fine art and abstract photography. In the second flipped photo of Figure 11-34 the overall photo has a sense of confusion. Is the shadow the real cyclist? Whenever you present your photos to the public, your hope is that the viewer lingers a bit longer on your images, trying to figure them out. In a good way, confusing your viewers can increase audience engagement.

Skewing your photo

The term skewing your photo seems a bit funny sounding, but the skew tool is incredibly useful. Take a critical look at Figure 11-35. Do you see what is slightly wrong with it? Buildings like this hotel have straight vertical lines and edges, yet in this photo the edges of the hotel seem to fall inward.

Now take a look at Figure 11-36. The edges of the building are now perfectly vertical, which looks a lot more realistic. In this example skew refers to the ability to make vertical lines straight by altering the photo's corner handles.

© MarkHemmings.com

FIGURE 11-35:
In this photo
the hotel wall
edges appear
to be falling
inward instead
of vertically
straight.

© MarkHemmings.com

FIGURE 11-36:
With a skew
adjustment
the building's
architectural
lines are now
vertical.

The use of the skew tool is very common with architectural photographers when photographing buildings from either a lower or higher perspective. Go through the following steps to get an idea of how you can manipulate skew to make your own architectural photos much straighter:

1. **Tap the Skew tool icon circled in Figure 11-37.**

2. **With your finger, slide the lower left and lower right crop handles inward, also illustrated in Figure 11-37.**

3. **Stop moving the Skew crop handles when your white skew line is parallel to the angle of the building's corner edge.**

 I added a red line in Figure 11-38 as an example where the angle of the hotel's edge and the skew line are equivalent.

FIGURE 11-37:
Tap the Skew tool icon to initiate the straightening of vertical architectural lines.

FIGURE 11-38:
The added red line illustrates how you line up the white skew line parallel to the angle of the building's corner.

4. **Angle the white skew line on the other side of the photo as well.**

5. **Tap Done at the lower right of your screen when you think that the skew lines are accurate.**

 You now see the result of the skew, similar to Figure 11-39.

6. **If all looks good to you, tap Save or Save as Copy.**

7. **If you feel that your skew isn't good enough, tap Reset and try again.**

It's most likely that the majority of your building exterior problem photos are from the ground looking up at the building. If you take a look at Figure 11-40 you see the problem that I encountered when I photographed the historic Algonquin Resort. It looked like the building was falling backward!

When you encounter a similar photo opportunity, use the same steps, except this time alter the top left and right skew crop handles as shown in Figure 11-41.

FIGURE 11-39:
When you see the result of your skew, tap Save to quit or Reset to try again.

Check out Figure 11-42 for the result of the vertical skew straightening.

TIP

While it's true that the skew process cuts off the extreme left and right of the photo, you may find that it's worth it anyway to get the architectural lines straight. To that end, try to get in the habit of photographing buildings with a wider lens than you normally would use, or simply walk backward a bit for more space around the building than you normally would compose for. Doing so allows for greater skew editing latitude and results in the entire building being represented in the corrected photo.

© MarkHemmings.com

FIGURE 11-40:
Photographing
from a lower
perspective
looking up,
it looks like
the hotel falls
backward.

FIGURE 11-41:
When
photographing
a building
from a lower
perspective,
alter the top
left and right
skew crop
handles.

FIGURE 11-42:
The corrected
photo with
architecturally
straight vertical
lines.

© MarkHemmings.com

Editing Your Photography

TIP

The term photo editing in its basic form simply means to alter your image to suit your use. It could be for a magazine, a website, or a social media post. For example, maybe you would like to crop your photo to a square shape for an Instagram upload, but retain the original aspect ratio for a Facebook upload. Maybe you want to convert the photo to black and white for a fine art framed photo for your wall.

The earlier sections in this chapter covered the editing tools that are usually described as auto editing tools. An auto edit is usually a quick one-tap change to your photo, such as tapping a filter to make your photo convert to a black-and-white image. This section, however, covers manual photo editing, which offers you much more creative freedom!

After you have chosen the photo that you want to manually edit, your editing tools can be found by tapping the Adjust icon, which is located at the bottom of the screen between the Crop and Filters icons. (See Figure 11-43.)

Here are all the editing tools available to you.

TIP

>> **Brightness:** Scroll the Brightness adjustment slider to the minus side for a darker image, and to the plus side (as in Figure 11-44) for a brighter image. The Brightness tool is a simple method for getting quick results when your photo is too bright or too dark to begin with.

The Brightness slider is an easy tool to start with when you first begin editing your photos. In time, however, you'll want to use the Highlights, Shadows, and Black Point tools, which allow you to achieve the same results with more accuracy and precision.

As shown in Figure 11-44, an increase of 29 makes the car photo look a bit washed-out, and not very appealing. This is because the original photo was well-exposed to begin with.

© MarkHemmings.com

FIGURE 11-43:
Access your manual editing tools by tapping Adjust.

FIGURE 11-44:
The Brightness tool is a quick but basic way to make your photo darker or brighter.

- » **Contrast:** The Contrast tool gives your photo a bit more punch, especially if you feel that the overall look of your photo is murky or soft looking. The Contrast tool can make all shadow and dark aspects of your photo even darker, and all highlight and bright aspects become even whiter. Be careful not to overuse this tool. It's okay in small doses, but you'll be better served to learn how to use other tools such as Highlights and Shadows for selective adjustments. This tool isn't used very much by pros because it often goes overboard with the highlight areas of your photo. In limited amounts, the look can be quite attractive for certain subject matters.

 Figure 11-45 shows how the Dodge muscle car is a prime example of where a high contrast amount of 100 actually looks great! Not all subject matter looks good however at such extreme contrast amounts. You may want to go to the minus side of contrast, reducing the effect for baby photos, dreamy wedding portraits, and some floral still life images.

- » **Sky:** This filter is only available if your photo includes a clearly defined sky, such as a landscape. It's also an extra filter that not all Android devices include. This filter allows you to selectively alter the look of your sky for any of your landscape photos. You can increase the blue of the sky, accentuate sunsets, and add even more drama to stormy skies.

- » **HDR:** This option isn't available on all Android devices and is dependent on whether you have a Google One cloud subscription. Nevertheless, if you have access to this tool, use it to reduce contrast in a way that doesn't look soft. HDR reduces contrast, but in a way that retains the feel of punchiness and visual aggression. (See Figure 11-46.)

 HDR is also useful for not allowing very bright highlights to be so bright that they lose detail. So, if your original photo has far too many deep shadows with a lot of highlights, and you want to reduce such radical contrast, give HDR a try. Keep in mind that this tool isn't a true HDR (High Dynamic Range) process, but a simulated version.

- » **White Point:** A White Point slider adjustment to the positive side, such as 96 in Figure 11-47, increases the brightness of only the very light parts of the photo. For example, the white parts of the garage door and the car's rims are now very bright compared to the original photo. White point adjustments can be overused, so adjust this slider sparingly. What you don't want is to go overboard where your lightest areas become pure white, as they are in this figure. Feel free to try the opposite as well, scrolling the slider to the negative side to reduce the brightness of the photo's lightest areas.

FIGURE 11-45:
The Contrast tool can make your bright areas brighter, and your dark areas darker.

FIGURE 11-46:
HDR reduces overall contrast but still retains a sharp, punchy look. It also protects highlights from becoming overly white.

» **Highlights:** The Highlights tool adjusts the light-toned areas of your photo while ignoring and not adjusting the middle and dark tones of your image. This tool is helpful for rescuing photos that have gray or muddy looking highlight areas that in real life should look much whiter. Think of the Highlights tool as a less radical version of the White Point tool.

If you compare the Highlights example in Figure 11-48 to the White Point example in Figure 11-47 you see a much more pleasing brightening of the lighter areas of the photo. As expected, in both examples the mid-tone and shadow areas of the photo are untouched by the editing. This process of only adjusting one aspect of a photo is called *selective adjustments* and is a far more accurate way to edit your photo than the basic Brightness and Contrast tools.

» **Shadows:** The opposite adjustment of the Highlights tool, the Shadow adjustment slider affects only the darker areas of your photo. You may find yourself using this tool to make your shadows a bit brighter to see the full picture better or to decrease the shadows for a more dramatic, fine art look.

FIGURE 11-47:
The White Point tool adjusts only the lightest areas of your photograph.

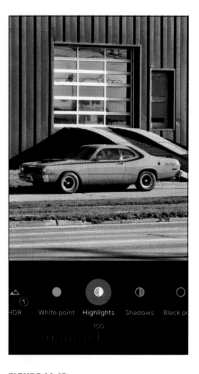

FIGURE 11-48:
The Highlights tool is a less aggressive version of the White Point tool, adjusting the light areas of your image.

>> **Black Point:** The Black Point tool is a favorite for fine art, street, and fashion photographers. Think of this tool as a far more aggressive version of the Shadows tool. Use the Black Point tool to add drama to your photos. Added drama is easily accomplished when the shadow areas of your photo become darker and darker. Keep in mind that you probably won't want to use this tool when you want to show a sense of peace, calm, relaxation, or if you're doing wedding or family photography. Extreme Black Point adjustments are more for gritty and bold photos that are meant to shake things up, as in Figure 11-49.

TIP

One thing to keep in mind is that when this tool is scrolled to the minus side, such as -100 in Figure 11-49, the saturation of the photo's colors usually increases. This may be a good thing, as the orange color of the classic Dodge now really stands out! However, the skin tone of any people probably looks unrealistically red. If so, try the Saturation slider.

>> **Saturation:** The Saturation tool adjusts all colors in your photo, either with more color boost or less color vibrancy depending on how you scroll the adjustment slider. If you go to the minus side on the Saturation adjustment slider, your colors progressively fade to black and white. Use this tool sparingly on the plus side, as your photo can look a bit too garish if the colors are boosted to the extreme. However, there are many great opportunities for a moderate increase in saturation, such as landscape and nature photography.

TIP

Try not to use the Saturation tool on the plus side for portraits, as skin tone tends to get red and blotchy. Feel free, however, to experiment with the Saturation tool to the minus side with portraits, which reduces the color vibrancy for a more fine art look.

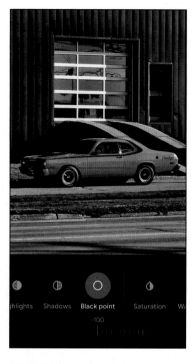

FIGURE 11-49:
The Black Point tool is a more aggressive version of the Shadows tool, adjusting the very dark areas of your image.

>> **Warmth:** The Warmth tool adjusts your photo to a more blueish color cast on the minus side and a warm, yellow/orange-toned look when adjusted to the plus side. Landscapes and nature look great with slight warm tones, and moody, dramatic photos often look better with a cool blue cast.

>> **Tint:** The Tint tool adjusts your photo between the green and magenta color spectrum. If you feel that your photo is too greenish due to old tube-style fluorescent light bulbs, simply go to the magenta side of the adjustment slider (the plus side) to correct the color balance of your photo. If you have a photo that has too much purple or magenta color tones, scroll the slider to the minus side, which adds green to counteract the magenta.

>> **Skin Tone:** When editing portraits, you may find skin tone red and blotchy. By using this selective editing tool, you can alter the look of a person's skin while the rest of the photo's colors remain mostly untouched. Give this tool a try if you feel that someone's face is too reddish looking. Scrolling your adjustment slider to the minus side reduces red blotchy skin tone but won't affect other colors in your photograph.

>> **Blue Tone:** The Blue Tone tool is a fantastic editing option that makes only the shadow areas and the already blueish areas of your photo even more blue. Blue shadows add a sense of drama to action and fine art color photographs.

- » **Pop:** The Pop tool is a more aggressive version of the HDR tool. It acts as a sort of middle-tone contrast adjustment, which allows for a contrasty appearance while not ruining your highlight areas. Use this tool for any image that needs a hint of fine-art drama. This filter should probably not be used in excess for weddings, baby photography, or happy-looking family portraits. It's used more for a gritty, tough look.

 Keep in mind that some Android devices and operating system versions don't offer the Pop tool, nor the following three tools: Sharpen, Denoise, and Vignette.

- » **Sharpen:** Late model Androids usually don't need much image sharpening. However, if you feel that your photo just isn't as sharp as you'd like, this adjustment slider can give your photo an extra sharpness boost.

- » **Denoise:** The Denoise tool is almost irrelevant with latest Android cameras due to in-camera denoise processes. However, if you have an earlier model Android camera and you feel that your photo has too much of what is often called grain, then this slider can help remove those digital dots that detract from photos taken in low light.

- » **Vignette:** The Vignette tool adds a soft dark border around your photo. Vignettes look great with gritty black-and-white street and portrait photographs. A vignette also tends to push the viewer's attention directly into the center of the photo, which is often the location of the subject matter (see Figure 11-50).

FIGURE 11-50:
The Vignette tool adds a gradually increasing dark border around your photo.

Editing Your Portrait Photos

You discover how to use Portrait mode to take selfies in Chapter 4, creating beautiful self-portraits that really stand out. But did you know that you can re-edit your portrait photos long after you take them?

When you photograph a friend using Portrait mode, or yourself using the selfie front-facing camera, you see a pleasant background blur that looks like a DSLR portrait. The blurred background portrait technology allows for the person's face to really stand out. The amount of blur behind your head in Portrait mode is automatically determined by your phone. You can, however, adjust that blur amount, plus make other light and tonal adjustments for the perfect portrait of your friend or a selfie.

TIP

Not all Android cameras have Portrait mode. If none of what is shown in the following sections looks familiar to you, your Android probably doesn't have Portrait mode. Don't feel left out if that's the case! Do a Google Play Store search for "Portrait Mode Camera" and choose a well-reviewed app. Chapter 13 explains the Google Play Store if you're unfamiliar with it.

Portrait

The Portrait filter is a one-touch button that fills in your facial features as if you were illuminated with photo studio light. This tool is useful for portraits where the light illuminating the face is uneven or had deeper shadows present. If your Android camera has this feature, follow these steps to activate the Portrait lighting tool:

1. **Choose a Portrait mode photo from a Google Photos app album or create a new portrait of a friend or a selfie.**

2. **Tap Edit to open your editing tools.**

3. **Tap the Portrait button in the Suggestions section, as shown in Figure 11-51.**

4. **Tap either Save or Save as Copy.**

FIGURE 11-51:
Tap the Portrait button within the Suggestions section of your editing tools.

B&W Portrait

B&W (Black and White) Portraiture is an easy way for you to create a classic, no-color portrait. Not all Android devices have Portrait mode, so you may or may not have access to the B&W Portrait filter. If you do have access to it, keep in mind

that you can use this filter for both a front-facing camera selfie and a rear facing portrait that you take of a friend. Follow these easy steps for a quick black-and-white portrait:

1. **Choose any Portrait mode photo from a Google Photos app album or create a new portrait of a friend or create a selfie.**

2. **Tap Edit to open your editing tools.**

3. **Tap the B&W Portrait button in the Suggestions section, as shown in Figure 11-52.**

4. **Tap either Save or Save as Copy.**

Saving a black and white portrait as a copy may be helpful to you, as you can see both the color and black and white version side by side within your Google Photos app.

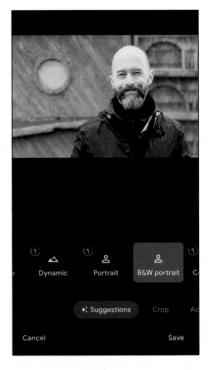

FIGURE 11-52:
Tap the B&W portrait button within the Suggestions section of your editing tools.

Blur

The Blur tool allows you to dial in the exact amount of background blur that you want. Maybe you actually want the blur to be removed altogether to show off the background texture. No problem! Maybe you want even more blur than what your Android camera automatically created for you. Either adjustment can be done quickly and easily:

1. **Tap Adjust, located between Crop and Filters. (See Figure 11-53.)**

2. **Tap the Blur icon and make sure the icon turns blue, as shown in Figure 11-54.**

3. **Place the white circle somewhere on the face and scroll the slider, located at the bottom of the screen, to 0 for no background blur or to 100 for maximum background blur**

 Figure 11-54 is set to a blur strength of 96 out of 100.

 Settle on a blur strength that you feel looks good. The default amount that Google Photos automatically applies is usually just the right amount.

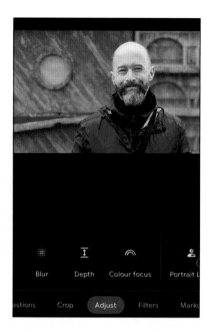

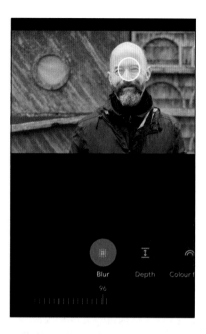

FIGURE 11-53:
Tap the Adjust icon for any Portrait mode photo.

FIGURE 11-54:
Tap the Blur icon, place the white circle on the face, and scroll the adjustments slider from 0 to 100.

Depth

The Depth tool allows you to choose whether to blur either the person or the background. What this means is that you can make the person in the portrait blurry and make the background sharp. It's a complete reversal of what a normal Portrait mode image looks like!

REMEMBER

The Depth tool isn't always available, especially if you took the photo and then attempted to edit the photo using two different Android devices. Further, the tool doesn't show up in your options if the Google Photos app believes that the technique won't look good, or it doesn't have enough depth information to create the Depth effect. This tool is usually available on multi-lens Android cameras on the rear-facing lens when doing Portrait mode photos of a friend.

1. **To the right of Blur, tap the Depth icon as in Figure 11-55.**

2. **Scroll the adjustment slider.**

 For example, in Figure 11-55, I set it to 98 out of 100.

3. **Place the little white circle on the background instead of your face.**

4. **Tap Done, and you see the final product similar to Figure 11-56. Only the background is in focus!**

My guess is that I won't be using Figure 11-56 for my @markhemmings Instagram profile photo!

Colour Focus

The next Portrait mode filter is called Colour Focus, which, if available on your Android, is located to the right of Depth as shown in Figure 11-57. Tap the icon, scroll the slider to 100 and the background turns to black and white, and the person's face remains in color.

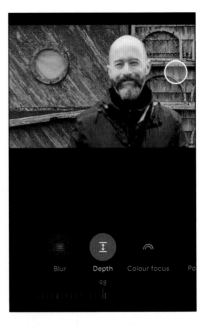

FIGURE 11-55:
Tap on the Depth icon for a Portrait mode photo created with a multi-lens Android device.

But that's not all! If you tap one section of the background, such as the red portion of the fishing shack in Figure 11-58, only that color comes back. As you can see, the other side of the fishing shack is still black and white, because that section of the shack is not painted with red paint.

FIGURE 11-56:
Only the background is in focus when you place the white circle on the background, instead of the person's face.

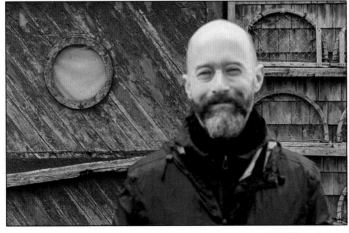

© MarkHemmings.com

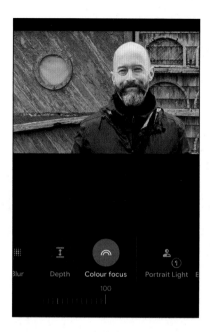

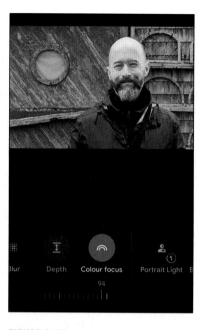

FIGURE 11-57:
Tap the Colour Focus icon to make the background black and white while retaining skin tone.

FIGURE 11-58:
Tap a background section that has a unique color, and that color only reverts from black and white to color.

Portrait Light

In the earlier "Portrait" section, I show you how the Portrait filter can fill in the shadowy parts of your face to mimic photo studio lighting. If you don't have that tool, a similar tool, called Portrait Light, may be available to you.

By tapping the Portrait Light icon (to the left of the Brightness icon) the portrait receives more portrait studio-type light when you place the little white circle somewhere on the face. (See Figure 11-59.) The circle mimics the direction of the photo studio light, so experiment with placing the circle to the left, right, and in the middle of the face for different portrait lighting effects.

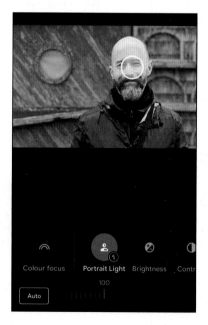

FIGURE 11-59:
Place the little white circle on the left or right side of the face, or in the middle to mimic portrait photo studio lighting.

Chapter **12**

Organizing and Sharing Your Photos Like a Pro

As an international photography workshop instructor, I often hear the following complaint from my workshop participants: "I love taking photos, but I have thousands of images and they are spread out everywhere! I need a logical and efficient workflow."

It's quite possible that you've dealt with the same frustrations, or possibly will in the future. This chapter can be a great benefit to you as you discover how to create an organized post-production photography workflow.

Understanding Post-Production Workflows

The term *post-production workflow* is often used in photography circles and refers to what you do with your image the moment after you take the photo.

After you take your photo, you have several options:

>> Place it in an album.

>> Edit it (see Chapter 11).

>> Delete it if necessary.

>> Mark it as a favorite.

>> Share it with other people.

Deleting Unwanted Photos

Hitting the delete button to erase a photo from existence often strikes fear into the heart of photographers!

TIP

Don't ever delete photos when you're tired, hungry, frustrated, or in a bad mood. Delete unwanted photos when you're feeling fine. You'll have far better objectivity when you purge your images coming from a good mindset. You want to delete photos based on a few parameters:

>> You have duplicate photos that are pretty much identical to each other.

>> You really dislike the photo and realize that no editing magic can save it from the trash can.

>> You're concerned about filling up your phone and/or your Google Photos cloud allotment with sub-par photos. If you have a Google account, you will eventually surpass your 15GB of free cloud storage space. If you don't want a monthly Google One paid cloud subscription, you will want to keep your photo and video collection purged of unnecessary photos and videos. Alternatively, download your photos to your computer as described in Chapter 3, and then delete them from your device.

TIP

It's a good idea to schedule a monthly purge session at your favorite café. Get comfortable with a tasty drink, and as you are in a great mood you will have the objectivity to delete photos that really won't serve you in the future. Keeping your collection clean and organized each month (at the least) is part of an efficient photographers' workflow.

Deleting a photo

The following steps walk you through the process of deleting one of your photos:

1. **Go to Photos view within your Google Photos app.**

 The Photos icon appears in blue at the bottom left of the screen.

2. **Tap the photo that you'd like to delete. (See Figure 12-1.)**

3. **When your photo opens full screen, tap the Delete trash can icon at the bottom right, as shown in Figure 12-2.**

 A warning message appears. Figure 12-3 shows the warning from a Samsung device. The wording for the warning on your own Android may look a bit different, but it means the same thing. For example, a Google Pixel 4a warning states: "Remove from Google Account and synced devices? Move to Bin."

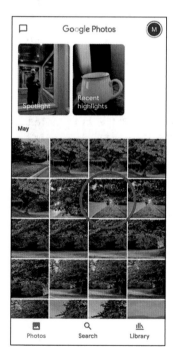

FIGURE 12-1:
Within the Albums view, tap the photo you want to delete.

© MarkHemmings.com

FIGURE 12-2:
Tap the Delete trash can icon to delete your photo.

FIGURE 12-3:
Tap Allow to delete the chosen photo.

Allow Photos to move this photo to bin?

Deny Allow

4. **Tap Allow if you want to continue with the deletion.**

 The photo disappears from the Google Photos main album.

Restoring a deleted photo

REMEMBER

After you delete a photo, you have 30 days to rescue it from the trash can if the photo hasn't been backed up, or 60 days if the photo has been backed up. After these two deadlines have passed, that particular photo is gone forever from your phone. While not completely necessary, some photographers like to scan their trash can once in a while just to make sure they didn't delete a photo prematurely. This practice is completely up to you and may or may not be helpful.

Follow these steps to restore your mistakenly deleted photos:

1. **At the bottom right of your Google Photos app screen, tap the Library icon, and make sure the icon turns a blue color.**

2. **Tap Bin, indicated by a trash can icon, as shown in Figure 12-4.**

 You see an album of photos that are in the queue to be deleted. The most recently deleted photos are at the top of the Bin trash can.

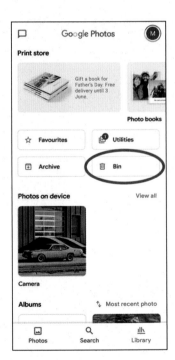

FIGURE 12-4:
Within the Library section, tap the Bin trash can icon.

3. **Search for the photo that you mistakenly deleted and tap it, such as the blossoming apple tree shown in Figure 12-5.**

You can select multiple photos as well as a single photo.

4. **When the photo opens full screen as in Figure 12-6, tap the Restore icon located at the bottom right of the screen.**

You now see a confirmation warning, as shown in Figure 12-7.

5. **Tap Allow (or other affirmative wording for non-Samsung devices).**

The photo is now restored and once again in your Google Photos app.

FIGURE 12-5:
Tap the photo that you mistakenly deleted.

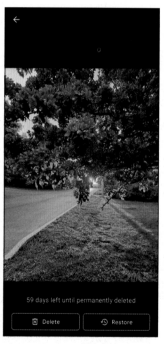

© MarkHemmings.com

FIGURE 12-6:
Tap the Restore icon at the bottom right of the screen.

FIGURE 12-7:
Tap Allow (or other affirmative wording) to restore the photo.

Favoriting Photos with the Star icon

Professional photo management software, such as Adobe Lightroom, allows for multi-star ratings and flagging, which are tools used by photographers to assign value to an image. Your Google Photos app has a simplified star rating system, known as a *favorite*.

When you star a photo, you're placing a certain value on that photo based on whatever parameters that you ascribe to it. For example, maybe you starred all your favorite photos because they're destined to be uploaded to your Instagram page. Or maybe all your starred photos are singled out because you want to print each one of them.

Regardless of why you tapped the star icon, the fact that you have the ability to single out one or many photos for a future end use is convenient. To apply the star to your favorite photos, and then review them in the collected favorites album, follow these steps:

1. **In Photos view, scroll through your photo collection and locate a photo that you want to favorite with a star.**

2. **Tap your chosen photo.**

 The photo is now visible full screen with the star icon to favorite it at the top right, as shown in Figure 12-8.

© MarkHemmings.com

FIGURE 12-8:
Tap the star icon at the top right of the screen.

3. **Tap the star icon.**

4. **At the top left of your screen, tap the left-pointing arrow to exit.**

5. **Within the Library section of the Google Photos app, tap Favorites. (See Figure 12-9.)**

 You now see your Favorites album that includes all your starred photos, as shown in Figure 12-10.

FIGURE 12-9:
Tap Favorites within the Google Photos app Library section.

© MarkHemmings.com

FIGURE 12-10:
Your starred photos are all within the Favorites folder.

Mastering Album Organization

It may initially seem like a chore or waste of time to organize your photos into specific, custom labeled albums. However, if you get in the habit of placing every photo within an album, your future self will greatly thank you for being so organized!

Take a look at Figure 12-11. The Photos section is the master folder that contains all the photos that you've taken with your phone's camera and/or have imported from external cameras or devices. Now it's time to talk about the value of album organization within the Library section of Google Photos, which is located to the right of Photos and Search. The Library section contains all your uniquely named photo albums.

FIGURE 12-11:
The Photos section contains all of your photos; the Library section contains your photo albums.

Selecting photos to create a new album

Your Google Photos app lets you create as many albums as you like, which keeps your photo collection organized. To discover how to quickly create and populate a new album, follow these easy steps:

1. **Within the Photos section, select a number of photos that you want placed in a photo album.**

 Figure 12-12 shows eight photos selected, and they're all images of covered bridges.

 TIP

 Long-press (for about one second) the first photo until you see a blue check mark, and then tap the remaining photos. You know that the photos are selected by the blue check marks.

2. **Tap the More icon (three vertical dots) at the top right of the screen, circled in Figure 12-12.**

 The actions you can take appear under the Create section, as shown in Figure 12-13.

3. **Tap Album to create a new album.**

 You're prompted to name your new album, as shown in Figure 12-14.

4. **Enter a descriptive title.**

FIGURE 12-12:
Select a number of photos that you would like grouped into a photo album.

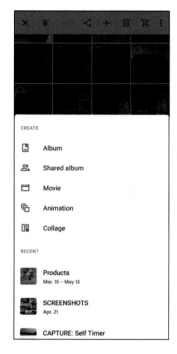

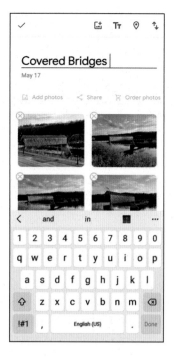

FIGURE 12-13:
In the Create section, tap Album.

FIGURE 12-14:
Type a descriptive name for your newly created album.

5. **Tap the blue check mark at the top left of the screen when you finish typing your album's title.**

 Your newly created album now contains your selected photos. Figure 12-15 shows my own collection of covered bridge photos neatly organized in a single album.

6. **Tap the left-pointing arrow at the top left of your screen to exit the album and return to the Google Photos app Library section.**

 Within the Library section of the Google Photos app you see your newly created album, plus any future albums that you create. My own Covered Bridges photo album contains eight photos, shown in Figure 12-16.

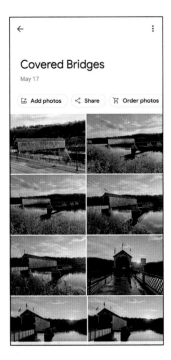

FIGURE 12-15:
A photo album that contains a group of similar images.

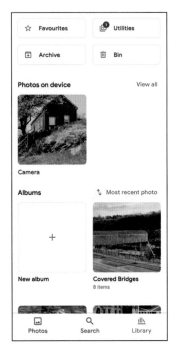

FIGURE 12-16:
Your photo albums are located within the Library section of the Google Photos app.

TIP

You can organize your photos in these ways as well:

» If you've already created an album and want your selected photos to be placed within it, find your album in the Recent (refer to Figure 12-13) or All Albums section and tap your desired album. Your selected photos are placed within that album immediately.

» You can create a new album even before you select photos. Tap the + sign within the square shaped New Album, and then name your album. It remains empty until you populate it with images.

» You can add photos from one album to another album. Simply select the photos from one of your albums, tap the + icon at the top of your screen, and then select the album that you want the photos added to.

Removing a photo from an album

When you remove a photo from an album, you're not deleting your photo. You're just removing it from the particular album that you're viewing. The photo is visible with your Photos master album. Follow these steps to remove a photo from an album:

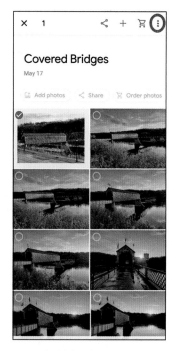

1. **Within your album, select the photo that you want to remove.**

 Figure 12-17 shows how I selected, with a one second long-press, the first covered bridge photo to remove from my album. I felt that the photo didn't have the same dramatic sunset light as the other photos within the album.

2. **Tap the More icon (three vertical dots) at the top right of the screen.**

3. **Tap Remove from Album, as shown in Figure 12-18.**

 You now see your album with the selected photo removed and not visible. You can still locate the photo within the Photos section of the Google Photos app. Figure 12-19 shows my covered bridges photo album with the less-dramatic bridge no longer a part of the album. Tap the left-pointing arrow at the top left of the screen to exit your album and return to the Library section of the Google Photos app.

FIGURE 12-17: Select the photo that you want removed from your album and then tap the More icon.

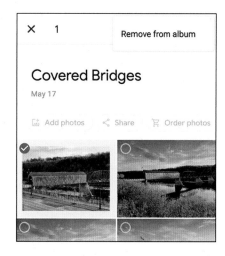

REMEMBER

Removing a photo from your photo album doesn't delete your photo; it only removes it from your album. If you want to delete the photo entirely, see the "Deleting a photo" section earlier in this chapter. Think of it this way: the Library section is for photo album creation where you can add or remove photos, and the Photos section is where you can delete photos.

FIGURE 12-18: Tap Remove from Album.

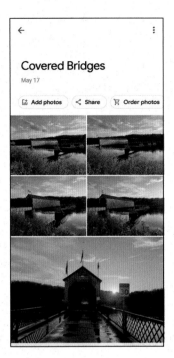

FIGURE 12-19:
The album
now no longer
includes the
photo you
removed.

TIP

You can also delete an entire album by tapping it, tapping the More icon at the top right (the three dot icon), and then tapping Delete Album. Don't worry: Your photos remain safe within your Photos collection. Deleting an album doesn't delete the photos that were within the album.

Naming albums logically

Ideally, every photo that you see in your Photos section should also be organized within a specific photo album within the Library section. While it may be a lot of organizational work to get your photo collection organized into albums, it's worth your time.

One of the biggest complaints that beginner and amateur photographers have is not being able to find a specific photo quickly. You can save so much time by placing each photo that you take or import into a specific album. In fact, every photo that's in your Photos section should have a home within a custom-created folder with a logical naming structure.

Here are some common folder name ideas that make sense for organizing your entire photo collection:

» Greece Trip 2020

» Grandchildren

» Business receipts

» House ideas

» Nature photos

» Baseball games

The names of the albums are completely up to you. Even though placing every photo in an album may seem like a lot of work, it's actually a timesaver in the long run as you will have very quick access to each photo in the future.

Exploring the Search Tools

The Search tools are an indispensable yet often overlooked part of the Google Photos app. Think of the Search section as photo albums that the Google Photos app creates on your behalf. Use this section of the app to quickly find photos and other media without scrolling through thousands of images within the Photos section. Within the Google Photos app, you can access the Search tools by tapping the Search icon that is located between the Photos and Library icons. (See Figure 12-20.)

FIGURE 12-20:
All the Search tools are accessible by tapping the Search icon.

Finding photos of a single person using People

The People feature within the Search section of the Google Photos app is a great way for you to quickly find most or all photos of a single person. Using clever facial recognition, this feature shows you all photos of you, and then all photos of other friends or family members if you so desire. Google Photos uses artificial intelligence to categorize the people who you photograph most, including yourself.

Take a look at Figure 12-21. Under the People section the first album has my name on it, Mark Hemmings. It also has thumbnail portrait photos of other people who I photograph often, mostly friends and family members. As your own photo collection grows, you see more and more automatically generated people albums. You can even name these albums, which is what I did for the Mark Hemmings People photo album.

Tap one of the People albums and you see a page that looks similar to Figure 12-22. All the photos within this album includes me, or me with friends.

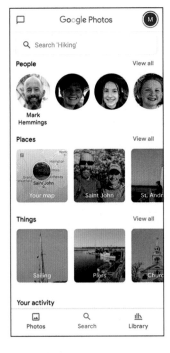

FIGURE 12-21:
The People section contains automatically created photo albums of people who you photograph the most.

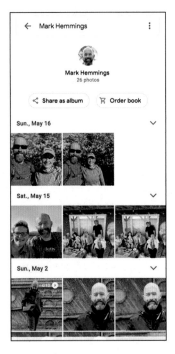

FIGURE 12-22:
A People album contains photos of a certain person, such as yourself or anyone who you photograph often.

Tap the left-pointing arrow at the top left of your screen to return to the Search tools section.

TIP

Some Android users prefer that the Google Photos app not sort facial data for the automatically created People albums. If this is the case for you, these following steps will turn off facial recognition:

1. **Within the Google Photos app, tap your profile icon, which is located at the top right of your screen.**

 The purple and rainbow colored icon usually has your first initial inside the circular icon ("M" for Mark, for example).

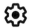

2. **Tap the Photos Settings icon, which is illustrated with a little gear.**

3. **Tap the Group Similar Faces option.**

 Figure 12-23 shows the Face Grouping setting on, its default setting.

4. **Tap this button to turn face grouping off.**

 Notice in Figure 12-23 that Google Photos knows what I look like. That is because I named myself within the People section, so that all photos that include Mark Hemmings would automatically show up in a single folder. I also have the Help Contacts Recognize Your Face option turned on by choice. This privacy option offered by Google Photos allows you to choose how much of your data is shared to the public.

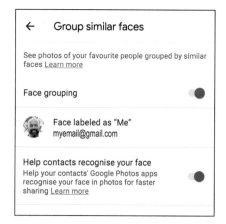

FIGURE 12-23:
To deactivate Face Grouping, tap the little blue button.

5. **To exit, tap the left-pointing arrow at the top left of your screen when you have made your privacy decisions.**

6. **Tap the same arrow one more time to get from the Settings page back to the Google Photos app main page.**

Checking your location using Places

The Places feature uses location data to determine what city and country your photos were taken from. Places is just another great way for you to quickly access photos that previously would take a lot of scrolling to find. Being a good Android photographer is one thing, but the complete photography workflow also includes quick access to your entire photo collection. With this and other search tools, you're well-positioned to access your photographic history quickly.

1. **Within the Search section of the Google Photos app, tap Your Map, which has a small Google Maps icon.**

 You now see all the places on a version of Google Maps where you've created photographs.

2. **Tap any of the mapped photo locations to see the photos that you took in that particular spot.**

3. **Tap the little left-pointing arrow at the top left of your screen to return to Places.**

 In Figure 12-24, Saint John and St. Andrews is a Place album, plus many more Places are viewable by tapping the View All.

FIGURE 12-24:
Find all the photos you've taken in one place in a group that's automatically created by Google Photos.

When you tap View All, you see all the major locations that you've photographed in. These albums are usually titled by the name of the nearest town or city.

If you want to disable location services so that your phone doesn't track your photo's capture location, follow these steps:

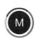

1. **Tap the profile icon at the top right of the Google Photos app.**

2. **Tap the Photos Settings icon, which is illustrated with a little gear.**

3. **Scroll down and tap the Google Location Settings option.**

4. **Turn the Location button on or off, depending on your privacy comfort level.**

REMEMBER

Most photographers keep location turned on because of the wealth of data that it affords future generations. Knowing the exact location of a photo long past the time of the photographer's memory is a real asset for future-proofing your photo collection. However, the choice is available if you decide that location tracking is not for you.

Using Things to locate photos by type

Google is a world leader in AI (artificial intelligence) when it comes to understanding what objects are within a photograph. Because of its access to almost all the world's online photos, Google's computers can accurately describe what is in your photographs.

Take a look at Figure 12-25. Under the Things section I see all my sailing photos automatically collected in one album. I also see photos of fishing piers, as I live on the ocean surrounded by the fishing industry. It also recognizes all the churches that I've photographed, plus so many more auto-generated albums.

Tap View All on your own Android to see all of the Things albums that Google Photos has created for you. When I tap View All I see my photos automatically arranged in albums such as Hiking, Skylines, Skiing, Fog, Beaches, Cooking, and so many more. This resource is such a timesaver. All my hundreds of waterfall photos automatically organized in an album for me? Yes, and thank you, Google!

FIGURE 12-25:
The Things section automatically arranges the subjects of your photos into relevant albums.

Accessing photos using Your Activity

The Your Activity section, shown in Figure 12-26, is a quick way to access your starred Favorites photos and your most recently captured (or imported) photos.

Using Categories and Creations to sort by media type

The Categories and Creations sections are a quick way for you to access certain types of media. Here's a brief description of each available media type that you can search through at the tap of a button (see Figure 12-27):

FIGURE 12-26:
The Your Activity section gives you access to your favorite and most recent photos.

>> **Screenshots:** The home of all your screenshots. A screenshot is a visual snapshot of whatever is on your screen, usually created by pressing the power and down-volume buttons at the same time for about 1 second.

>> **Selfies:** Each selfie that you've taken of yourself with the front-facing selfie camera shows up here.

>> **Videos:** The location of all videos that you've taken. (More on video creation in Chapter 14.)

>> **360 Photos & Videos:** A 360 photo or video is most often used in conjunction with the Google Street View app, which allows viewers to feel that they're immersed in the actual street that they're virtually exploring. You can experiment with this option by creating a panorama photo with most Android devices.

>> **PhotoScan:** By tapping PhotoScan you can access the scans of your photo prints using the Google PhotoScan app. Do you have a lot of photographic prints that you want recorded for future generations? Try the PhotoScan app, explained in greater detail in Chapter 13.

>> **Motion Photos:** The home of your motion photos. A motion photo is like a short, looped video that was created with still photos automatically created before and after you press the shutter button.

>> **Saved Creations:** Access to all your animations, collages, and movies.

>> **Animations:** Home of your animations, which you can create by tapping Create Animation, and by selecting a few photos taken of the same subject matter. You then see an animation created from those still images.

>> **Collages:** The location of all your collages. You can create beautiful collages with a number of your photos by tapping Create Collage, and then by selecting a few photos that you feel would look good within a collage.

>> **Movies:** The home of all the movies that you have created. Tap Create Movie, which guides you through the movie making process from scratch or with templates.

>> **Cinematic Photos:** While not always accessible to all Android users, here's where your cinematic photos are located. A cinematic photo is a normal still photo with a three-dimensional effect applied to it.

FIGURE 12-27:
The Categories
and Creations
section helps
you quickly
search for only
certain types of
media.

Sharing Your Photo Albums

In Chapter 1, you discover the ease of sharing photos to friends and family by using Google Messages or Gmail. But what if you want to share many photos to family members who live far away? The solution is to share an entire photo album! No more concerns about your email getting clogged up with more photos than your email program can handle. Follow these steps to share one of your photo albums:

1. **Within the Library section, choose the photo album that you want to share by tapping the album.**

 Figure 12-28 shows six of my albums, and I choose to send the Interiors: Pizzeria album to my client who hired me to take these interior photos.

2. **Tap the Share icon located directly above the photos and below the photo album name. (See Figure 12-29.)**

FIGURE 12-28:
Within the Library section, tap an album that you want to share.

FIGURE 12-29:
Tap the Share icon.

3. **Share in one of three ways:**

 - *If you use Gmail:* Tap Gmail at the bottom of the screen, shown in Figure 12-30, which opens a new email within Gmail with the link to the album. You can then send the email to all your friends and family.

 - *If you don't use Gmail:* Tap the Get Link icon, which is located next to the Gmail icon (also shown in Figure 12-30). Then tap the Create Link button. The link is copied to your clipboard, so you can paste it into an email.

 - *If you want to share your album with a friend who also has the Google Photos app*: Tap the More icon in the Invite to Album section. Enter your friend's email address where it says Search by Name, Phone Number, or Email. They receive an email inviting them to view the photos within their Google Photos app.

FIGURE 12-30:
Get a link to
your album
by tapping the
Gmail or Get
Link icons.

4

The Part of Tens

Discover ten photography enhancing Android apps.

Find out about ten video tips and tricks.

Explore ten extra Google Photos app features.

Chapter **13**

Ten Android Apps to Further Your Skills

O ne of the major goals of this book is to help you with a complete *photographer's workflow*. A photography workflow includes everything from taking, editing, and then organizing photos into a logical album structure. There are times, however, that you will want to go outside the Google workflow and experiment with other photography apps. This chapter introduces you to alternate ways to edit your photos other than the Google Photos app. I also include some of my favorite photography apps. I use these apps a lot and have been able to create quite a few photographic gems using their unique sets of tools. Have fun experimenting!

ACCESSING THE GOOGLE PLAY APP STORE

The first step in the exploration of using other apps is to introduce you to the Google Play app store. This is the easiest and safest way for you to load apps onto your Android device.

Every Android device has the Google Play app built-in, and the current look of the icon is similar to what you see here. Simply tap the Google Play app, and then search for any of the apps that you can read about in the next section.

Most apps are free to initially download but may offer extra features for a fee. Other apps may require an up-front payment. Regardless, I personally use the following ten apps all the time, and I give them my thumbs up.

Adobe Photoshop Express

The name Photoshop carries a lot of weight, and for good reason. Photoshop is the world leader in photo manipulation, and it spans many creative and business genres. The Express app is full of great features, one of which can help you create montages of your best photos. It also helps you with offering aspect ratio templates for all of the major social media platforms. For example, its Google Play store promo photo (Figure 13-1) shows a portrait with a 2:3 aspect ratio, perfect for a Pinterest upload. Use these aspect ratio templates to prep your photos for social media uploads.

© Adobe

FIGURE 13-1:
The Adobe Photoshop Express app has many social media aspect ratio crop templates.

Adobe Photoshop Camera

Adobe Photoshop Camera is a camera app that you can use to take photos with really cool filters applied to the photos in real time. You choose which filter you like, and you can see that applied filter even before you take the photo. This live-view filter application makes it much easier to compose your photo based on the filter style that you have chosen. But filter usage is just one aspect of this very fun camera! I suggest you spend a day photographing with only this app to get a sense of what it can do for your photography.

Figure 13-2 shows a promo photo by Adobe of a portrait using lens defocus. The app has a filter called Portrait that allows you to mimic the look of DSLR depth-of-field blur, which always looks great for portraits. If your Android camera doesn't allow for the Portrait mode blur that you discover in Chapters 2 and 4, try using the Portrait filter in the Adobe Photoshop Camera app.

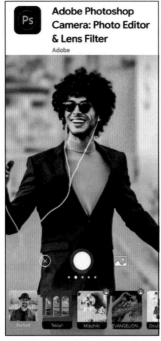

© Adobe

FIGURE 13-2:
The Adobe Photoshop Express app is a camera that helps you see your filter choices in real-time.

Photo365

When I teach international photo workshops, I often get asked how I stay excited and inspired to keep photographing every day. I suggest to them that the Learn Photo365 app is very helpful to keep their creative muscles exercised. The app gives you daily challenges on things to photograph that you can find in your own environment. Figure 13-3 shows the app from the Google Play store.

FIGURE 13-3:
The Learn Photo365 app gives you subjects and topics to photograph as daily challenges.

Foodie

Foodie is an app that has a really good collection of filters that help you raise your food photography game. Have you ever wanted to post a fantastic meal straight out of the kitchen from a great restaurant, but your photo made the food look terrible? It's not your fault, as it's very hard to photograph food under typical restaurant lighting. This app increases your plated food photography success rate. Take a look at its promo image shown in Figure 13-4.

FIGURE 13-4:
Foodie is
an app that
specializes
in filters that
make plated
food look
great.

© Snow, Inc

Prisma Photo Editor

Prisma is a photo editor that performs many editing tools. However, it's most famous for its photo-to-painting conversions. If you need new wall artwork for your house or office, why not use Prisma to change your favorite photo into an

abstract painting? Then take the digital photo and print it with a nice frame for your wall. Its Google Play app store promo image (Figure 13-5) shows the end result of a hot air balloon photo transformed into a beautiful painting.

© Prisma Labs, Inc.

FIGURE 13-5:
The Prisma app is really good at converting your photos to painterly wall art.

Facetune2

Improving skin smoothness is as easy as painting the brush over the face, and Facetune2 looks after the rest. This app also has face-specific filters, one of them shown in Figure 13-6, that can really add a sense of fine art drama to your portraits or selfies.

Facetune2 - Selfie Editor & Filters, by Lightricks

© Lightricks Ltd.

FIGURE 13-6:
The Facetune2 app is very good as smoothening skin for portraits and for adding fine art facial filters.

Canva

Canva is famous for its ability to make beautifully designed posters and banners using your photos and good-looking text. Do you have an upcoming art gallery showing of your photos? Use Canva to create a stunning promotional flyer or Facebook ad, similar to the sample work-in-progress collage in Figure 13-7. With a powerful background removal tool you can create incredible designs to fit any end-use or occasion. The app can even help you create a company logo for yourself!

Canva: Graphic
Design, Video
Collage, Logo Maker

© Canva

FIGURE 13-7:
The Canva
app is perfect
for creating
promotional
material using
your photos.

VSCO

The VSCO app has many fantastic editing tools and ways to enhance your photography, but my favorite aspect of the app is the collection of film simulations. A film simulation can transform your photo to look like actual film photos from the past, such as Kodak Ektachrome, Ilford black and white films, and Fuji Velvia slide film as shown in Figure 13-8.

© VSCO

FIGURE 13-8:
The VSCO app has many editing features but is really well-known for its film simulations.

TouchRetouch

The TouchRetouch app has similar functionality to the Photoshop Fix app, described earlier in this chapter. However, TouchRetouch is famous for getting rid of power and telephone lines. With its dedicated Line Removal tool, you simply trace over where the line is within the photo, and the app takes care of the rest. This app is worth every penny for that feature alone! However, it does so much more, such as the tools you would expect . . . clone stamping, healing, and object removal.

Use this app when the beauty of the exterior suffers from distracting powerlines and other objects as illustrated in their Google Play sample photo. In Figure 13-9 you see how the photographer simply traces the telephone wires, and when done tracing the wires disappear.

© ADVA Soft

FIGURE 13-9:
The TouchRetouch app is one of the best apps for removing power lines from your photos.

PhotoScan

Google's PhotoScan app helps you digitize your printed photos from the film days. Do you have boxes full of family 4"x6" prints in your basement or garage? Why not digitize them to keep for future generations! The PhotoScan app is an easy and quick way to save those memories. PhotoScan digital images can also be safely stored within your Google cloud account, which makes sharing those photos very easy. Figure 13-10 shows a sample promo image of the app taking a scan of an old family print.

PhotoScan by Google Photos

Google LLC

FIGURE 13-10:
The PhotoScan app helps you digitize your old family prints.

© Google LLC

IN THIS CHAPTER

» **Holding your video camera properly**

» **Trimming the length of your video**

» **Cropping your video**

» **Applying video filters**

» **Capturing slow motion videos**

» **Creating time lapse videos**

Chapter **14**

Ten Tips for Creating Stunning Videos

C reating videos with your Android camera is easy and fun! In this chapter, you discover ten features of your Android video camera that help you record life's fleeting moments. Use the video camera for family events, nature scenes, and for recording video selfies.

TIP

Most of the tips in this chapter also work with the front-facing selfie camera in video mode, which is great for vlogging or sharing a video greeting to friends and family.

In this chapter, I use sample video clips that I took from around the world during the annual photography workshops that I teach. I hope you enjoy the virtual world tour while you practice using your own videos.

Accessing the Video Camera

Each Android device has a slightly different way to access the video camera, but almost all of them have the Video icon next to the normal Camera (or Photo) icon. Take a look at Figure 14-1, which is a screenshot of a video that I took in Jamaica

during a Caribbean Photo Workshop. I accessed the video camera by tapping the Video icon located beside the Camera icon.

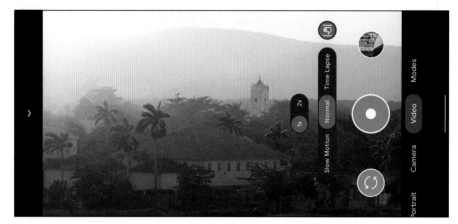

© MarkHemmings.com

FIGURE 14-1:
Tap Video to access the video camera, which is often located next to the Camera (or Photo) icon.

I took this video with a Google Pixel 4a, which gives three options for videos: Normal (see the next section), Slow Motion (see the "Capturing Video Clips with Slow Motion" section), and Time Lapse (see the "Creating Time Lapse Video Clips" section).

Properly Holding Your Camera for Videos

To create a video clip, make sure that you position yourself for stable video recording. In addition to the tips I share in Chapters 2 and 4 about holding your camera steady while standing, add the following stability tips to your video recording routine:

>> **If your level of mobility allows, kneel on the ground so that your elbow rests on your leg, as shown in Figure 14-2.** Gardener's knee pads are cheap and very easy to pack in your camera bag for comfortable kneeling. You can buy them at any gardening or hardware store.

>> **Use your elbow anchor point for lateral (horizontal panning) motion from left to right or right to left.** Your elbow acts as a stabilizer to reduce shaky video clips.

>> **For vertical panning (up and down), use your two wrists to initiate the movement rather than your arms.** Figure 14-2 also illustrates with arrows how your wrists act as a pivot point when recording video in an up and down motion.

When you're ready to take your video, press the shutter button to start recording. You know you're recording when the button turns red. When you're done recording, press the shutter button again. To review your video, go to the Google Photos app and you'll find it in the Photos section. You can also access your video clips within the Search section. Tap the magnifying glass icon at the bottom of the Google Photos app, scroll down, and tap Videos.

FIGURE 14-2: If possible, kneel and rest your elbow on your leg for added video capture stability.

© Susan Hemmings

Trimming the Length of Your Video Clip

After you've taken your video, you most likely want to take out all the unnecessary parts. Figure 14-3 shows my Japan Photo Workshop participants eagerly awaiting a Japanese bullet train. I decided to create a video clip of them photographing the train as it pulled into the station. I recorded far too much video prior to the train's

arrival, so I want to trim the video to only show the most important parts. Follow along with your own video to practice the trimming tool:

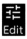

1. **With your video onscreen, tap Edit.**

2. **As shown in Figure 14-3, slide the left video clip handle slightly to the right, and choose a new video clip start point.**

 Figure 14-4 shows the new start point of the video, which appropriately is the sleek and fast bullet train. I wanted the new video clip to start with the train visible.

3. **If you want to trim the end of your video, simply do the same thing in reverse. As in Figure 14-4, slide the right video clip handle to the left to create a new endpoint.**

 You now see the result of the video clip end trimming, where I wanted the last video frame to show my photography student capturing a photo of a train conductor outside of the window (see Figure 14-5). Now my video starts with a really cool view of the bullet train and also ends with an interesting scene!

4. **Tap Save Copy at the bottom right of your screen when you're happy with your trimming work (also shown in Figure 14-5). Tap Cancel to discard any changes if you decide not to trim your video, or you want to start the process again.**

 You now see your newly created shortened video clip. The original unedited video and the newly edited shortened video can be viewed anytime in the Photos section of the Google Photos app, or the Videos section within the Search section of the app. Feel free to delete or keep the original longer video.

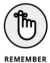

REMEMBER

Keep the original and trimmed video in case you ever need access to the original for future video productions.

FIGURE 14-3:
Slide the left video handle to the right and choose a new video clip start point.

FIGURE 14-4:
Slide the video clip handle from far right to the left to trim the tail-end of your video clip.

FIGURE 14-5:
The end-trimming stops at a key point of the video that has an interesting scene.

Reducing Video Shakiness

Each year that I take photo workshop participants to Greece we always do photography and videography lessons from a boat. The goal is to teach camera stability techniques and how to come away with a prize-winning travel photo or video. There are times, however, that even the best techniques are still not adequate, especially when photographing or filming from a smaller-sized boat on a windy day.

To help with video shake-reduction, most Android video cameras have a stabilizing feature with a similar look to the icon circled in Figure 14-6. Tap this icon if you're walking while filming, if you are in a windy environment, or like in this figure sailing around the breezy Greek islands!

FIGURE 14-6:
Most Android
video cameras
have a shake-
reduction
stabilizer tool.
Tap it for
smoother
videos when
conditions
aren't ideal
for stable
videography.

Exporting a Still Frame

Did you know that you can create a normal photo from one split-second of your video clip? The technical term for this helpful process is *exporting a still frame*. The video clip shown in Figure 14-7 is from a stunningly beautiful mountain village called Barga, in Italy. When I teach photo workshops in Tuscany, I encourage my participants to approach videography as a photographer. In videography you're essentially taking 30 still photos every second, so in a sense you're continually using your photography composition and lighting techniques that you regularly use as a photographer.

The goal was for each person to capture a video clip within the village, and then choose a single frame to export as a normal photo. You can do this too with your own video clip:

1. **While in Edit mode, scroll your end video clip handles or tap anywhere within your video timeline to a point in your video that has great potential for a normal photo.**

 Figure 14-7 shows a part of my video clip that I want to export as a single travel photo.

FIGURE 14-7:
By using video
clip handles
or by tapping
within the
timeline, locate
a section of
your video that
you want as
a normal still
photo.

2. **Tap Export Frame, located just under your video timeline.**

You newly created still photo is saved within the Photos section of your Google Photos app.

3. **Edit your newly created still photograph.**

I felt that my still photo was a bit soft-looking, so I increased the contrast and saturation, plus cropped out the road sign to come up with a decent travel photograph (see Figure 14-8). See Chapter 11 for other photo editing techniques you can use.

TIP

Keep in mind that your exported still photo doesn't have the same resolution as a normal photo, but it's more than enough resolution to show on social media and any screen-based viewing. If you want to print the exported still photo, an approximate 4"x6" print looks good, and you could probably push the limits by printing a 5"x7" at your local photo print lab. Anything larger than an approximate 5"x7" may looked pixelated and stretched.

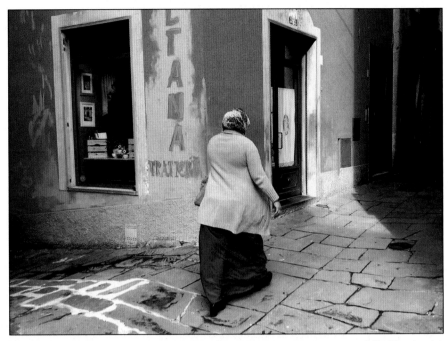

© MarkHemmings.com

Cropping Your Video

Even though I've been using both still and motion cameras professionally since 1998, I still sometimes photograph or film a little bit unevenly. To level your video whereby straight horizontal lines within your video are perfectly level, use the Crop tool.

Check out Figure 14-9. I created this video clip in preparation for my Jerusalem Photo Workshop but was slightly disappointed to find that I didn't film the Western Wall evenly. You can easily spot this because the horizontal cracks in the Western Wall are tilting slightly downward to the right.

Follow these steps to practice straightening, and other crop tools using your own video clip:

1. **Tap Crop.**

 The Crop tool icon is located to the right of your Video icon when in the Edit mode. You now see your video with gridlines and an adjustment slider, as shown in Figure 14-10.

FIGURE 14-8:
You can edit
your exported
still photos.

2. **With your finger, scroll the adjustment slider left or right to straighten your video.**

 Notice that a -1° adjustment slider scroll has straightened the Western Wall video clip.

3. **(Optional) Use any or all of the other cropping tools on your video.**

 You have access to the same cropping tools for videos that you do for your photos. See Chapter 11 to find out all about them.

4. **Tap Save Copy when you're happy with your video editing.**

FIGURE 14-9:
Initiate the Crop tool when your video is slightly uneven.

FIGURE 14-10:
Scroll the adjustment slider left or right to level your video.

Adjusting Your Video

Adjust allows you to change the following aspects of your video: Brightness, Contrast, White Point, Highlights, Shadows, Black Point, Saturation, Warmth, Tint, Skin Tone, Blue Tone, and Vignette. Chapter 11 covers all these tools.

Figure 14-11 shows the beautiful cityscape of San Miguel de Allende, Mexico. Thousands of birds were flying past the famous pink church, so I encouraged my photo workshop participants to capture as many photographs and video clips as possible. While the video clips looked great, I found that they didn't look warm enough. So, to remedy that I tap the Adjust icon (to the right of Crop), and simply choose any color, tonal, or contrast editing tool that I like to jazz up the look of my video. For this particular scene the addition of the Warmth tool would be more accurate to what I saw with my own eyes.

FIGURE 14-11: The Adjust tools help you with color, tonal, contrast, and other adjustments for your video clips.

Applying Filters to Your Video

The same filters I cover in Chapter 11 are also available to use on your video clips! Filters such as Vivid, West, Palma, Metro, and others are easily accessible within the Filters section. The Filters icon is located between Adjust and Markup icons.

Each year I lead photo workshop participants throughout Japan, and one stop is the quaint hot spring village of Shibu Onsen in Nagano. After a day of photographing the famous Japanese Snow Monkeys relaxing in their hot spring baths, we saw a woman braving the snow covered streets down in the village. She was navigating the snowy streets wearing traditional Japanese wooden clogs! We took a video clip of this traditional scene (see Figure 14-12) and felt it represented rural Japan in a lovely way.

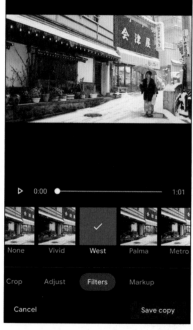

FIGURE 14-12: Use any filter that you like to add drama to your video clips. I used the West filter for this Japanese village video clip.

© MarkHemmings.com

The only problem with the video clip was that I felt it lacked a sense of drama. To change things a bit I chose the West filter, which adds a slight matte effect. A matte effect, for both photos and videos, has a nostalgic film look that suited the traditional scene very well. With your own video clip, I encourage you to experiment with each filter and choose the one that you like the best.

Capturing Video Clips with Slow Motion

When using the Slow Motion video camera mode, any object in motion appears to be moving incredibly slow. This fantastic tool of self-expression is perfect for sports videography, family video memories of small kids tearing through the house, or a fun dance party.

Tap the Slow Motion icon next to the Normal icon, as shown in Figure 14-13. (A non-Google Pixel Android device won't show the icons exactly in this way. Look for the words Slow Motion. For example, on a Samsung S21, you find Slow Motion within the More icon.)

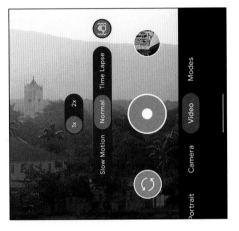

With Slow Motion activated, film as you normally would, but the real magic happens when you review the video clip afterward. Everything slows down!

FIGURE 14-13:
Tap the Slow Motion icon to record video clips with a very slow appearance.

TIP

Usually, three or four seconds of slow motion capture is more than enough, as that three or four seconds expands to a double digit amount of seconds upon video playback.

Creating Time Lapse Video Clips

A Time Lapse video ends up looking like a normal video but sped up to show the passing of time very quickly. You can have endless fun creating time lapse videos with your Android. Anything that moves around within your composition looks like a funny animation when you finish your time lapse and press play to watch.

Tap the Time Lapse icon, and film for about 30 seconds to a minute. If you walk around while filming, it looks even better! Makes sure that either your subject matter is moving, or you're moving. When you're done filming, review the time lapse, and you will see how much fun you can have by radically speeding up life!

IN THIS CHAPTER

» **Viewing the Memories carousel**

» **Creating screenshots**

» **Clearing the clutter**

» **Accessing your metadata**

» **Searching with Google Lens**

Chapter **15**

Ten Extra Google Photos Features

The Google Photos app has a few more surprises that add to all the tools that you can discover in earlier chapters. The following ten extra features and tools are my favorites, and I know that you will benefit from them as much as I do!

Viewing the Memories Carousel

The Memories carousel contains a few auto-generated albums that the Google Photos app thinks might interest you. Figure 15-1 shows my Google Photos app, with automatically generated albums called In the Woods and Recent Highlights. In your own Google Photos app you see the Memories carousel within the Photos section, at the top of the screen.

The In the Woods album contains all the photos and videos that I've taken of various forests, trees, and hikes in the woods. Google's artificial intelligence soft-ware scanned my photo and video collection and created this album assuming that I liked trees! Fortunately, I love the woods, so I appreciated Google's suggestions.

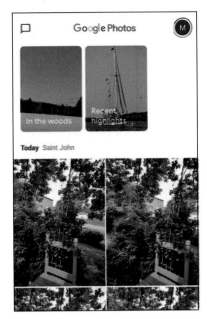

FIGURE 15-1:
The Memories
carousel
contains
recently
highlighted
photos and
videos, plus a
custom created
album based
on photos of
a common
theme.

The other album, Recent Highlights, contains a number of photos and videos that the Google Photos app thinks are priorities for me. Of course, Google Photos can't read my mind, but it's pretty good at guessing what types of media that I like to create. These suggestions from Google are periodically placed in the Recent Highlights album.

Watching Creations

The Google Photos app has an automatically generated feature that creates stylized versions of your images. These stylized photos and memories periodically pop up within the Recent Highlights album. For example, the other day I got a notification on my Android that Google Photos created a stylized photo for me. I was intrigued, so I tapped the link and Figure 15-2 shows what the app created.

It took my color photo of spring flowers and a granite wall and converted it to a black-and-white photo. And I liked it! So, at the bottom left of the screen, I tapped the Save Stylized Photo icon. The black-and-white stylized image is saved with all of my other photos within the Google Photos apo, and the original photo remains untouched. If you don't want to save your stylized photos you can just ignore the suggestions.

FIGURE 15-2:
A Creation is a
stylized photo
or special
memory that
Google Photos
periodically
creates
for you.

© MarkHemmings.com

Creating Auto Panoramas

In Chapter 4, you discover how to create a panorama photo. There is another way to have a panorama photo made for you, and it's quick and easy. Take a number of photos of the same scene from left to right or right to left, making sure that each photo has a bit of overlap from the previous photo for easy panorama photo stitching. Figure 15-3 shows a front yard scene with eight photos that I took that covered a very wide scene.

And now all you do is wait! Within an hour you may receive a notification from the Google Photos app that you have an auto-generated panorama photo to view. The new panorama can be located with the Library section of the app, and then within Utilities. If you like the panorama press Save, shown in Figure 15-4, or if you want to ignore the panorama suggestion, press the X at the top right of the panorama to remove the suggested creation.

FIGURE 15-3:
Take a number
of photos of
a scene with
a slight left to
right, or right
to left motion.

FIGURE 15-4:
Your
Panorama
photo
suggestion
is within
the Utilities
section, and
you can save
or delete the
panorama.

Adding a Partner Account

The Google Photos app makes sharing photos easy and fun. You can share photos using a number of parameters such as people (using facial recognition) and even photos from a specific date in the future. To see all of the sharing features available to you, make sure your friend has a Google account, and then follow these steps:

1. **Within the Library section of your app, tap Utilities.**

2. **Scroll down until you see Add Partner Account, as shown in Figure 15-5.**

3. **Tap Get Started.**

4. **Type your friend's email address.**

5. **Choose to grant access for all your photos, photos of specific people, or recent photos based on a certain start date.**

 Whatever option you choose is reflected in what your friend can access when they receive the invite email from Google.

FIGURE 15-5: Share some or all your photos with a friend using the Partner Account sharing tool.

Marking Up Your Photo

The Edit section of the Google Photos app also has Markup tools, placed to the right of Filters. Markup allows you to make textual notes and basic pen sketches to your photos. Figure 15-6 shows a screenshot of the markup notes that an editor sent me. As you can see, the editor asked me to alter certain aspects of my photo to prepare it for magazine publication. You too can mark up your own photos using the pen, highlighter, and text tools. As the app usually forces you to save your copy, your original photo remains untouched without any markups.

© MarkHemmings.com

FIGURE 15-6: Use the Markup tool to add text notes and basic pen drawings to any of your photos.

Accessing Your Metadata

Metadata is information stored within photographs that contains data on the type of camera and lens used, the exposure parameters, and often the location where the photo was taken. You can check the metadata information for each of your photos in two very easy ways:

» Tap the More icon (three dots) at the top right of your photo review screen.

» Swipe your photo in an upward motion from the lower part of your photo.

Figure 15-7 shows both methods for accessing your photo's metadata.

I took the Figure 15-7 sunset photo with my Samsung S21 Ultra, but I forgot what time I took the photo. Because I wanted to go back to the same location at the same time for another sunset shot, by accessing the photos metadata I could see that I took the photo at exactly 9:02 p.m. (See Figure 15-8.)

You also see that there is Google Maps location info, the filename of the photo, the photo's megapixels count, the pixel resolution, the file size (2MB), the official technical name of the Samsung camera, and the camera exposure information. Wow! That's a lot of useful information.

© MarkHemmings.com

FIGURE 15-7:
To access your photo's metadata swipe upward or tap the More (three dot) icon.

FIGURE 15-8:
The photo metadata contains a lot of useful information about the photograph, location data, and camera data.

Searching with Google Lens

Google Lens is a really helpful tool to view other photos on the web that look similar to your own photo. For example, Figure 15-9 shows an unusual maintenance train that I photographed in my home city. I was intrigued by the train as I had never seen it before, nor did I know what it was used for. So, at the bottom of my screen, I tapped Lens (shown in Figure 15-9) and it found other photos of the same train!

Figure 15-10 shows the other websites that feature the Herzog train, and I was then able to get all the info that I needed quickly and easily. While not within the scope of this book, Google Lens also has many more features such as translation of text on photographs, shopping for the object in your photo (maybe I will buy a Herzog!), searching locations similar to where your photo was taken, and if your photo is of food, a restaurant search that relates to your food photo. You will no doubt have a lot of fun with the Google Lens tool.

© MarkHemmings.com

FIGURE 15-9:
Tap Lens at the bottom of your photo review screen.

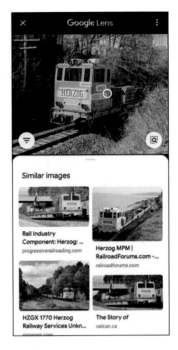

FIGURE 15-10:
Google Lens shows results similar to the subject matter in your own photo.

Buying Photo Books

Within the Library section of the Google Photos app, at the top of the screen is a Photo Books section (see Figure 15-11). In the Photo Books section, you see suggestions for photo books, as well as the ability to design photo books based on the photo albums that you've created. You can create a photo book based on people search or simply design a book from scratch. The books are printed in hard or softcover.

FIGURE 15-11:
Within the Library section, the Google Photos app can print books of your photographs.

Creating Screenshots

A *screenshot* (or screen grab) is a visual duplication of whatever is on your Android screen at the moment. For example, I'm currently planning the restaurants that my Italy Photo Workshop participants will be eating at in Florence. I used Google Maps for my restaurant search but had to take a break for a phone call, so I created a screenshot of the Italian restaurants listed on Google maps. I now have a record of the restaurant names if I need to recall what I was searching for.

To create a screenshot simply press and hold your Android's power and volume-down buttons at the same time for about one second. You see a flash of light onscreen, and possibly hear the sound of a camera shutter click. To access your screenshots (as shown in Figure 15-12), go to the Library section of the Google Photos app, and for most Android devices a Screenshots folder is created.

FIGURE 15-12:
To create a screenshot, press and hold the power and volume down button, and the screenshot is saved within the Library section.

Clearing the Clutter

While creating this book I've amassed so many screenshots! The screenshots are scattered everywhere within the Photos section of my Google Photos app, and they make my photo collection reviewing less efficient. To clean up my Photos section to see only photographs, I periodically make use of the Clear the Clutter tool. By tapping the tool, you're shown a number of suggestions for a cleaner photo collection. If you choose to accept the suggestions, the Photos section of your app has far less non-essential images. But don't worry! Those screenshots aren't deleted; they're simply archived.

1. **Tap the Library section of the Google Photos app.**

2. **Tap Utilities.**

3. **Tap Review Suggestions within the Clear the Clutter section. (See Figure 15-13.)**

 Any photos and screenshots Google suggests archiving have a blue check mark.

4. **Review all suggestions that have a blue check mark. Uncheck photos or screenshots if you don't want certain images to be archived.**

5. **Tap Archive (at the top right of the screen) when you have finished your review.**

The Clear the Clutter option is based on Google's AI decision-making process that looks for screenshots and other images that may not be as important as your normal photographs. The suggestions are usually quite accurate; however, if Google missed some images that you feel should have been selected for archiving, you can switch to manual archiving, explained in Chapter 3.

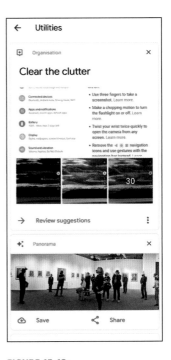

FIGURE 15-13:
The Clearing the Clutter tool helps you to archive non-essential media such as screenshots.

Index

H

HDR (High Dynamic Range)
 contrast and, 187–191
 editing tool, 230
high contrast, 111–112, 206
high quality photos, uploading, 44–45
High-Key Mono effect, 68–69
Highlights tool, 231
horizontal grip, stabilizing camera with, 22–23
horizontal panorama photos, 78–81

I

Instagram website, 183
interior architecture photography, 176
interior lighting, 125–127, 176
interpolation, 30

J

Joby website, 168

L

landscape photography
 composition in
 framing "L" shaped, 98–99
 photographing during magic hours, 90–92
 positioning subjects, 99–100
 Rule of Thirds, 97–98
 editing tool for, 233
 exposure in, 87–89
 family and portrait photography and, 134–135
 filters for, 210
 gear for, 92–95
 lens for, 95–97
 lighting, 90–92
 overview, 85–89
 panoramas, 77–82, 291–292
 recommendations for, 97–100
 stabilization in, 86–87
 timers, 36–37
 tripods, 92–95

lens flare, 152, 154
lenses
 for architecture photography, 226–228
 blur from, 165–166
 compression, 121–123
 for family photography, 121–123
 for landscape photography, 95–97
 panoramas and, 81
 for portrait photography, 121–123
 for selfies, 31–32
 for street photography, 182–183
 for travel and vacation photography, 142–143
 types by model, 8–11
 zooming in/out, 26–31
lighting
 avoiding certain types of, 125–126
 backlighting, 35, 126–127
 defined, 107
 editing tool, 235, 239
 effects and, 68–69
 exterior, 174–175
 in family and portrait photography
 backlighting, 126–127
 exterior, 129–131
 interior, 125–127
 position of camera and, 125–126, 131–132
 silhouettes and shadows, 127–129
 fill-light, 35
 flash, 32–35
 interior, 176
 in landscape photography, 90–92
 magic hours
 overview, 90–92
 sports photography in, 107–110
 travel and vacation photography in, 152
 Night Sight feature and, 93–95
 in selfies, 35, 60–61
 in sports photography
 cool and warm color tones, 111
 high contrast, 111–112
 sunrise and sunset, 107–110

About the Author

Mark Hemmings is a professional travel and street photographer of more than two decades. His first international photography related trip was in Japan in 1997, and he's been photographing in Japan and around the world annually since then. When not working in his Canadian home city as an architectural and advertising photographer, Mark teaches annual photography workshops in Italy, Jerusalem, Mexico, the Caribbean, Greece, and Japan.

In addition to an extensive history with Canon, Nikon, Sony, and Fujifilm DSLR and mirrorless cameras, Mark is an internationally recognized mobile device photographer using both Android and iPhone cameras. His @markhemmings Instagram profile offers almost daily photography inspiration, created to encourage people from around the world to hone their photographic skills. You can view Mark's full photography portfolio and photo workshop dates and locations at www.markhemmings.com.

Dedication

To my fantastic parents Don and Jane who have always been incredibly supportive in all my endeavors. Thank you, mom and dad! You both made it very easy for me to stay creative over the decades.

Author's Acknowledgments

I would like to thank my Wiley contacts and helpful editors, specifically Steve Hayes, Rebecca Senninger, and Scott Proctor who guided me through this, my second *For Dummies* book. And most importantly, my wonderful wife Susan and daughters Aren and Adrienne. All three of them are very talented smartphone photographers and are always very supportive and encouraging.

Publisher's Acknowledgments

Development Editor: Rebecca Senninger

Executive Editor: Steven Hayes

Technical Editor: Scott Proctor

Production Editor: Tamilmani Varadharaj

Cover Image: © Photo courtesy of Mark Hemmings

Take dummies with you everywhere you go!

Whether you are excited about e-books, want more from the web, must have your mobile apps, or are swept up in social media, dummies makes everything easier.

Find us online!

dummies.com

dummies
A Wiley Brand

Leverage the power

Dummies is the global leader in the reference category and one of the most trusted and highly regarded brands in the world. No longer just focused on books, customers now have access to the dummies content they need in the format they want. Together we'll craft a solution that engages your customers, stands out from the competition, and helps you meet your goals.

Advertising & Sponsorships

Connect with an engaged audience on a powerful multimedia site, and position your message alongside expert how-to content. Dummies.com is a one-stop shop for free, online information and know-how curated by a team of experts.

- Targeted ads
- Video
- Email Marketing
- Microsites
- Sweepstakes sponsorship

20 MILLION PAGE VIEWS EVERY SINGLE MONTH

15 MILLION UNIQUE VISITORS PER MONTH

43% OF ALL VISITORS ACCESS THE SITE VIA THEIR MOBILE DEVICES

700,000 NEWSLETTER SUBSCRIPTIONS TO THE INBOXES OF *300,000* UNIQUE INDIVIDUALS EVERY WEEK

of dummies

Custom Publishing

Reach a global audience in any language by creating a solution that will differentiate you from competitors, amplify your message, and encourage customers to make a buying decision.

- Apps
- Books
- eBooks
- Video
- Audio
- Webinars

Brand Licensing & Content

Leverage the strength of the world's most popular reference brand to reach new audiences and channels of distribution.

For more information, visit dummies.com/biz

PERSONAL ENRICHMENT

Staying Sharp
9781119187790
USA $26.00
CAN $31.99
UK £19.99

Facebook
Carolyn Abram
9781119179030
USA $21.99
CAN $25.99
UK £16.99

Guitar
Mark Phillips
Jon Chappell
9781119293354
USA $24.99
CAN $29.99
UK £17.99

Investing
Eric Tyson, MBA
9781119293347
USA $22.99
CAN $27.99
UK £16.99

Beekeeping
Howland Blackiston
9781119310068
USA $22.99
CAN $27.99
UK £16.99

Digital Photography
Julie Adair King
9781119235606
USA $24.99
CAN $29.99
UK £17.99

Meditation
Stephan Bodian
9781119251163
USA $24.99
CAN $29.99
UK £17.99

Pregnancy
9781119235491
USA $26.99
CAN $31.99
UK £19.99

Samsung Galaxy S7
Bill Hughes
9781119279952
USA $24.99
CAN $29.99
UK £17.99

iPhone
Edward C. Baig
Bob "Dr. Mac" LeVitus
9781119283133
USA $24.99
CAN $29.99
UK £17.99

Crocheting
Karen Manthey
Susan Brittain
9781119287117
USA $24.99
CAN $29.99
UK £16.99

Nutrition
Carol Ann Rinzler
9781119130246
USA $22.99
CAN $27.99
UK £16.99

PROFESSIONAL DEVELOPMENT

Windows 10
Andy Rathbone
9781119311041
USA $24.99
CAN $29.99
UK £17.99

AutoCAD
Bill Fane
9781119255796
USA $39.99
CAN $47.99
UK £27.99

Excel 2016
Greg Harvey, PhD
9781119293439
USA $26.99
CAN $31.99
UK £19.99

QuickBooks 2017
Stephen L. Nelson, MBA,
CPA, MS in Taxation
9781119281467
USA $26.99
CAN $31.99
UK £19.99

macOS Sierra
Bob "Dr. Mac" LeVitus
9781119280651
USA $29.99
CAN $35.99
UK £21.99

LinkedIn
Joel Elad, MBAs
9781119251132
USA $24.99
CAN $29.99
UK £17.99

Windows 10
Woody Leonhard
9781119310563
USA $34.00
CAN $41.99
UK £24.99

SharePoint 2016
Rosemarie Withee
Ken Withee
9781119181705
USA $29.99
CAN $35.99
UK £21.99

Fundamental Analysis
Matt Krantz
9781119263593
USA $26.99
CAN $31.99
UK £19.99

Networking
Doug Lowe
9781119257769
USA $29.99
CAN $35.99
UK £21.99

Office 2016
Wallace Wang
9781119293477
USA $26.99
CAN $31.99
UK £19.99

Office 365
Rosemarie Withee
Ken Withee
Jennifer Reed
9781119265313
USA $24.99
CAN $29.99
UK £17.99

Salesforce.com
Liz Kao
Jon Paz
9781119239314
USA $29.99
CAN $35.99
UK £21.99

Coding
Nikhil Abraham
9781119293323
USA $29.99
CAN $35.99
UK £21.99

dummies.com

dummies
A Wiley Brand

Learning Made Easy

ACADEMIC

9781119293576
USA $19.99
CAN $23.99
UK £15.99

9781119293637
USA $19.99
CAN $23.99
UK £15.99

9781119293491
USA $19.99
CAN $23.99
UK £15.99

9781119293460
USA $19.99
CAN $23.99
UK £15.99

9781119293590
USA $19.99
CAN $23.99
UK £15.99

9781119215844
USA $26.99
CAN $31.99
UK £19.99

9781119293378
USA $22.99
CAN $27.99
UK £16.99

9781119293521
USA $19.99
CAN $23.99
UK £15.99

9781119239178
USA $18.99
CAN $22.99
UK £14.99

9781119263883
USA $26.99
CAN $31.99
UK £19.99

Available Everywhere Books Are Sold

dummies.com

Small books for big imaginations

GETTING STARTED WITH **Coding**
Get Creative with Code!
Camille McCue, PhD

9781119177173
USA $9.99
CAN $9.99
UK £8.99

MODDING **Minecraft**
Build Your Own Minecraft Mods!
Sarah Guthals, PhD
Stephen Foster, PhD
Lindsey Handley, PhD

9781119177272
USA $9.99
CAN $9.99
UK £8.99

MAKING **YouTube** VIDEOS
Star in Your Own Video!
Nick Willoughby

9781119177241
USA $9.99
CAN $9.99
UK £8.99

DESIGNING **Digital Games**
Create Games with Scratch!
Derek Breen

9781119177210
USA $9.99
CAN $9.99
UK £8.99

GETTING STARTED WITH **Raspberry Pi**
Program Your Raspberry Pi!
Richard Wentk

9781119262657
USA $9.99
CAN $9.99
UK £6.99

EXPERIMENTING WITH **Science**
Think, Test, and Learn!
Oliver J. Mullins, PhD

9781119291336
USA $9.99
CAN $9.99
UK £6.99

CREATING **Digital Animations**
Animate Stories with Scratch!

9781119233527
USA $9.99
CAN $9.99
UK £6.99

GETTING STARTED WITH **Engineering**
Think Like an Engineer!
Camille McCue, PhD

9781119291220
USA $9.99
CAN $9.99
UK £6.99

WRITING **Computer Code**
Learn the Language of Computers!
Chris Minnick and Eva Holland

9781119177302
USA $9.99
CAN $9.99
UK £8.99

Unleash Their Creativity

dummies.com